Stories of you, me and BC

FREE SPIRIT

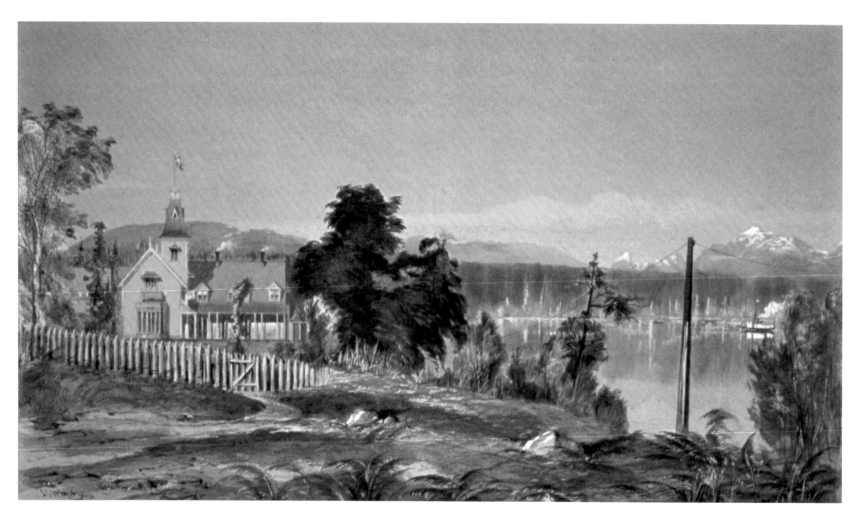

Government House, New Westminster, BC
John C. White, 1866.
BC Archives PDP001644

An artist and architectural draughtsman, John White (1835–1907) arrived in BC in 1858 as a Second Corporal in the Royal Engineers. Government House was on the former Royal Engineers campsite at Sapperton (now part of New Westminster) on the northern bank of the Fraser River.

FREE SPIRIT

STORIES OF YOU, ME AND BC

Gerald Truscott

ROYAL **BC** MUSEUM

Victoria, Canada

Published by the Royal BC Museum, 675 Belleville Street, Victoria, British Columbia, V8W 9W2, Canada.

The Royal BC Museum is grateful to our generous partners for their support of the Free Spirit project.

Funding Partner

Province of British Columbia

Partners

BC150 Years Secretariat

BC Hydro Power Smart

Global TV

The Vancouver Sun

CHEK News

Victoria *Times Colonist*

Book design by Chris Tyrrell, RBCM.

Digital imaging by Carlo Mocellin and Kim Martin, RBCM.

All colour photographs by Carlo Mocellin, Kim Martin and Andrew Niemann, RBCM, except those with credits. All black-and-white are credited unless the photographer is unknown.

Edited by Andrea Scott.

Production assistance and proofreading by Ellen Rooney.

Typesetting (in Gill Sans) and layout by Reber Creative.

Printed in British Columbia, Canada, by Blanchette Press.

Library and Archives Canada Cataloguing in Publication Data

Truscott, Gerald, 1955-

Free spirit : stories of you, me and BC.

ISBN 978-0-7726-5870-8

Issued in association with the exhibition "Free Spirit: stories of you, me and BC" in celebration of 150 years of BC, at the Royal BC Museum from March 2008 to January 2009.

1. British Columbia – History. 2. British Columbia - Biography. I. Royal BC Museum. II. Title.

FC3803.5T78 2008 971.1 C2008-960056-8

Contents

Village of Field, BC
Louis Comfort Tiffany, about 1914.
BC Archives PDP04687

Louis Tiffany (1848–1933) was a well-known American artist and
art patron. He was the son of Charles Tiffany, founder of Tiffany
& Company, maker of the famous lamps. Louis began his career
as a landscape painter before becoming interested in glassmaking.
Throughout his life, he travelled around North America "in pursuit
of beauty", and was inspired to paint the small town of Field in the
Selkirk Mountains, near Golden.

Foreword

In this land of extremes at the western edge of Canada, tales of big events and bigger-than-life characters are plentiful. Yet the truly amazing stories in British Columbia tell of ordinary people doing extraordinary things, individuals going about their lives and shaping the character of their province in the process. Like no other place, there is a spirit here – a free spirit – that courses through the veins of those who call BC home.

This book, *Free Spirit: Stories of You, Me and BC*, presents an innovative way of looking at British Columbia's history, offering glimpses into the lives of ordinary British Columbians by examining the objects and images associated with them. These are stories of arrival, survival, family tradition, community life and much more. Taken together, they show we are all connected and enriched by the fantastic history we share. But as much as this is a collective history, it is more importantly a personal heritage each of us is blessed with simply by living here.

The Royal BC Museum, as the archives and museum of our province, is proud to publish *Free Spirit: Stories of You, Me and BC*. It is an enduring legacy of the Free Spirit project, which was developed to celebrate British Columbia in its sesquicentennial. It endeavours to capture the story of British Columbia so that future generations can better understand the environment and culture of the land they inherit. Free Spirit builds on the strong collection and good research for which the Royal BC Museum is already known.

I hope the stories in this book inspire you to consider the richness of your own story and how it contributes to the larger tapestry of the province. After all, your history is part of our shared heritage here in British Columbia.

Pauline Rafferty, CEO
Royal BC Museum Corporation

To my mother, Laura Truscott,
a true British Columbian hero.

"... history is a pattern
of timeless moments."

– T.S. Eliot

Preface

Many months ago the Royal BC Museum began work on a project to celebrate British Columbia's 150 years of being a British colony and a province of Canada. The project, called Free Spirit, has six components: a major exhibition presented at the Royal BC Museum from March 2008 to January 2009; a smaller exhibition travelling via railway throughout parts of the province in the latter half of 2008; a Conservation Tour, focusing on energy conservation, in the fall of 2008; a website, featuring a virtual exhibition; the People's History Project, inviting the public to contribute family or community histories; and this book.

Tim Willis, the RBCM's Director of Exhibits and Visitor Experience, asked me to write the text for the Free Spirit exhibitions and to assemble and write this book. My task was to give a single voice to information coming from several curators and archivists. The prospect excited me, especially the writing of this book – I've lived all my life in British Columbia and I've been editing and publishing books for more than half of it, for almost 20 years here at the RBCM. This project gave me an opportunity to contribute more than advice on language and text presentation; it allowed me to develop the voice of the free spirit and tell a whole bunch of really interesting stories.

The free spirit of the exhibitions and the book is an average British Columbian who loves travelling around the province and sharing experiences, who's always amazed by the natural and cultural diversity of this place, who looks forward to another surprise around the next bend in the road.

The stories in this book arose from the major exhibition, which is based on the vast collections of the provincial museum and archives, with some objects borrowed from other sources. I have expanded on some of the stories, changed the focus of others to suit the pages of a book, and added a few related stories. With the help of Tim Willis and others involved with the People's History Project, I also chose a dozen stories from the early submissions to that project.

The result is a collection of vignettes and anecdotes that I think express the nature of the free spirit in all British Columbians.

GLT, February 2008

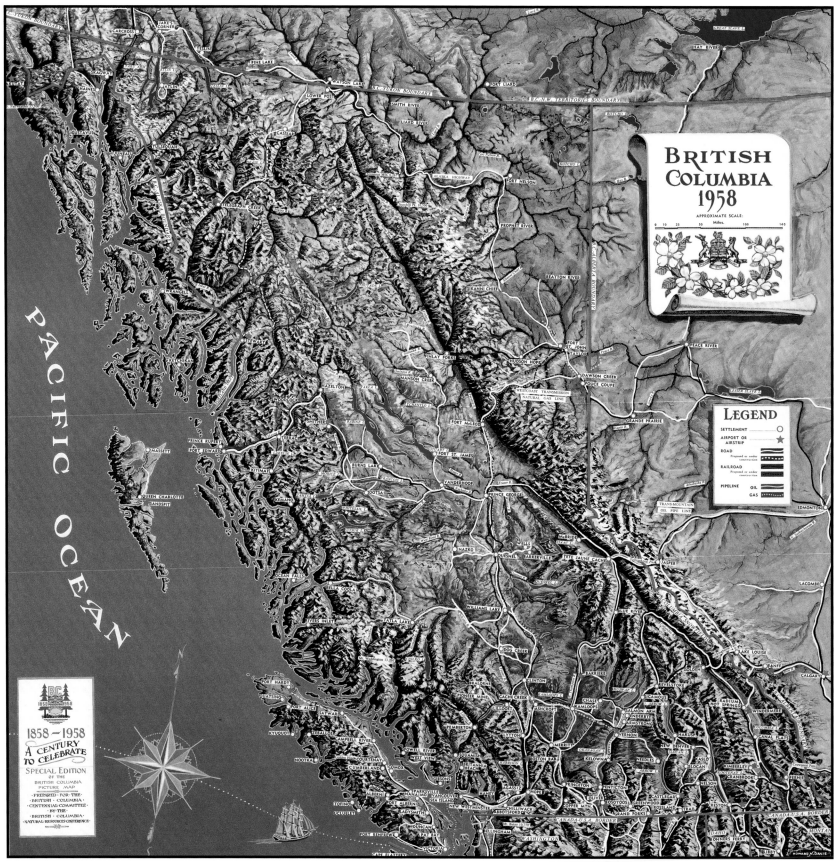

Map produced for BC's centennial celebration in 1958.

Introduction

On a good day flying in from eastern Canada I can always tell when home is near. After the seemingly endless Prairies, the Rockies rise up in greeting, and then another jagged spine of mountains, and another, and so on like great stony waves. Between them, if the clouds break kindly, I can see the green of forests and the blue of sparkling water snaking its way along valley bottoms or languishing in a lake. Sometimes, I'll see a grid of streets and avenues at the shore, or a small cluster of buildings on a high plateau, or the specks of cars and trucks gliding along a grey-black ledge cut into the side of a mountain slope.

The mountains keep coming, wave after wave, crested with snow, and appearing closer to the airplane than they really are. It always strikes me, flying over British Columbia, how big this province is, how much rougher it looks than most others in Canada, how stunningly beautiful it is, and how we humans have touched it and left our marks just about everywhere.

As the jet comes in for landing at the bustling Vancouver International Airport, I imagine that even a newcomer would recognize this as the population centre of the province. In fact, more than half of the population resides in BC's southwestern corner, and about 90 per cent lives in the southern half; the other 10 per cent have spread out in the north.

No matter where they live, British Columbians have adapted to the land. And they're as diverse as the landscape. First Peoples have lived here for thousands of years, but most of us have come from other places. Fewer than half of the population were born in BC, and while most immigrants have moved here from other provinces, many come from other countries. They bring with them their histories and their dreams, all contributing to the cultural mélange.

No matter where they originated, most British Columbians would agree, I think, that they live in one of the most beautiful, peaceful, easygoing places on Earth.

It's only been 150 years since people started calling this place British Columbia, but the people who have lived here in that time have packed a lot into its short history. This book celebrates BC's 150th anniversary with a collection of vignettes and anecdotes about its people. At first glance, the book may appear to focus on objects — after all, most of it is based on the collections of the provincial museum and archives — but every object has a story about the people associated with it.

The stories begin, as they must, with the founding of the colony — then they move freely through time and space in a kind of loose association, like a conversation among friends. One story sparks an idea for another, and that reminds someone else of another story, and so on. As in any conversation, the stories are short, focusing on an object, an event, a moment, a memory. No one dominates the discussion, because every voice is important.

The conversation is all about what makes British Columbia what it is today, what it means to live here, how we got here in the first place. Some stories are about groups of people, like the Mowachaht-Muchalaht people of Vancouver Island's west coast or the Finns of Sointula; some are about the individuals and symbols that represent the province, such as Sir James Douglas and the Steller's Jay; and some are about the nostalgia in objects like a pinball machine or a souvenir pennant. But most stories are about people whose ancestors have lived in this region for millennia or have come to BC seeking something, whether it's gold or happiness – people from a variety of backgrounds, who have given their spirit to this place. People like Fred Tibbs, who climbed a Sitka Spruce every morning to play songs for his neighbours on his cornet; Buster Wilson, cherishing his childhood memories of learning how to play hockey on a muddy field; Hannah Maynard, a woman with the courage to run a business in the late 1800s and create some amazing photographic art; and Richard Alexander, who built a good life for himself after arriving penniless and starving in New Westminster.

Together, the stories in this book show the astounding depth of experience of the people in this young colony-turned-province – often an experience much deeper than its 150 years.

The Stories

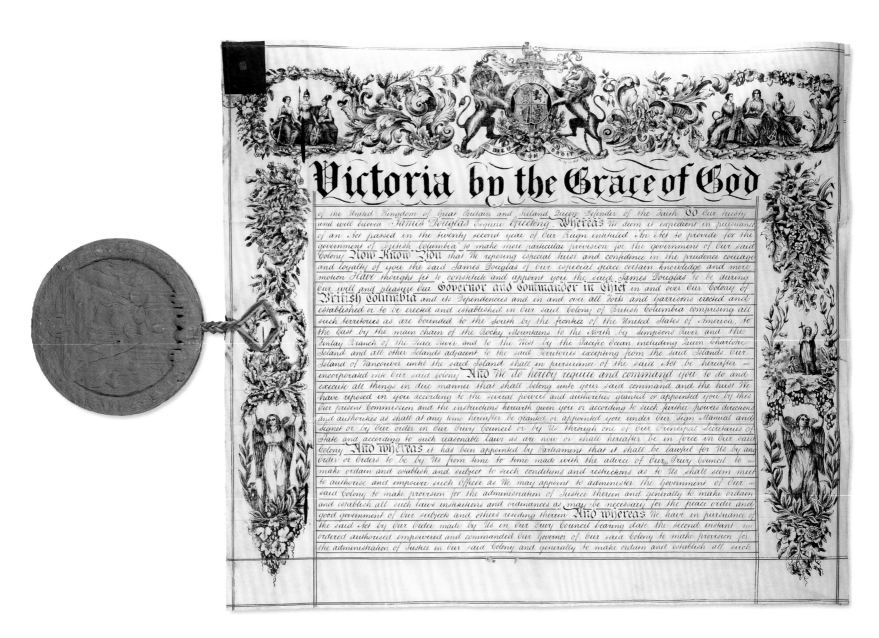

The Douglas Commission, the official document that appointed James Douglas as governor of the colony of British Columbia in 1858.

Colonial Roots

This province began with strong leaders and a determined people.

On November 19, 1858, before a gathering of about 100 people at Fort Langley, James Douglas read out the proclamation creating the Crown Colony of British Columbia. This small ceremony, concluded by a 17-gun salute, transferred control of the vast territory from the Hudson's Bay Company to Great Britain, and commissioned James Douglas to govern the new colony.

Three months later, Colonel Richard Moody, commander of the Royal Engineers, established the capital at Queensborough, which Queen Victoria renamed New Westminster.

Vancouver Island had already been established as a colony of Great Britain in 1849. The two colonies merged in 1866 as British Columbia, and joined the Confederation of Canada in 1871.

We could have been New Caledonians

The leading contender for the name of the new colony was New Caledonia. But this name met strong opposition from a few important people. Edward Bulwer Lytton, the colonial secretary, wrote to Queen Victoria, and Her Majesty replied:

"If the name of New Caledonia is objected to as being already borne by another colony or island claimed by the French, it may be better to give the new colony west of the Rocky Mountains another name.... The only name which is given to the whole territory in every map the Queen has consulted is 'Columbia', but as there exists also a Columbia in South America, and the citizens of the United States call their country also Columbia, at least in poetry, 'British Columbia' might be, in the Queen's opinion, the best name."

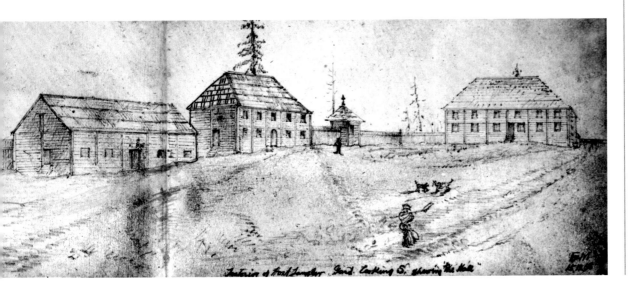

Interior of Fort Langley Yard Looking South Showing the Hall
Edward Mallandaine, 1858.
The hall is where Douglas read the proclamation declaring British Columbia as a colony of Great Britain.
BC Archives PDP03395

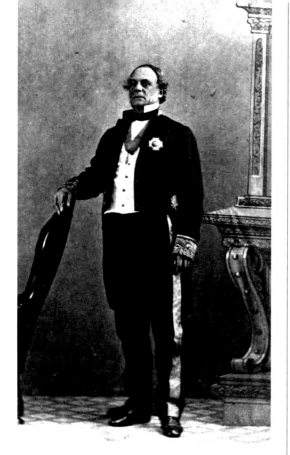

James Douglas (1803–77), governor of Vancouver Island from 1851 to 1863 and British Columbia from 1858 to 1863.
G.R. Fardon photograph; BC Archives A-01232

Before he became BC's governor...

James Douglas arrived in British North America when he was just 16. He came to work for the North West Company, and continued with the Hudson's Bay Company when the two fur-trading enterprises merged in 1821.

In 1828, while stationed at Fort St James, Douglas married Amelia Connelly, daughter of Chief Factor William Connelly. The Douglases moved to Fort Vancouver in 1830 and James became chief factor for the Columbia District in 1839. Two years later, the company sent him to find a site for a new trading post on the southern shore of Vancouver Island.

Fort Victoria was built in 1843 and Victoria became the capital of the new colony of Vancouver Island in 1849. Richard Blanshard, the first governor of the new colony, gave up his appointment and returned to England in 1851, after less than two years of service. The Crown asked James Douglas to take his place.

BC's First Governor: James Douglas

James Douglas governed the colonies of Vancouver Island and British Columbia with an icy stare and clenched fist. When he made a decision, good or bad, he stuck to it. You need to be tough and often stubborn when you're in charge of a huge frontier. Thankfully, most of his actions proved to be good for the colony. Governor Douglas was probably the most important person in shaping early BC and its government.

He held off the Americans when they pressed for more territory, negotiated several land treaties with First Nations around Fort Victoria, and settled disputes and misunderstandings among the long-time residents and new arrivals. The governor had the help of Judge Matthew Begbie and Colonel Richard Moody, commander of the Royal Engineers. Together, they maintained law and order when hoards of gold seekers invaded the colonies.

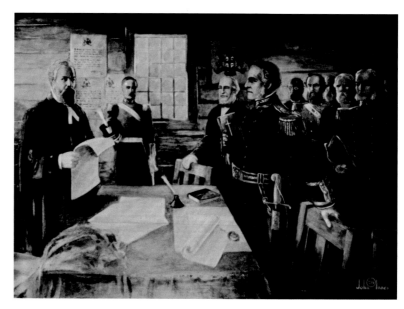

Governor Douglas Takes Oath of Office at Fort Langley
John Innes, about 1940.
A 20th-century interpretation of the ceremony on November 19, 1858, creating the Crown Colony of British Columbia. BC Archives PDP00462.

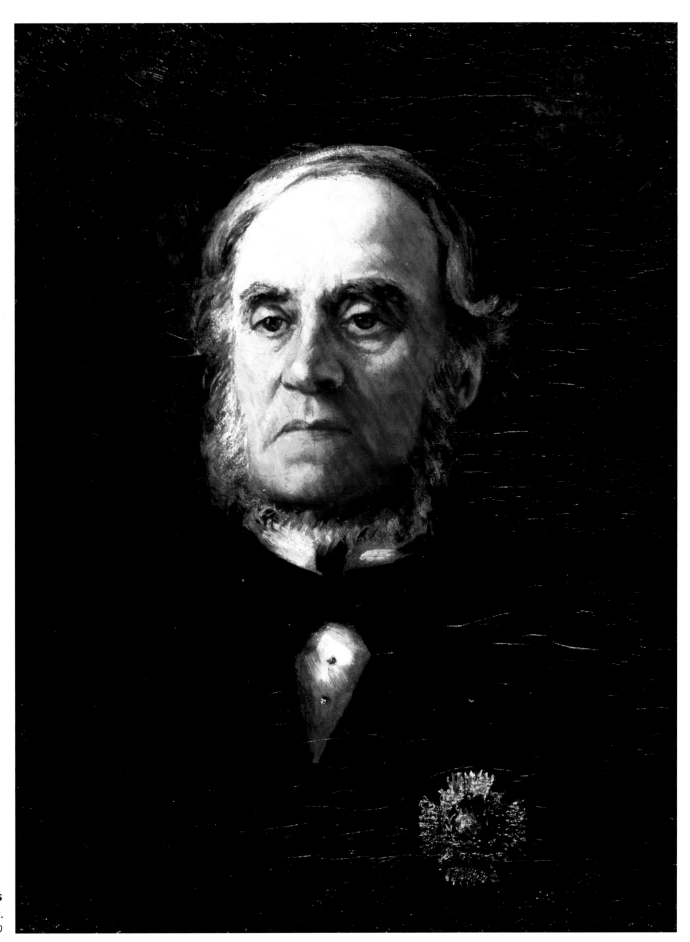

James Douglas
Unknown artist, 1860s.
BC Archives PDP 90

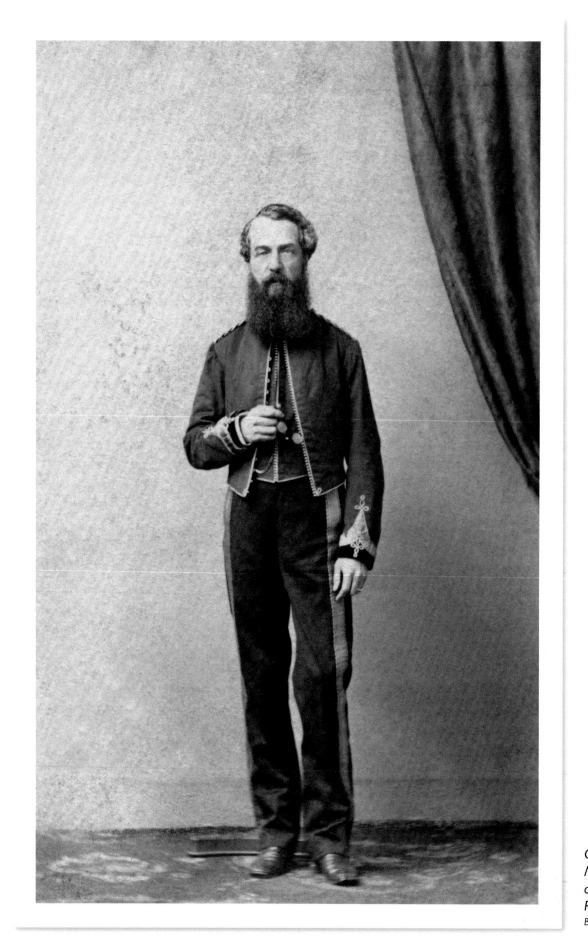

Colonel Richard Clement Moody (1813–87), commander of the Royal Engineers, 1859.
BC Archives A-01724

Larger Than Life: Colonel Richard Moody

Colonel Richard Clement Moody was a small man, but you'd have been unwise to measure him by the size of his uniform. After Governor James Douglas, no one had more influence over the shape of early British Columbia than Colonel Moody.

He led the Columbia Detachment of the Royal Engineers, a small but effective military force in the colony. As the military commander, Moody chose Queensborough (now New Westminster) as the colonial capital; it moved to Victoria when the colony merged with Vancouver Island. Moody also oversaw the surveying of much of southern BC, including the boundary with the United States, and the building of the Cariboo Road through the Fraser Canyon.

Colonel Moody urged the governor to make more use of the Royal Engineers and other resources in the colony, but Douglas often resisted him. They simply had different views on how things should be run – and they didn't communicate very well, either. But, despite their differences, the two men accomplished much in this huge territory called British Columbia.

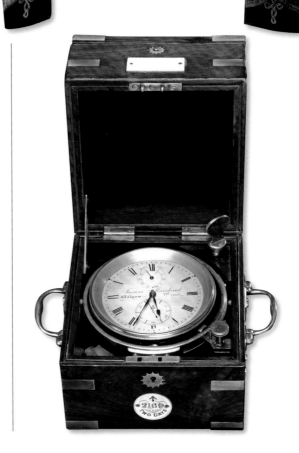

Colonel Richard Moody's Royal Engineers tunic.
RBCM L2007.13.1

Chronometer used by the Royal Engineers during their survey of the 49th parallel, the boundary between BC and the United States, 1858–62.
RBCM 985.96.1 a-b

Law and Order on the Frontier: Judge Matthew Begbie

Why would Matthew Begbie leave a successful law practice in London, England, to become a judge in a gold-crazy frontier? It wasn't the salary that lured him. And it certainly wasn't the prestige. It was the adventure. Begbie craved adventure – so he jumped at the chance to be the first judge in a new colony.

Judge Matthew Begbie spent 35 years – from 1859 until his death in 1894 – delivering justice throughout British Columbia, ensuring that people accused of crimes had fair trials, whether in a courtroom, log cabin, tent or open field.

About a century later, legal historian Alfred Watts referred to Matthew Begbie as "undoubtedly … the right man in the right place at the right time".

Don't hang a label on this judge

The first time anyone called Judge Begbie a "hanging judge" was four years after his death. How's that for not letting a man defend himself?

The truth is that Judge Begbie didn't hang any more people than any other judge of the time. In those days, hanging was the only sentence a judge could give to a convicted murderer. Begbie reduced several murder convictions to manslaughter and successfully urged the governor to grant mercy on several more. Between 1859 and 1872, Begbie's court convicted 47 men of murder, but he saved 20 of them from hanging.

Judge Begbie's bench book, written in his own special shorthand and decorated by an assortment of his doodles.
BC Archives GR-2025

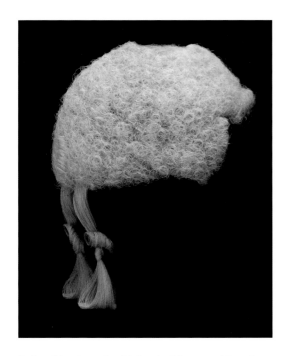

Judge Matthew Begbie's wig. He wore his robes and wig when court was in session — even when his courtroom was an open field and his judge's bench a horse's back.
RBCM 964.583.1

Matthew Baillie Begbie *(1819-94)*
Rowland Lee, 1876.
BC Archives PDP00174

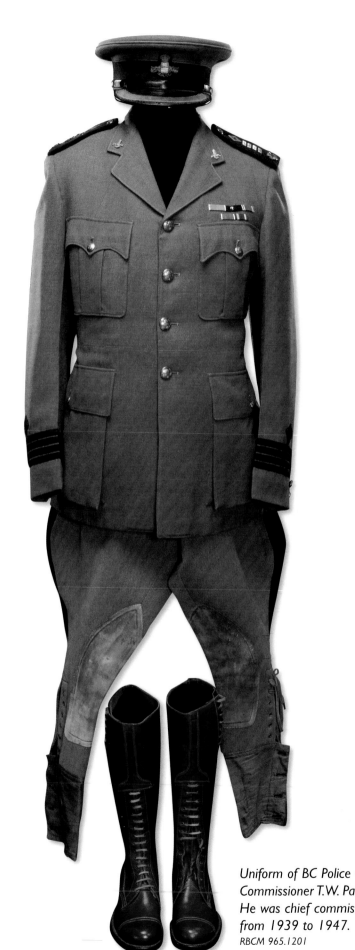

BC Police Chief Commissioner
T.W. Parsons, 1930s.
BC Archives I-68628

Uniform of BC Police Chief
Commissioner T.W. Parsons.
He was chief commissioner
from 1939 to 1947.
RBCM 965.1201

Leg irons used by the
BC police until 1871.
RBCM 967.195.1

Keeping the Peace for 150 Years

When British Columbia became a colony in 1858, it needed a police force to maintain law and order. It's no coincidence, then, that BC's police are also celebrating their 150th anniversary in 2008.

For many decades, police officers did not wear a uniform. Just like in the movie westerns, the badge identified officers of the peace – actually, in most communities, just about everyone knew the local officer.

In 1924, the newly reorganized provincial police put on their first uniforms. The province had grown a lot in 60-plus years, and the government thought it was time for a more formal approach to law enforcement. Later, in 1950, the provincial police joined forces with the RCMP.

The first ever CSI unit – here in BC

The BC police force was the first in North America to develop crime labs for forensic investigations, with sections for fingerprinting, ballistics and identification. It was also the first to have highway patrols and investigation divisions, the first to use airplanes in police work and the first to use an inter-city radio communication system, including radio-equipped boats. It's truly amazing what progressive thinking and a healthy budget can do for an organization.

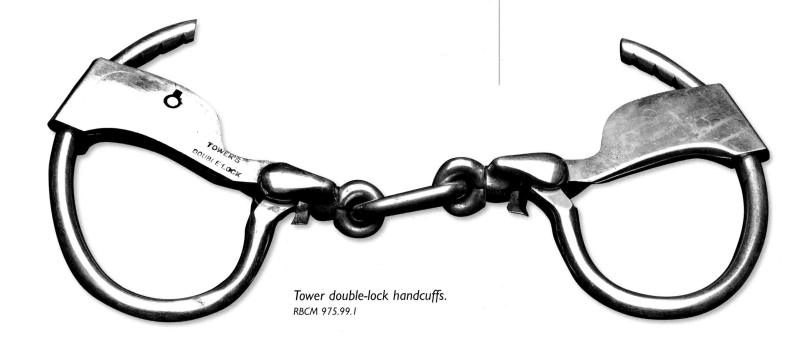

Tower double-lock handcuffs.
RBCM 975.99.1

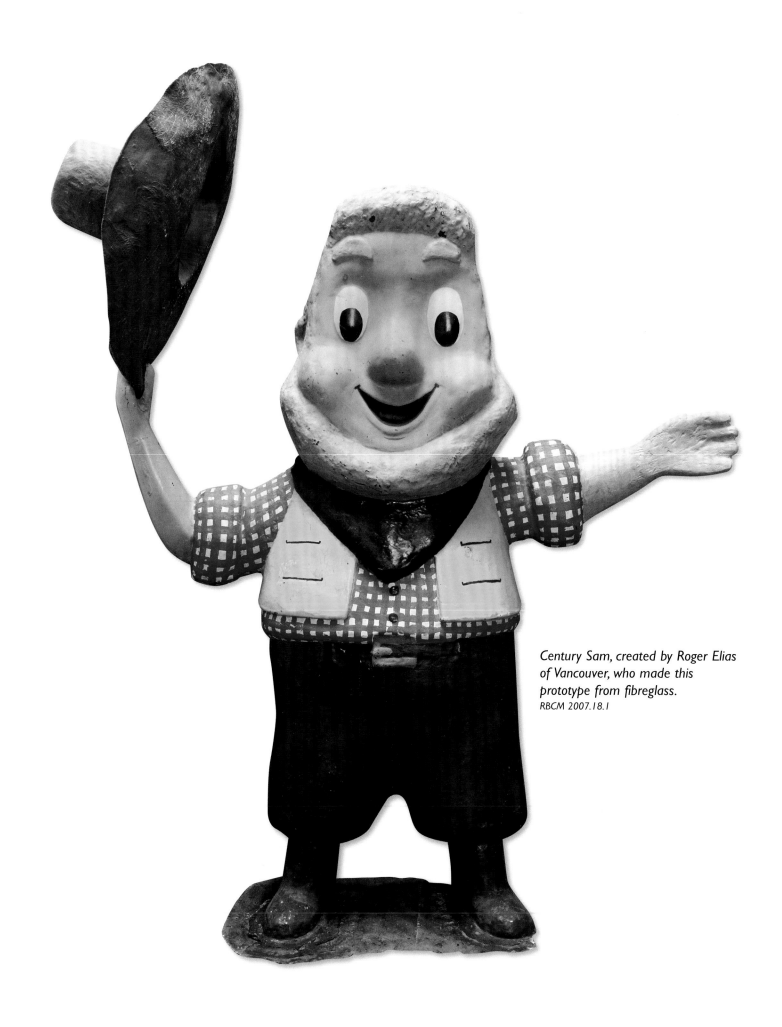

Century Sam, created by Roger Elias of Vancouver, who made this prototype from fibreglass.
RBCM 2007.18.1

Celebrating with the Pixie Prospector

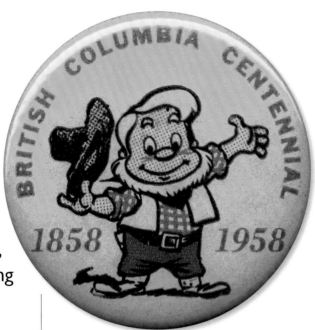

*W*hen British Columbia celebrated its colonial centennial in 1958, Century Sam led the festivities. This gold-mining frontiersman, who some called the "pixie prospector", looks like he's struck it rich. He showed up everywhere – in parades, on films, wherever people celebrated the centennial – reminding everyone of BC's beginnings as a gold-mining frontier.

Buttons and other souvenirs featuring Century Sam appeared throughout the province. The original caricature of Century Sam was drawn by BC artist Robert Banks. RBCM 2007.56.1

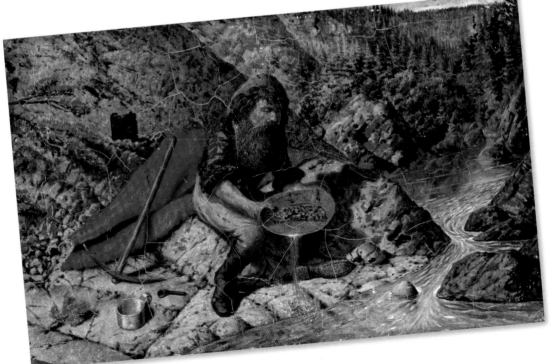

Prospecting for Alluvial Gold in British Columbia
William G. Hind, 1864.
BC Archives PDP02612

A colony's golden roots

Some would say that British Columbia exists because of a gold rush. In 1858, thousands of people sought their fortunes in the gold fields on the Thompson and Fraser rivers. The British government decided to create a legal authority for the gold fields, so it established the colony of British Columbia.

A Glint of Gold in Her Eye

When is an ounce not an ounce?

When it doesn't measure up to the official ounce, that's when. Okay, you might not care much whether your bathroom scale is off by a few ounces (or grams), especially if it's in your favour. But you want the gold assayer's weights to be spot-on and the grocer's scale near exact; if you have a company that ships tons of goods every year, you want accuracy in the weight.

In 1864, the colonial government had these brass weights made in Britain, the home of Imperial measures. They became the official standards. Now in BC we have two sets of official weights and measures, one for metric (SI) and another for the old Imperial units.

On a sunny day in 1937, Alice Shea went for a walk along a stream in the area where she and her husband had staked a gold claim. She noticed a curious glint in the water and looked closer. It was a rock — a big, shiny gold rock!

The Sheas had struck it rich. The nugget weighed more than 3½ pounds. They sold it for the going rate and netted about $1,500, a lot of money in those days. (In 2008, this gold nugget is worth more than $50,000.)

The Turnagain nugget is the fourth largest nugget and the largest existing nugget ever found in BC. It's called "Turnagain" because Alice Shea found it near the Turnagain River.

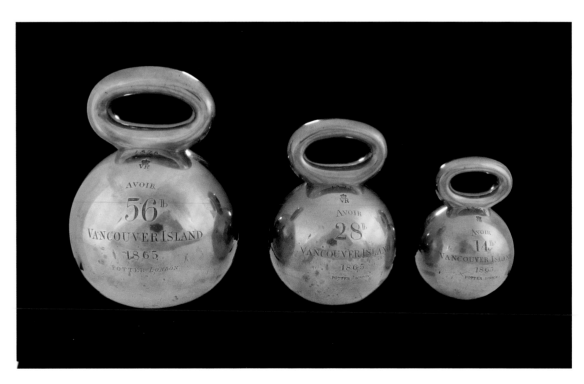

Official brass weights and measures, 1864.
RBCM 965.42

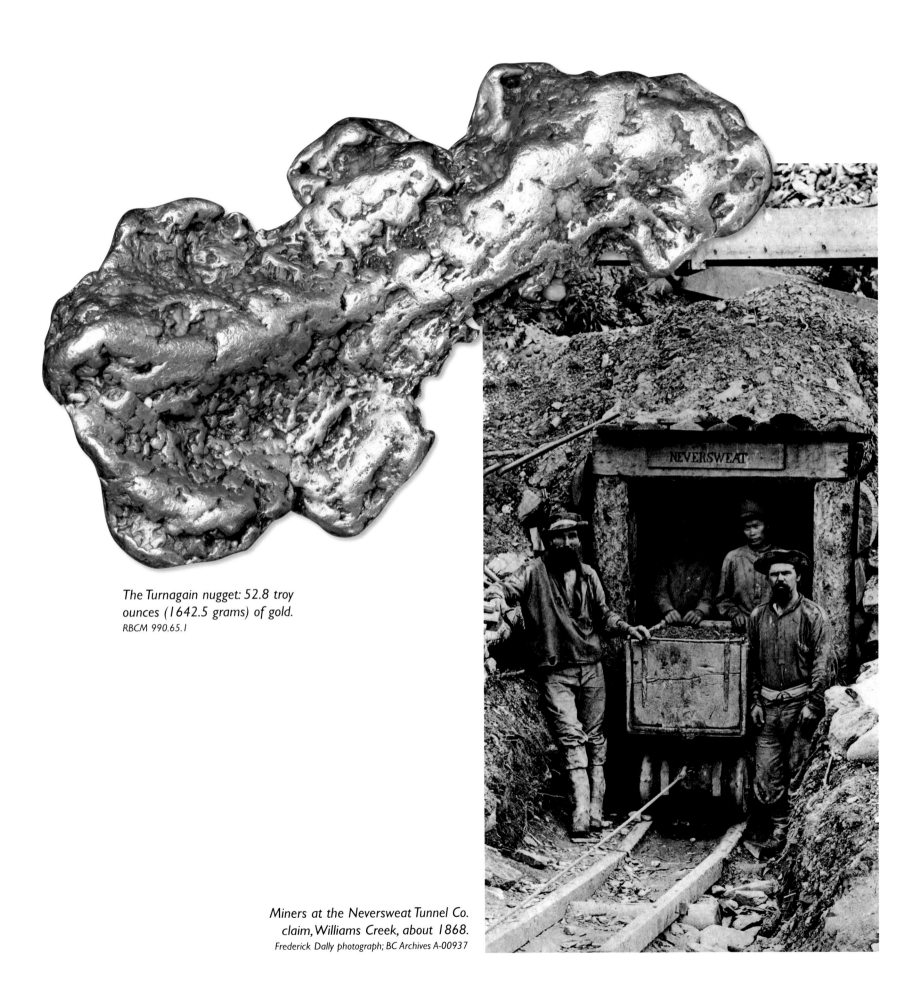

The Turnagain nugget: 52.8 troy
ounces (1642.5 grams) of gold.
RBCM 990.65.1

Miners at the Neversweat Tunnel Co.
claim, Williams Creek, about 1868.
Frederick Dally photograph; BC Archives A-00937

The Jade Capital of the World

British Columbia has an official mineral, but it's not gold. It's jade – not surprising when you learn that BC is the world's leading supplier. It's true, about three-quarters of the jade sold in stores comes from here. Three areas in the northern, central and southern interior of the province produce 225 tons of jade every year. No wonder it became the provincial mineral in 1968.

Most jade is used to make sculptures. The largest sculpture made from BC jade is a statue of Buddha at the Wat Dhammamongkol Monastery in Bangkok, Thailand. The sculptor carved it from a 32-ton boulder.

Souvenir made from BC jade.

Jade blade

Jade is hard and can be ground to make a sharp, durable blade. For more than 3000 years, many First Nations have used it to make blades for woodworking tools.

Symbols of British Columbia

What's a province without symbols? Every sovereign state must have recognizable symbols for official documents, a flag to fly above property and ceremonial icons to represent the people and the place. BC has a coat of arms, a flag, a flower, tree, mineral, bird, bear and even a tartan. Alone or collectively, they represent the spirit of the province.

Raw jade, like this chunk found near Lillooet on the Fraser River, sells for $10–100 per kilogram, depending on the quality. This piece is 46 x 23 x 16 cm.
RBCM EeRI Y:13

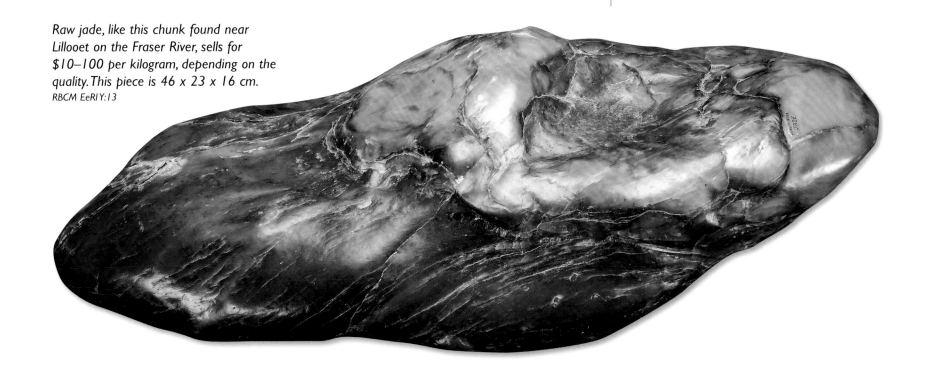

Big, Bold, Beautiful — BC's bird

The voyage of Vitus Bering and Georg Steller

The Steller's Jay takes its name from Georg Steller, the German naturalist who sailed with Vitus Bering on a fateful voyage from eastern Russia to Alaska in 1741. Steller collected specimens of this previously unnamed bird and many other animals and plants.

The voyage went well until the return trip. Most of the crew caught scurvy and the ship barely survived a perfect storm or two on the North Pacific. Captain Bering became ill and died. Finally, the ship ran aground on an island. Bering's buried there, on what's now known as Bering Island in the Bering Sea.

The crew hated Steller for his arrogance and overbearing grumpiness, but he helped most of them survive for a year on the island, thanks to his knowledge of plants and animals. Forty years later, biologists formally named the jay *Cyanocitta stelleri*, Steller's Jay.

*I*n 1987, the Steller's Jay outcompeted several other candidates in a public vote to become British Columbia's provincial bird. It's a lively bird, smart and cheeky, well known for chasing other birds away from backyard feeders and helping itself to unattended picnic lunches.

In the end, the Steller's Jay squeaked past its nearest rival, the Peregrine Falcon. Maybe its winsome character and familiarity gave it the edge. If you didn't know better, you'd think the Steller's Jay had boldly campaigned for the title. And it might be that the people who voted forgave this handsome candidate its shortcomings, as voters often do.

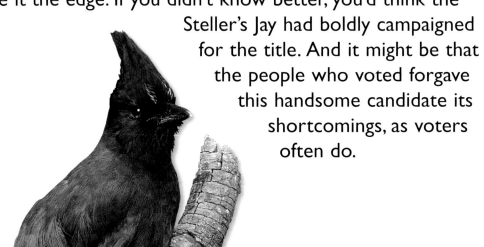

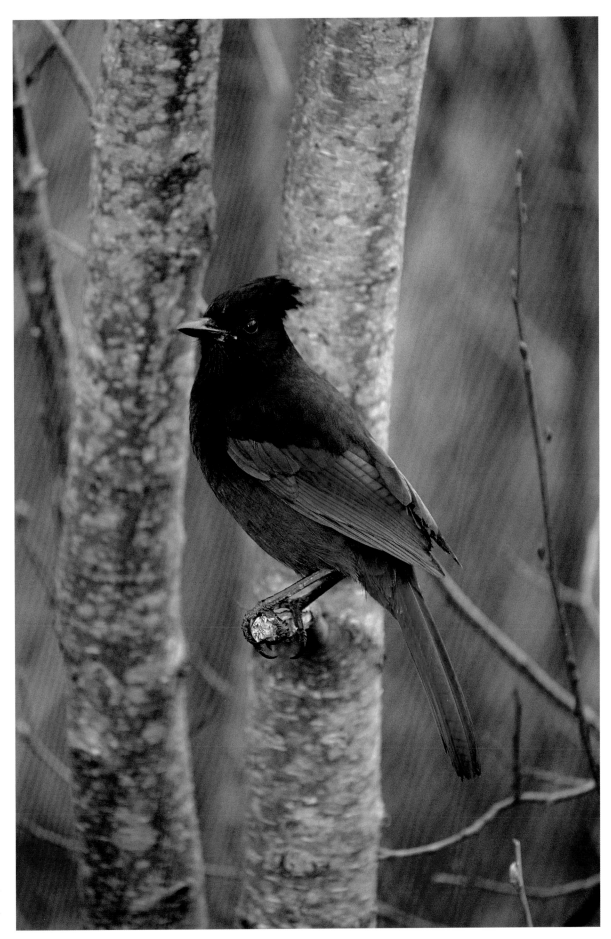

Steller's Jay
(Cyanocitta stelleri).
Jared Hobbs photograph

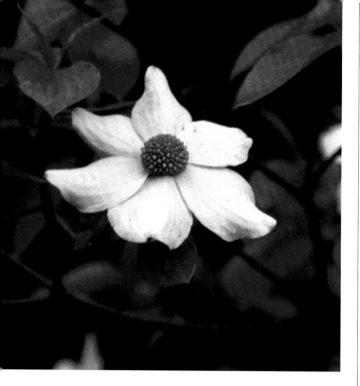

*Pacific Dogwood (Cornus nuttallii).
What appears to be the flower is actually
a group of tiny flowers surrounded by white,
modified leaves, called bracts; the bracts
look like flower petals.*
RBCM 2003s0506110

What would Blondie think?

Some people think that the dogwood got
its name because the berries are unfit
even for a dog to eat. A more convincing
explanation is that people used to make
skewers from the branches. Another name
for *skewer* is *dag*, and *dagwood* eventually
became *dogwood*.

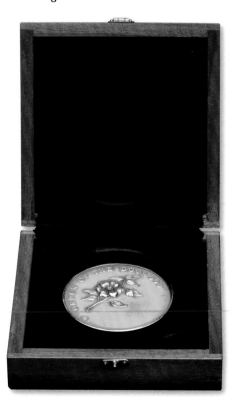

A Dogwood's Life

For almost 80 years, the Pacific Dogwood has been
BC's floral emblem. It was unofficial, at first, when the 1931
Dogwood Protection Act prohibited picking the flowers or
cutting the trees on public land. Then in 1956, the province
officially declared the dogwood flower BC's emblem.

For decades, everything looked good for the Pacific
Dogwood. But now, this magnificent tree, which in BC grows
only in the southwestern corner, is suffering from a serious
illness. Recent years of moist springs and autumns have
favoured the spread of fungus spores on trees already stressed
by dry summers.

Global warming may bring more stress on our dogwoods,
and their future in BC remains uncertain.

Dogwood earrings.
RBCM 2006.59.1a-b

*Medal of the Order of the Dogwood, 1958.
This was BC's highest civilian honour until
1989, when it was replaced by the Order
of British Columbia. RBCM 2006.59.3a-b*

BC's Tree

The Pacific Dogwood is the provincial flower, but the majestic Western Redcedar is BC's official tree. This imposing conifer grows tall and straight, dominating forests in the south and along the coast of BC. The wood resists rot, cuts easily and splits evenly, so people use it to build fences, roofs, decks and many other structures.

For centuries, coastal First Peoples have harvested just about all parts of the Western Redcedar – wood, roots, branches and bark – to make everything from canoes to clothing, baskets to big houses.

The Western Redcedar truly is BC's provincial tree.

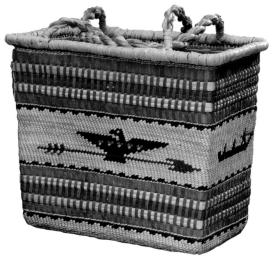

Cedar-bark shopping basket
Jessie Webster, Nuu-chah-nulth, 1975. Renowned basket weaver Jessie Webster (1909–92) created the design by weaving dyed grass over cedar bark. It features a bird, likely a Thunderbird, holding an arrow (its harpoon). RBCM 17651

The scent of cedar

When Europeans first arrived in this area, they noticed the pleasant aroma of the wood used in so many ways by the native inhabitants. It smelled like the wood of European cedars, so they called it cedar.

But the Western Redcedar *(Thuja plicata)* and the Yellow-cedar *(Chamaecyparis nootkatensis)* actually belong to the cypress family. Biologists agreed to accept the common English names as long as they are fused together, to show that the trees are not true cedars.

Western Redcedar (Thuja plicata).
Syd Cannings photograph

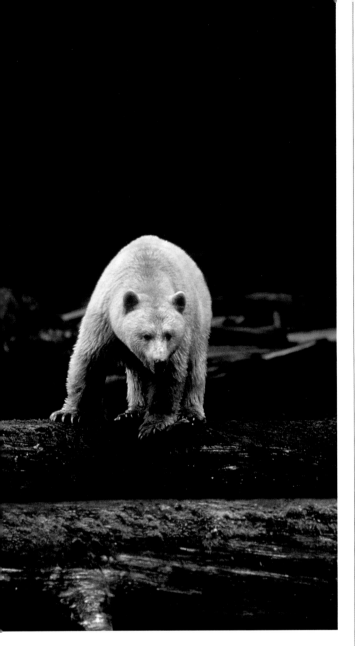

The Kermode Bear – a Black Bear (Ursus americanus) in white fur.
Ian McAllister photograph; All Canada Photos.

All bears have a spirit

The Kermode Bear has also been called the Spirit Bear, maybe because its whiteness gives it a ghostly appearance. But the First Peoples of the coast gave no special significance to this colour form of the bear. In the traditions of many First Nations, all bears – not just the white ones – have powerful spirits.

Rare Bear in the Rainforest

The white Kermode Bear recently emerged from BC's coastal rainforests to become the mascot for ancient forest preservation. And in 2006, the government declared it our provincial mammal.

Francis Kermode, director of the provincial museum in the early 1900s, believed that he had discovered a new species. Dr William Halliday thought so too. He described the white bear as a distinct species in 1905, and named it after Francis Kermode.

But scientific testing rained disappointment on Halliday and Kermode. It turned out that the white bear is just a colour variation of *Ursus americanus,* the American Black Bear, a species that roams the entire continent. On rare occasions, Black Bears have fur in shades of brown, blue-grey, white or even cinnamon. But most stay true to their common name, and the oddly shaded bears almost always have black brothers, sisters, mothers, fathers and children. The colour variations happen only when a recessive gene wins out against the odds for black.

Even so, the Kermode Bear fan club can feel good knowing that the white variation has only been seen along the coast of BC. It's come to symbolize the coastal temperate rainforest and represent the need to preserve the remaining pockets of ancient forests.

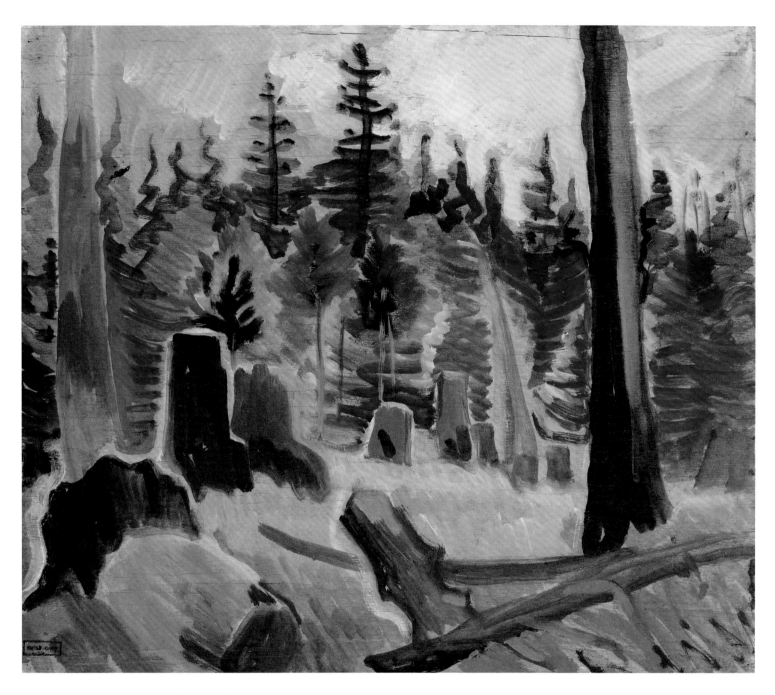

Forest Clearing
Emily Carr, 1939.
BC Archives PDP944

This scene is probably in Metchosin, west of Victoria. In her later years, Emily Carr (1871–1945) often had her trailer, affectionately called "The Elephant", pulled out to the local woodlands where she camped with all her pets and painted. About the time she painted this scene, she wrote in her journal (September 24, 1939):

 "The woods are trembling under the glow of autumn. There is a still, vibrating quiver, moist and luminous, over everything, as incongruous as a 'slow-hurry'. Summer is lingering, winter pushing, and autumn standing contemplative, impatient to get to winter, yet reluctant to leave summer – just as I feel about camp this minute. I want to stay and I want to go."

Cheeky Monkey

**How the monkey
got her name**

When Emily Carr bought a female Javanese monkey from a Victoria pet store, she had a few names in mind. But that first day in her new home, the little monkey ran around calling "Woo! Woo! Woo!" She seemed insistent, so Carr agreed to call her Woo.

The monkey lived with Carr for many years. Near the end of Carr's life, when she became too ill to care for her pets, Woo and the others had to go to new homes.

\mathcal{E}mily Carr's paintings of dark west-coast forests and First Nations villages made her one of Canada's most famous artists. So why did this serious artist paint a monkey in a dress?

The people who lived near Carr in Victoria thought her quite a character – some would say, intentionally eccentric. She lived alone with her pets, and she had many: dogs, cats, parrots, rats, and a monkey named Woo.

Woo got into all sorts of mischief, like eating Carr's paints or teasing her dogs. But the little monkey must have earned a special place in the artist's heart, because Carr rarely painted her pets. Maybe she admired Woo's cheeky attitude, thinking it much like her own.

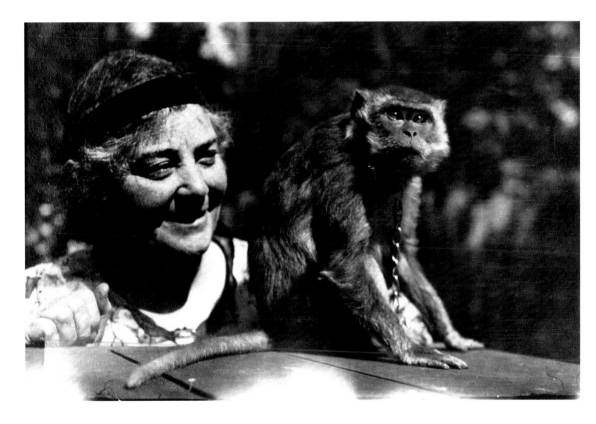

Emily Carr with Woo, about 1930.
BC Archives I-61505

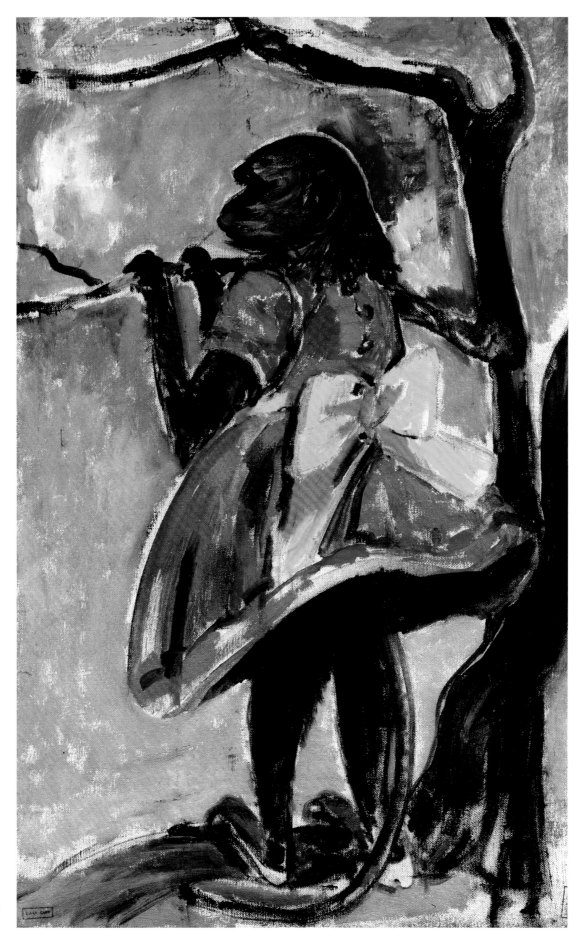

Woo
Emily Carr, 1932.
BC Archives PDP603

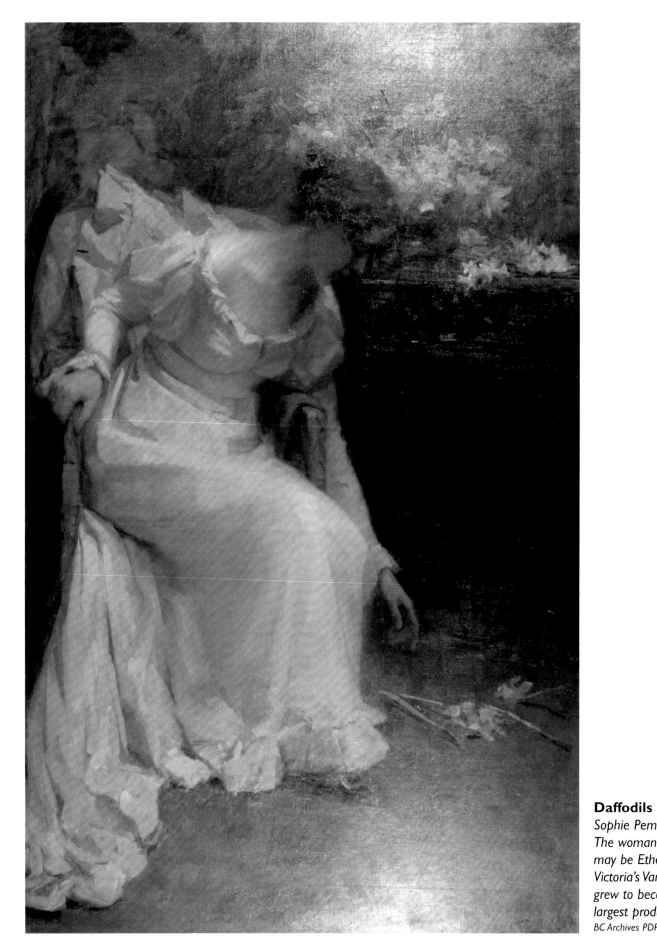

Daffodils
*Sophie Pemberton, 1897.
The woman in the painting
may be Ethel Vantreight.
Victoria's Vantreight Farms
grew to become Canada's
largest producer of daffodils.*
BC Archives PDP03664

BC Daffodils in England

*I*n 1897, Victoria artist Sophie Pemberton debuted her painting, Daffodils, at the Royal Academy of Art in London. So, you see, Emily Carr was not the first woman from BC to gain international fame as an artist.

Pemberton received critical acclaim for her work, a great beginning to a career that never happened. She continued to paint until 1905 when she married the widowed Reverend Canon Arthur Beanlands. In those days it wasn't proper for a wife to have an artistic career. Besides, as Mrs Beanlands, Sophie became stepmother to four children.

She still showed some of her paintings now and then, into the 1950s. Sophie Pemberton's work remains important to the artistic history of British Columbia.

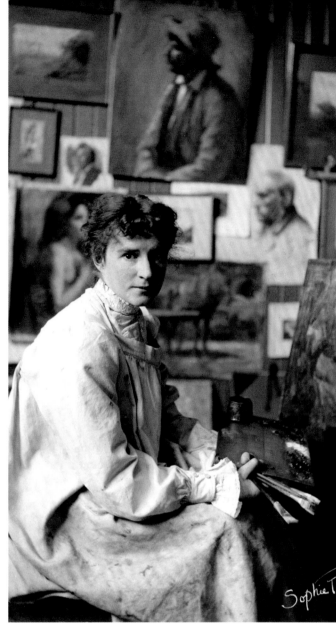

Sophie Pemberton (1869–1959)
in her studio, 1904.
BC Archives F-02807

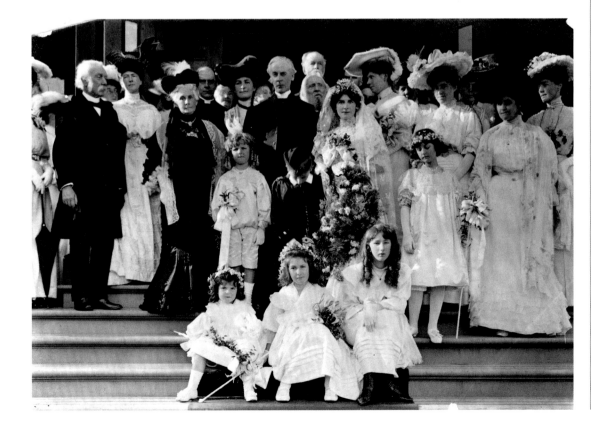

Wedding of Sophie Pemberton and
Canon Arthur Beanlands, 1905.
BC Archives I-46770

BC's Coat of Arms

Don't let the sun go down on the British Empire

Canon Arthur Beanlands created BC's original coat of arms. He's the man who later married artist Sophie Pemberton (see page 33), so ending her career. The province adopted Beanlands' design by an order-in-council on July 18, 1895 and soon put the new coat of arms to use. It appeared on the lamp standards on the grounds of the legislative buildings, and on the official government seal.

Meanwhile, in England, the Royal Household received notice of BC's coat of arms – and did not approve. Indeed, the College of Arms, the part of the Royal Household responsible for all coats of arms in the British Empire, summarily rejected the design. It would not do to have the Union Jack placed below a sun that appears to be setting – it could be interpreted as the sun setting on the British Empire. Years later, after much fuss and other design changes, the College of Arms approved a new BC coat of arms by Royal Warrant of Edward VII on March 31, 1906.

The BC defenders of the original coat of arms may have pointed out that the sun isn't actually going down, that it symbolizes permanence and glory. But they couldn't have defended the perception of a setting sun. And now, some historians would say that the sun really was setting on the British Empire at that time.

Walk by a provincial government building, read an official document, fill out a form and you'll see this crest – it identifies the BC government and its services.

The shield part of the crest became the provincial coat of arms in 1906 and has remained unchanged since then. Many of the other elements have been used since 1906, but not officially until 1987, when they all became official. Now the provincial coat of arms is BC's most widely recognized symbol.

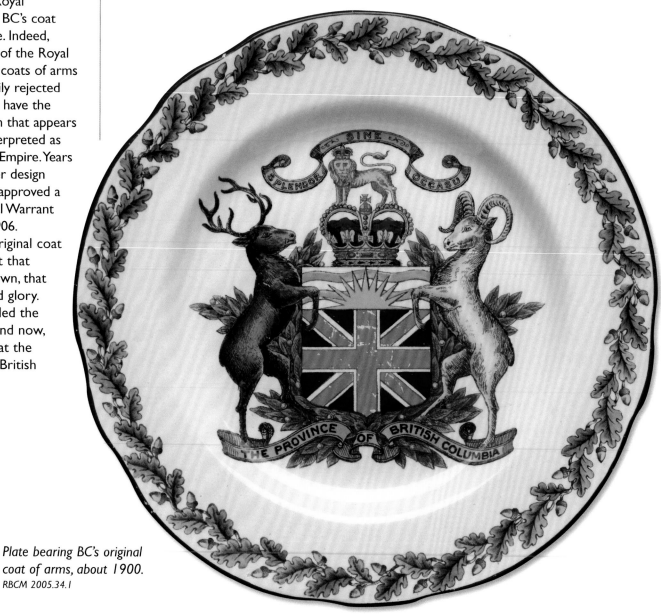

Plate bearing BC's original coat of arms, about 1900.
RBCM 2005.34.1

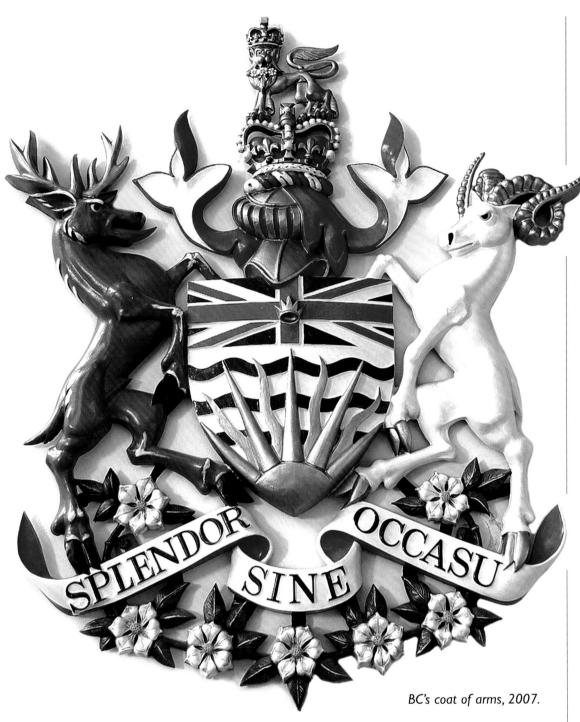

BC's coat of arms, 2007.

How to read British Columbia's coat of arms

In the shield in its centre the never-setting sun on the sea declares the province's permanence and glory, while above, the Union Jack represents unity with Britain. The Latin motto, translated as "brilliance without setting", leaves no doubt that BC will always be glorious.

Supporting the shield, the Elk of Vancouver Island and the Bighorn Sheep of mainland BC represent the union of the two colonies in 1866. And above the shield, the Royal Crest expresses loyalty to the Crown.

The Sound of Democracy

*T*his desk once stood among many in BC's legislature. How many representatives of the people leaned on it while making a rousing speech? How often has the legislative chamber echoed with a chorus of "Hear! Hear!" shouted over the bass rhythm of many hands thumping desks like this one? That's the sound of democracy.

In 1863, the British colonial secretary decided that the population was stable enough to support an elected government. The original council had just five elected representatives out of fifteen. By 1870, the balance had shifted, with nine elected members and only six appointed.

Today, BC's Legislative Assembly has 79 elected members. We've come a long way, haven't we?

Journal of the British Columbia Executive Council.
BC Archives GR-1223

The first Executive Council of Vancouver Island, 1856.
BC Archives G-01345

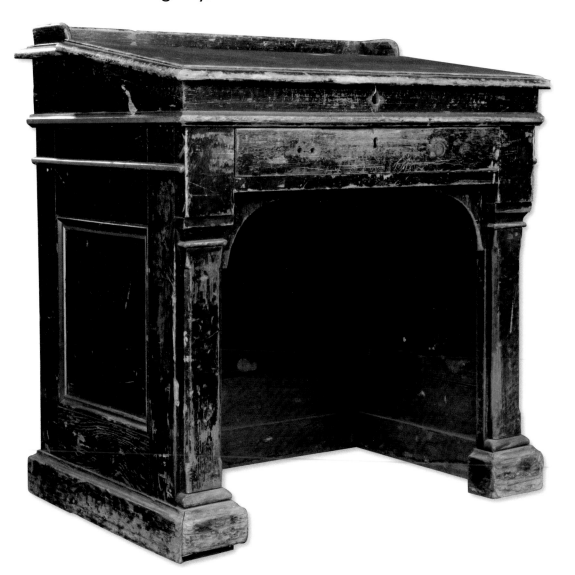

Desk from the BC legislative chamber, about 1875.
RBCM 972.261.2c

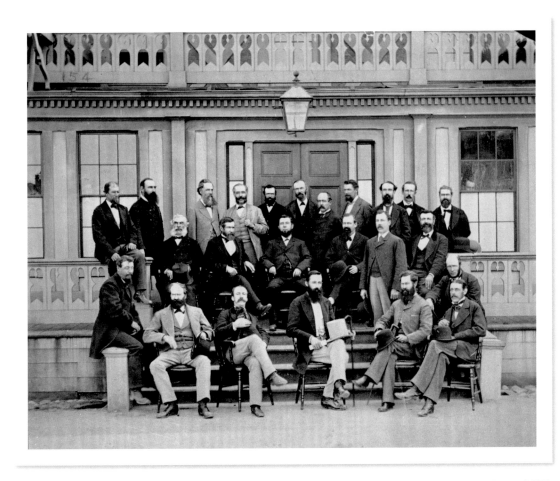

The BC Legislative Assembly in front of the legislative buildings, 1878.
Maynard photograph; BC Archives A-02560

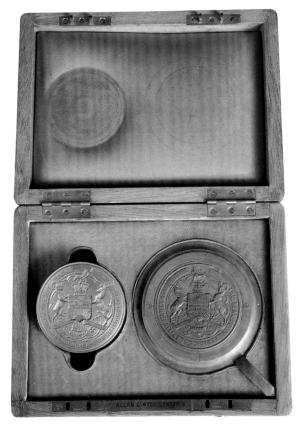

The Great Seal of the Province of British Columbia, about 1897.
BC Archives

Signed, sealed and delivered

The provincial seal makes everything official. It has to appear on every decision made by the government, from laws to commission documents. Over the years, technology has changed the way the seal is applied to documents, but the legal requirement for the seal has remained.

The Sun Never Sets on British Columbia

BC became a province of Canada in 1871, but we didn't have our own flag until almost 90 years later – in 1960. Up to then, we flew the British Union Jack with the provincial crest at its centre.

After much debate, the government of the day decided on the flag we know and love. It's adopted from the provincial coat of arms. The wavy bars represent the ocean – the west coast, where the sun never sets. Above, the Union Jack reminds us of our colonial roots and our ties to Britain.

Let the banner unfurl ...

As the 1958 colonial centennial approached, Premier W.A.C. Bennett demanded a new flag. He wanted a special flag, one that expressed the nature of BC better than the colonial standard. And he wanted it flying in the centennial breeze.

Premier Bennett got his flag in time, but a lot of people didn't want it to be our provincial flag. Not permanently. It took two more years to decide on the final design. And so the brilliant sun over the ocean first flew in 1960.

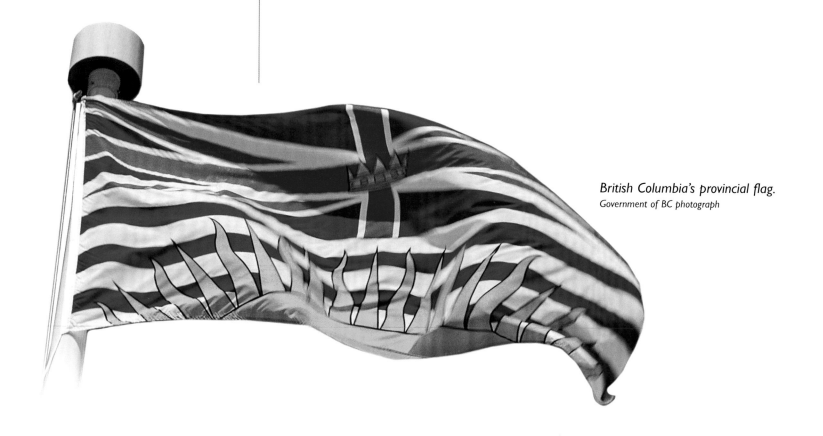

British Columbia's provincial flag.
Government of BC photograph

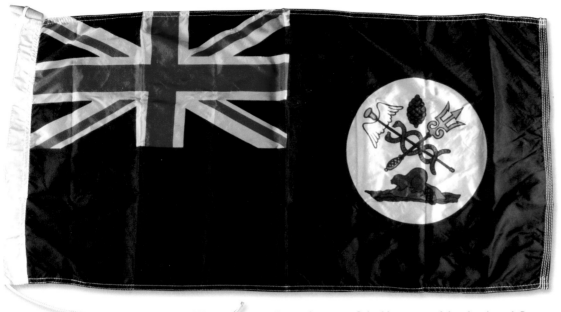

The flag that never flew

This may have been Vancouver Island's colonial flag ... maybe ... for part of a year.

The colonial government of Vancouver Island supposedly adopted this flag in 1865. Because the colonies joined just a year later, it wouldn't have had much flying time – and there's no evidence that it actually flew over any colonial building.

Reproduction of the Vancouver Island colonial flag.
RBCM 2007.35.1

In all the years before BC had its own flag, the Union Jack represented the colony, then the province. Sometimes, when displayed outside BC, it would have the provincial coat of arms sewn onto the centre, as shown here.
RBCM 974.70.77

The Uniform of Honourable Office

When British Columbia joined the Dominion of Canada as a province in 1871, it no longer needed a governor appointed by the British Crown, but an elected government led by a premier. The position of governor, in a sense, stepped back behind the elected government and became a lieutenant-governor, still representing the interests of Britain. We've had many lieutenant-governors since becoming a province – each one serves for a term of about five years.

Today, the position helps to maintain British Columbia's colonial heritage and tradition. The uniform symbolizes the province's ties to Great Britain, and the lieutenant-governor wears it for ceremonial occasions, like Remembrance Day and the opening of the legislature.

The traditional uniform is based on a design by King George III in 1777 for the male members of his family. It's called the Windsor uniform. Most lieutenant-governors have modified the design slightly to suit their personal style.

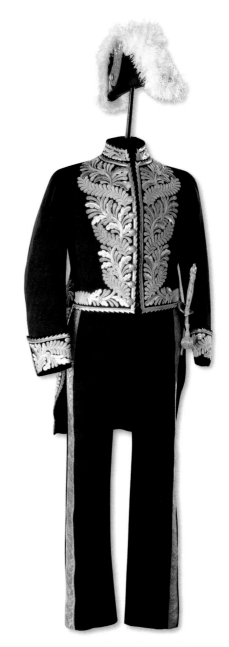

Lieutenant-governor Albert Norton Richards' uniform, based on the traditional Windsor uniform. Made of wool, it has gold oak-leaf embroidery and gold-plated buttons. The hat is made of Beaver fur and Ostrich plumes.
RBCM 971.221.3

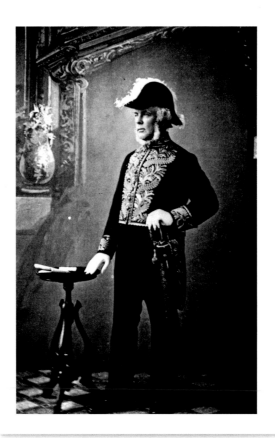

Lieutenant-governor Albert Norton Richards, 1875.
John Savannah photograph; BC Archives A-02431

New design for a new century

Iona Campagnolo served as British Columbia's first female lieutenant-governor from 2001 to 2007. She designed an elegant new uniform appropriate for a woman, and one that reflects the unique character of the province.

The military-style deer-skin jacket has embroidered silver dogwood flowers and cedar leaves on the collar and cuffs. It also features designs by two prominent First Nations artists: the right-hand side features a Haida Eagle, Bill Reid's original design modified (with approval from Reid's estate) by Tsimshian-Haida artist Roy Henry Vickers; the left-hand side has Vickers' own design of a Skeena River Killer Whale.

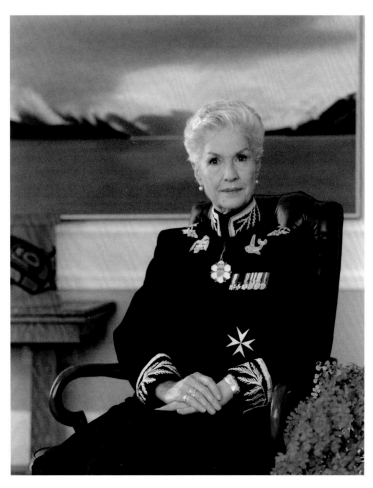

Lieutenant-governor Iona Campagnolo, 2001.
Destrubé Photography; RBCM 2007.44.2a

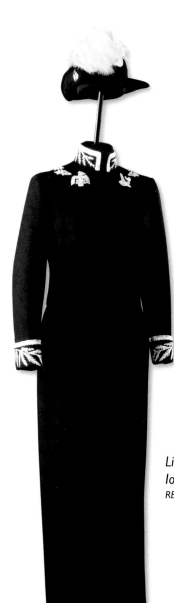

Lieutenant-governor Iona Campagnolo's uniform.
RBCM 2007.44.1a-c

"I wear all these symbols proudly in the silver of the moon, as a daughter of this magnificent land which gives to all its citizens the choices necessary to work toward our own best selves."

– Her Honour Iona Campagnolo

True Colours

Remember those tartan jackets that liquor-store employees used to wear? If you do, you were born before 1960 – or maybe you used fake ID. Anyway, that tartan is the provincial tartan, officially adopted in 1974 and registered with the Court of Lord Lyon in Edinburgh, Scotland.

The BC tartan has five colours: blue for the Pacific Ocean; white for our provincial flower, the dogwood; green for the forests; red for the maple leaf on Canada's flag; and gold for the crown and sun on BC's flag.

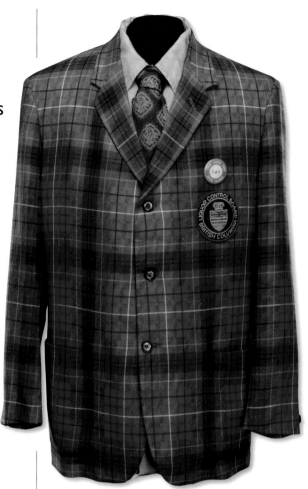

BC's official tartan jacket, worn by BC Liquor Control Board employees in the late 1970s.
RBCM 2004.22.1114a

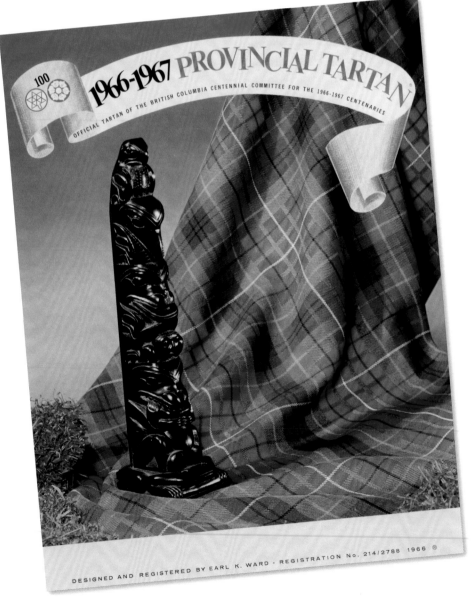

Canadian centennial poster, 1967, featuring BC's tartan and a Haida argillite model pole.
RBCM 984.25.19

Wardle's Store
Frederick Walter Lee, 1907.
BC Archives PDP03784

Frederick Lee (1863–1948) came to BC from England in about
1899. He settled in Chilliwack in 1903, where he set up a studio
and conducted painting classes. This painting is typical of his Fraser
Valley landscapes.

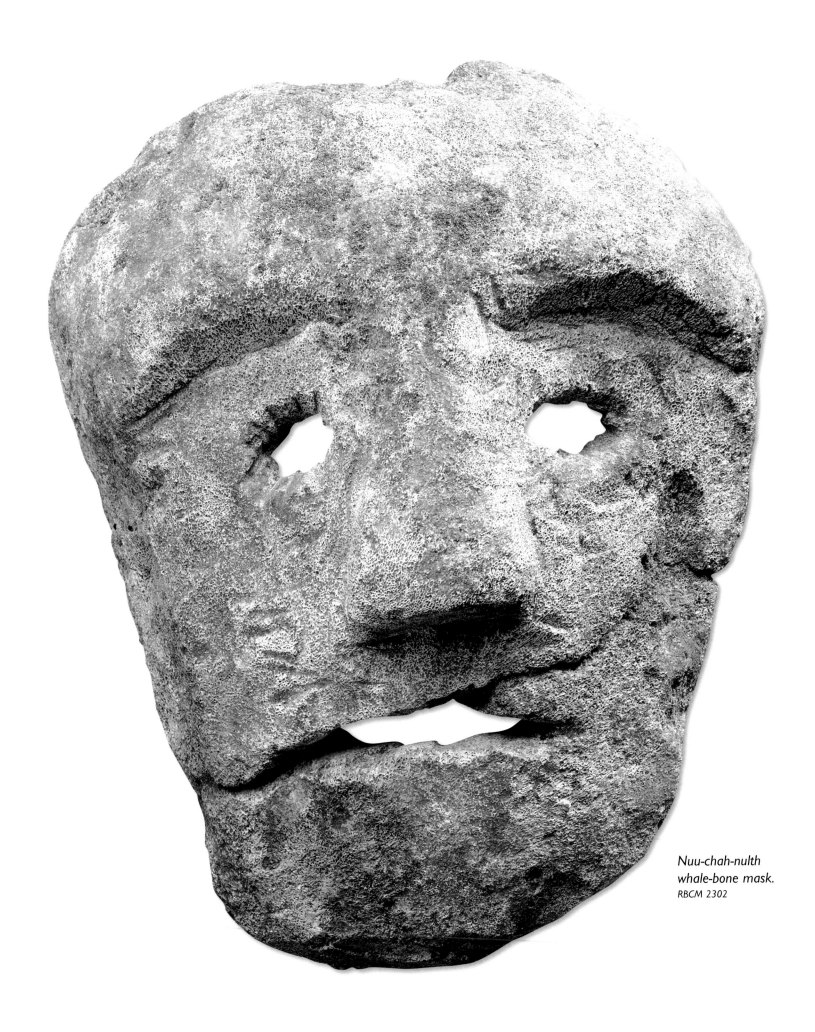

*Nuu-chah-nulth
whale-bone mask.*
RBCM 2302

We Have Always Been Here

People have lived on this land for thousands of years before Vancouver Island and British Columbia became British colonies. This whale-bone mask came from a mound of shells at Yuquot, Nootka Sound, in the ancestral territory of the Mowachaht-Muchalaht people.

"Archaeologists have dated our presence here for over 4,300 years. We know from our oral histories that we have always been here. Our histories, songs, dances and regalia document our relationship with the world around us and events from our history – they proclaim our ownership of the land, sea and resources within our territory."

– Mowachaht-Muchalaht First Nations

The centre of the world

Captain James Cook visited Yuquot in 1778 and called it Friendly Cove because the people welcomed him. To Cook and his crew, the people of Yuquot lived in a remote corner of the world. To the Mowachaht-Muchalaht people, the British visitors had come to the centre of the world from some remote corner.

A View of the Habitations in Nootka Sound
Copperplate engraving by J. Smith, 1784, after a 1778 John Webber drawing.
RBCM PN 4645

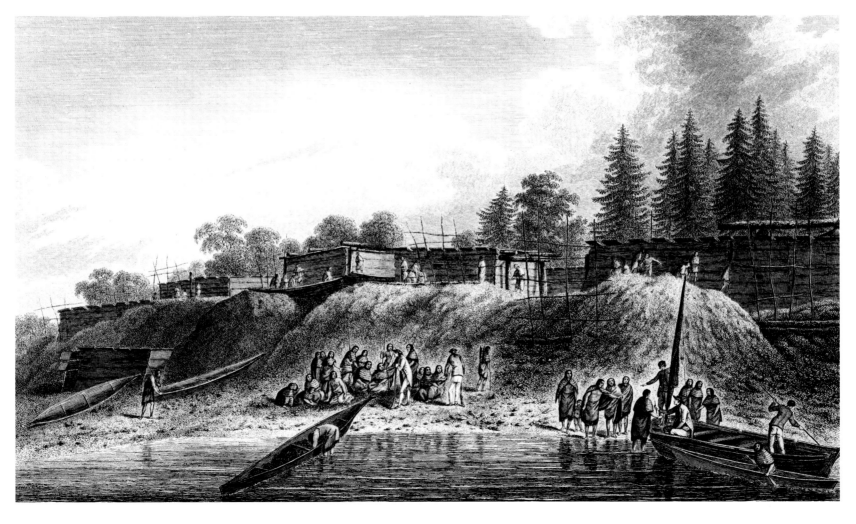

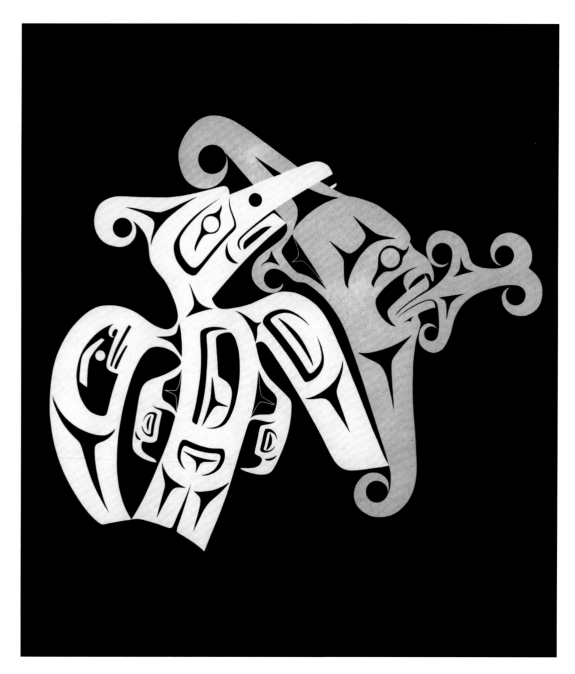

"Raven was white before he stole the sun. When he stole the sun, moon and stars from a powerful chief, he changed himself back into his Raven form, opened the chief's treasure chest, and took the celestial objects under his wing and flew to the top of the chief's house. But his wings were so full that he could not get through the smoke hole. When the chief returned he saw Raven in his true form and realized his deception. The chief ran to the fire and rekindled the flame. Heat and soot rose from the fire and singed Raven's feathers. Raven let go of the sun, moon and stars, which rose into the heavens and assumed the places that they have today. Ever since, Raven has been black."

– a Tlingit story

White Raven Stealing the Sun
Art Thompson (1948–2003), Nuu-chah-nulth, 1976.
RBCM 15298

Images of Raven

Raven appears as a trickster and instigator in the stories of many First Nations. He convinces the first Haida people to come out from a giant clam shell and populate the world. He steals the sun, moon and stars from a great Tlingit chief and inadvertently puts them in the sky. There are many other stories about Raven. These images by First Nations artists Beau Dick and Art Thompson show that he continues to inspire creation.

"Raven didn't create the world, but he knew where all the parts were. And what he did, through his cunning and conniving, was to put all the parts together to form the world as we know it today."
— Robert Davidson, Haida

"Haida stories tell of how the first people emerged from a gigantic clam shell on the beach at Rose Spit. They got out with the help of Raven, who is the most powerful creature from myth time. Raven was wandering on the beach, when he heard some noise coming from a clam shell. He looked more closely and saw that it was full of little human creatures. They were terrified by the Raven and the big world outside the shell. So, the Raven leaned his great head close to the shell, and with the smooth trickster's tongue, that had got him into and out of so many misadventures, in his troubled and troublesome existence, he coaxed and cajoled and coerced the little creatures to come out and play in his wonderful, shiny, new world."

— Bill Reid, Haida

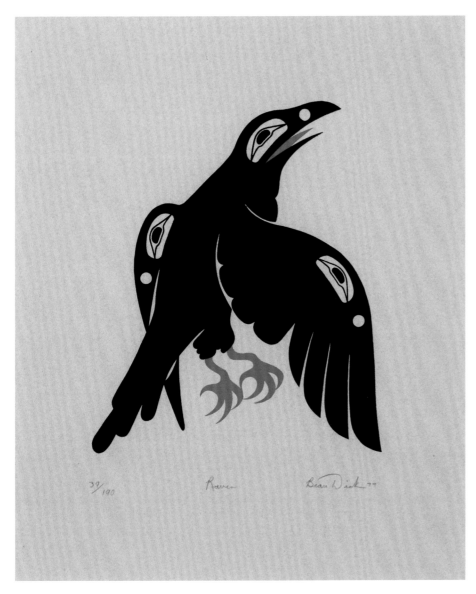

Raven
Beau Dick (1955–), Kwakw<u>aka</u>'wakw, 1977.
RBCM 15389B

Origins and Innovations

Doug Cranmer, 1978.
Born and raised in Alert Bay, Doug Cranmer (1927–2006) worked as a fisher and then a logger before he realized his true talent for art. He studied art under Mungo Martin and later worked with Bill Reid. With those two famous artists and on his own, Cranmer carved many poles now on exhibition in several countries.
Andrew Niemann photograph; RBCM PN 13575-13

*L*ong, long ago, after the great flood, Salmon came ashore at the mouth of the Nimpkish River. He took human form and began building a house. But the task was too much for one person alone, and he cried out in frustration. Hearing him, Thunderbird flew down, picked up the house beams and put them in place. Then Thunderbird also took human form. Salmon and Thunderbird became the first 'Namgis people.

This is the Kwakwaka'wakw origin story of the *G.i'g.ilgam, Nimkish*, by Dan Cranmer. His son, Doug Cranmer tells the story in a naturalistic way in a relief carving.

An accomplished artist, Doug Cranmer explored many forms, including two-dimensional relief carvings and abstract paintings. He began painting Kwakwaka'wakw designs in abstract forms in the 1960s; they show a little-known aspect of First Nations contemporary art.

Untitled
Doug Cranmer, Kwakwaka'wakw, 1976.
Design elements suggesting fins and feathers create the structural basis for this abstract painting.
RBCM 18462

Origin of the Nimpkish
Doug Cranmer, Kwakw̱aka'wakw, 1971.
In Doug Cranmer's version of the story,
the house builder is a halibut-type fish.
RBCM 13961

Untitled
Doug Cranmer, Kwakw̱aka'wakw, 1976.
RBCM 16325

Loss and Survival

*I*n the prosperous times of the early 1800s, at least 10,000 people lived on Haida Gwaii (Queen Charlotte Islands). Wealth flowed in with new trade from Europe and Asia; Haida culture thrived.

And then, in 1862, smallpox arrived, killing all but a few thousand Haida people. Those who remained lived under the restrictive laws of a new colonial power that suppressed their culture.

During this terrible time, Haida artists continued carving model houses and other art works for tourists and collectors. In this way they helped keep their cultural traditions alive and modern.

Haida house model collected in 1892.
RBCM 232 a-c

The fine art of Charles Edenshaw

Charles Edenshaw (*da.a xiigang*, 1839–1920) lived through the difficult times of population decline and cultural suppression. He was born in Skidegate (*hlragilda 'llnagaay*) on northwestern Haida Gwaii. He acquired much of his knowledge of Haida art and oral history from his uncle, Chief Albert Edenshaw (*7idansuu*).

The anthropologists Franz Boas and John Swanton commissioned Charles Edenshaw to produce replicas of traditional Haida objects and drawings of crest figures. Edenshaw's daughter, Florence Davidson, said that her father spent winters carving argillite, filling orders he received from collectors and vendors. Over 60 years, he produced a huge number of high-quality objects and expanded the boundaries of Haida artistic style.

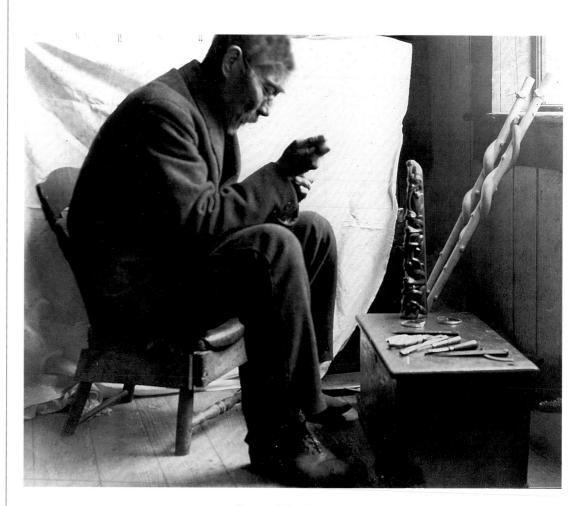

Charles Edenshaw carving a model argillite pole, about 1906.
Alfred Carmichael photograph; RBCM PN 5168

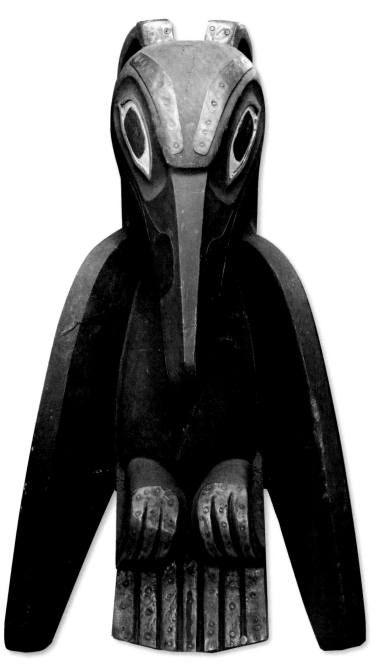

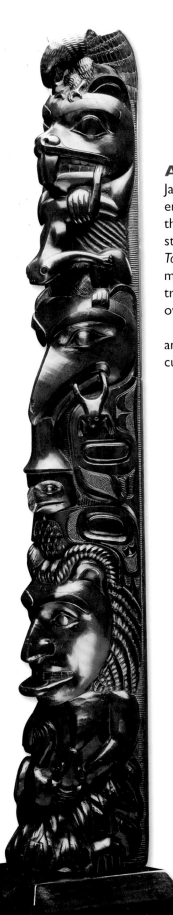

Canoe prow figure
Attributed to Charles Edenshaw, Haida.
This figure of Raven was attached to the
prow of a canoe on ceremonial occasions.
RBCM 10662

Argillite model pole
Attributed to Charles Edenshaw, Haida.
RBCM 16643

An outsider's view

James Deans, a former Hudson's Bay employee, collected Haida carvings in the 1890s. He retold some "quaint old stories" in a book called *Tales from the Totems of the Hidery*, published in 1899. Like many observers, he thought First Nations traditions were "rapidly being forgotten ... owing to the passing away of the old folks".

Deans was wrong. Charles Edenshaw and many others ensured that Haida culture continued.

A Man of Two Cultures

Mungo Martin.
Jim Ryan photograph; RBCM PN 13492

Renowned Kwakwa̱ka'wakw artist Mungo Martin made many ceremonial works for his own culture, and he also shared his cultural knowledge with the non-aboriginal peoples of British Columbia and the world.

This large curtain hung in a ceremonial big house during important potlatches. Martin also used it as the centrepiece of a float that he and his family entered in Victoria's 1955 Victoria Day parade.

Most dance screens and curtains are painted on one side only. This one is painted with the same design on the other side as well, so that it could be seen on both sides of the parade route.

Chief Na̱kapankam's legacy

Mungo Martin (Chief Na̱kapankam, 1881-1962) played a key role in continuing and developing First Nations art in 20th-century BC. Through his work in the carving program at the Royal BC Museum's Thunderbird Park, he helped keep artistic traditions alive. Martin's teachings live on in today's artists and in the way that museums work with First Nations. As anthropologist Wilson Duff said in 1982, "Few others will leave such lasting monuments and few will be remembered so long."

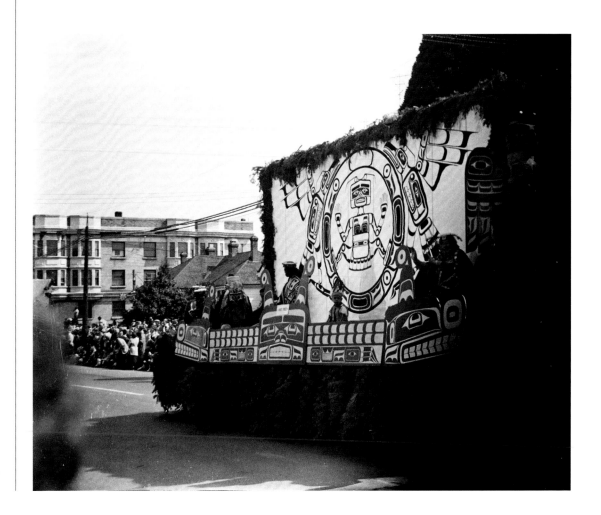

Victoria Day parade float, Victoria, 1955.
Wilson Duff photograph; RBCM PN 2002

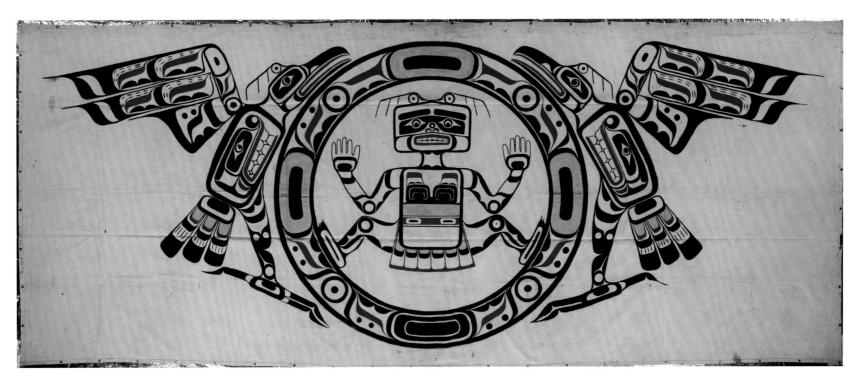

Ceremonial curtain
Mungo Martin, Kwakwaka'wakw, 1955.
Baxwbakwalanuxwsiwe', the Cannibal Spirit,
appears inside a circular motif flanked
by two Thunderbirds. The curtain
measures 6.5 x 2.6 metres.
RBCM 20095

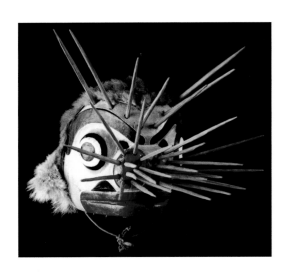

Bee mask
Mungo Martin, Kwakwaka'wakw,
about 1936.
Martin carved a Bee mask like this one
for Tony Hunt, then taught him how to
dance with it.
RBCM 9227

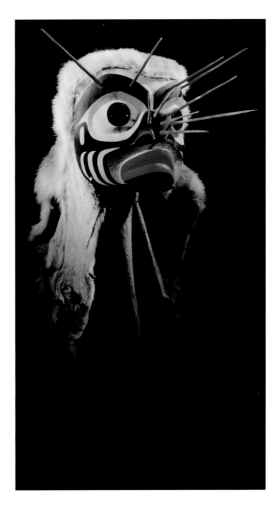

Hamat'sa bee mask
Tony Hunt, Kwakwaka'wakw, 1967.
The eyes are made from sunglass lenses.
RBCM 12731

Face of Change

For centuries, men and women who lived along the coast wore labrets (lip plugs), a bone or shell ornament inserted through a hole pierced just below the lower lip. Labrets symbolized status, rank and wealth. By the 1800s, only women on the north coast wore labrets, and many younger women did not have their lip pierced. When missionaries arrived they discouraged the practice.

This mask came from the Christian community of Metlakatla in the 1860s. The tiny wire labret is much smaller than those worn in earlier times, and shows the changing style of facial ornamentation among the Tsimshian people.

Gospel and hymn books, probably translated by a Tsimshian woman named Odille Morison, for use in the church at Metlakatla.
Acquired at Metlakatla in 1892; RBCM 16223, 16227

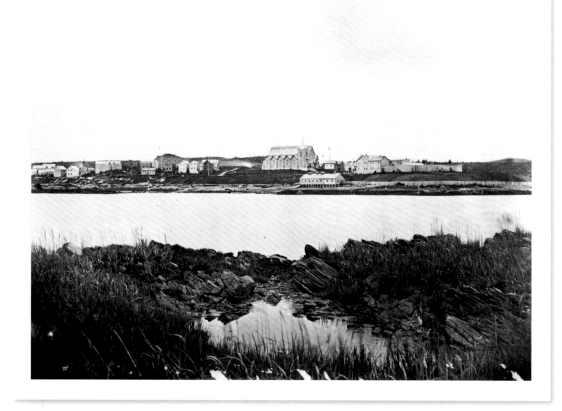

Metlakatla community and church, 1879. The church was said to be the largest on the coast north of San Francisco.
Oregon C. Hastings photograph; RBCM PN 11616

Tsimshian mask
Probably acquired by William Duncan at Metlakatla, about 1864; RBCM 1634

Metlakatla

Anglican missionary William Duncan arrived at Lax Kw'alaams (Port Simpson), on BC's north coast, in 1857. Five years later, he and 50 Tsimshian people moved to a nearby village site called Metlakatla to form a Christian community.

Duncan believed that a true Christian should not take part in Tsimshian rituals and ceremonies. He asked those who moved with him to give up their traditions and follow his strict rules.

Reverend William Duncan's rules for the Tsimshian residents of Metlakatla:

- give up "ahlied" ("Indian devilry");
- cease calling in "medicine men" when sick;
- cease gambling;
- do not give away property for display;
- stop painting faces;
- stop drinking liquor;
- rest on the Sabbath;
- attend religious instruction;
- send children to school;
- be cleanly;
- be industrious;
- be peaceful;
- be liberal and honest in trade;
- build tidy houses; and
- pay the village tax.

Tsimshian language and culture continued at Metlakatla despite these edicts. Some of the converts continued to divide their time between Lax Kw'alaams and Metlakatla.

The Settlement of Metlakatla, British Columbia, from Mr Duncan's House, May 14, 1866
Edwin Augustus Porcher.
BC Archives PDP02875

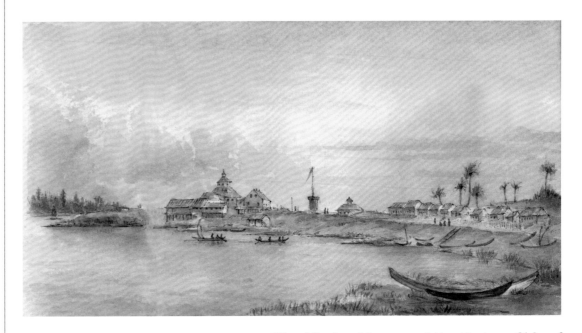

The Mission House and the Eastern Side of the Settlement of Metlakatla, May 17, 1866
Edwin Augustus Porcher.
BC Archives PDP02876

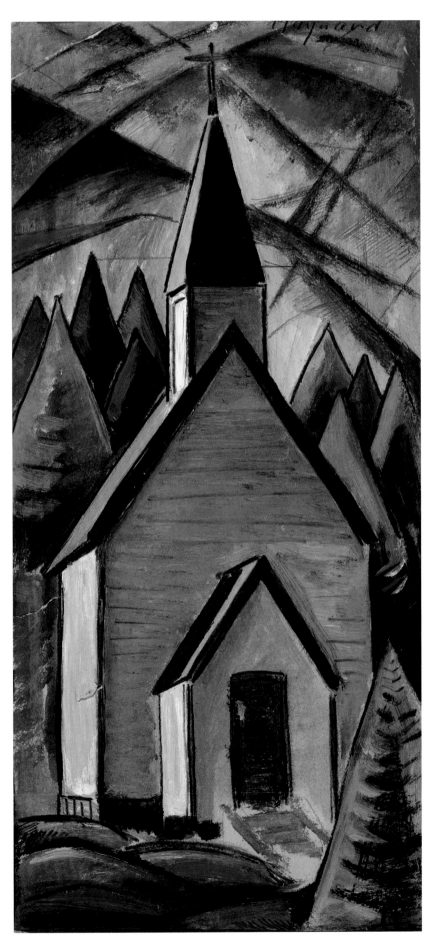

Saseenos, 1935
Max Singleton Maynard.
BC Archives PDP02135

Born to missionary parents, Max Maynard (1903–82) came to BC at a young age. His early influences were the Group of Seven and Emily Carr, and this cubist-inspired painting resembles *Carr's* Church at Friendly Cove. Saseenos is on the southern tip of Vancouver Island, near Sooke.

Our Eyes to the Past and Vision for the Future
by Lenny Sellars

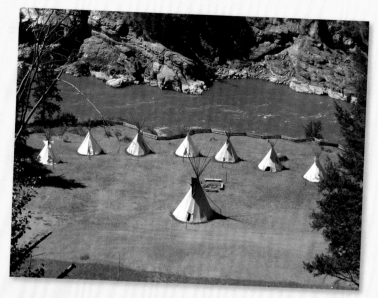

Two views of the Xat'sull Heritage Village, showing the teepees and winter home (below).
Rhonda Shackelly photographs

*T*he Soda Creek First Nation is a member of the Great Secwepemc (Shuswap) Nation. We were once known as the people of Xats'ull (pronounced *Hat'suth*, meaning "on the cliff where the bubbling water comes out").

Xats'ull is the northernmost Shuswap tribe of the Secwepemc Nation, which is the largest First Nation in BC's interior. The Xats'ull have stewarded territory ranging from the Coast Mountains in the west to the Rocky Mountains. Use of the land brought about contact with neighbouring peoples.

I am going to tell you a story about a venture that our community embarked on in 1996. As a community we opened the Xats'ull Heritage Village, located on a beautiful plateau overlooking the Fraser River 32 kilometres north of Williams Lake. It is a spiritual gathering place for community members, aboriginal visitors and non-aboriginal visitors. The Heritage Village consists of seven teepees, a winter home (pit house or kikule), drying/tanning racks, a lean-to, a sweat house, a summer hut and breathtaking scenery.

But we didn't come up with this concept on our own. The vision of a young German couple, Thomas and Bettina Schoen, started us on our journey. The Schoens brought forth their idea to the Soda Creek Band, because they were new to the country and fascinated with First Nations cultures. They also believed that there was high value in aboriginal tourism. I believed that it was an excellent opportunity to revive what was lost – pride – as well as bridge an understanding between the Soda Creek First Nation and the outside communities, and others around the world.

Xats'ull Heritage Village gives tourists a place to experience authentic aboriginal culture through hands-on education provided by the people of the Shuswap Nation. More specifically it offers an educational setting for elders to pass on their knowledge of Shuswap customs, culture, language, legends and stories to Xats'ull youth. I also felt that it was an awakening to the Soda Creek community, because the Heritage Village brought back dignity, a sense of worth, and proved that, because of our history, we do have something to offer the world.

Some of the community members struggled with the idea, thinking that we were selling our culture. We explained to them that their concerns were valid, since we have lost so much through assimilation, residential schools and so forth; but that it was also important to share our culture in order to conquer ignorance. The Heritage Village would help us find our place in history, regain our identity, build that bridge and share our knowledge. Suddenly community members realized that they had their own stories to share with those who would listen. It goes back to revival once again. Storytelling was a favourite pastime during the winter months for the Shuswap people, but at the Heritage Village you don't have to wait until the winter time to hear them.

The Xats'ull Heritage Village provides an atmosphere where you can learn about other cultures. For example, the teepees and some of the traditional ceremonies are not part of the Secwepemc way of life, but it helps visitors to see the diversity among aboriginal groups in BC and across Canada.

The most important assets of the Xats'ull Heritage Village are the Xats'ull community members; the elders are the eyes of the past, creating a vision for our future generations.

A fellow community member told me a story one time about a friend who was walking on the road above the Heritage Village one evening. He heard drumming and singing coming from the Village. He wanted to go down and check it out; but he had to get to the place of a friend who lived on the Soda Creek Reserve. The next day he told his friend about music coming from the Heritage Village the night before. He asked what was happening down there, but his friend told him that the village was closed at night, that nothing could have been going on there.

I believe that the grandfathers and grandmothers are happy that Xats'ull is sharing their knowledge and history; they are rejoicing in the revival of the past. The Heritage Village is an amazing concept. It is difficult to keep it going, but it's meant to be there. There is a reason for it to be there.

Kukstemc. Thank you for reading my story.

Lenny Sellars is chief of Soda Creek Indian Band.

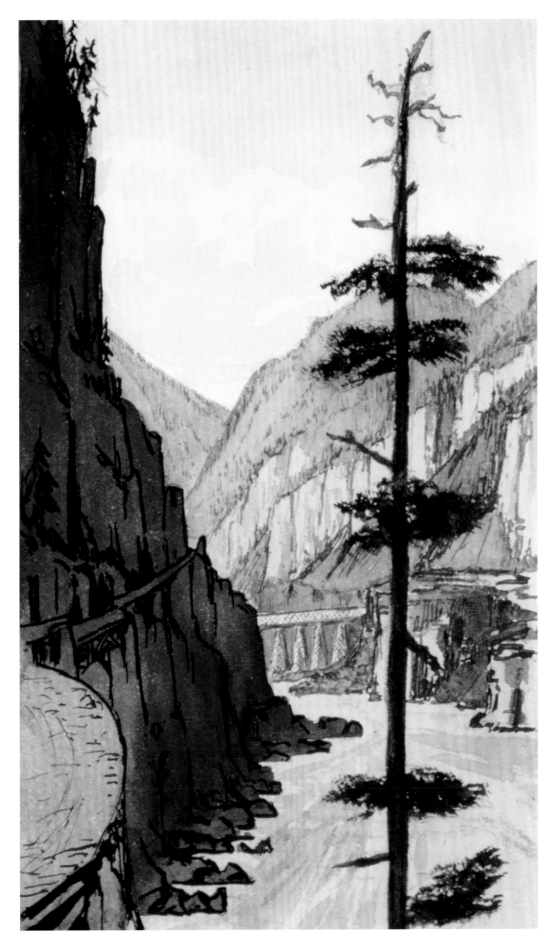

Fraser River Gorges, October 1882
HRH Princess Louise Caroline Alberta,
Duchess of Argyll.
BC Archives PDP02129

Princess Louise was the daughter of Queen Victoria. The province of Alberta and Lake Louise, in the Rocky Mountains, were named after her. Her husband, John D.S. Campbell, Marquis of Lorne, represented Great Britain as governor-general of Canada from 1878 to 1883. Princess Louise travelled with him many times across Canada and illustrated his book, *Our Railway to the Pacific* (1886). This painting shows the Canadian Pacific Railway route through the Fraser Canyon.

Meet Mister Coyote

Students at St George's Indian Residential School in Lytton made drawings of Coyote for their teacher in 1940. Some of them appeared in a booklet called *Meet Mr Coyote*. The booklet presented them as illustrations of quaint tales from the past.

But the students' drawings represent much more than charming stories. Coyote is a trickster, like Raven, in the oral histories of many First Nations. These images of traditional teachings show the importance of Nlaka'pamux heritage to the students, who were boys 11 to 13 years old.

Mr Coyote Conducting his Weekly Prayer Meeting
Reynold Smith, 1940.
The title of this painting is inscribed on the back of the wood, along with this interpretation, likely written by the teacher: "His choir of eight golden birds from heaven were in attendance. The birds were taught to sing in heaven and helped Mr Coyote to instruct the Animal People. After each weekly prayer meeting the choir birds returned to heaven." It also identifies the artist as "Reynold Smith, age 12, Sr Boy's Class, 1940. St George's Sch., Lytton, BC."
RBCM 15491

"Anglican Mission boarding school for Indians, Lytton, BC", 1926.
J.A. Calder photograph; Canada Department of Mines and Technical Surveys, Library and Archives PA-020080

The tragedy of residential schools

The Anglican Church operated St George's Indian Residential School in Lytton from 1901 to 1979. Most of the students belonged to the Nlaka'pamux First Nation.

The government and the churches set up Indian Residential Schools to educate aboriginal children in the ways of the "modern" (Euro-Christian) world. Removed from home, these children suffered loss of culture, language, family, self-esteem and often much more. St George's was one of many schools with documented cases of the staff abusing the students.

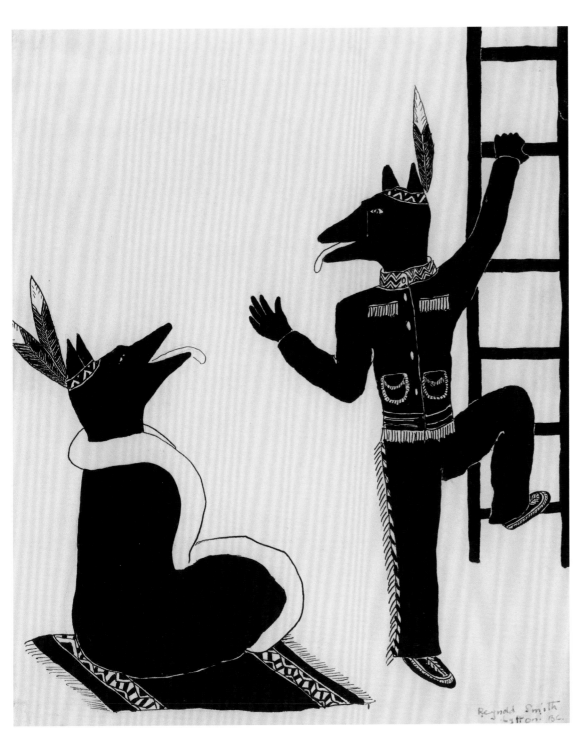

Mr and Mrs Coyote and Their Magic Ladder
Reynold Smith, 1940.
One of many drawings made by Nlaka'pamux students
at St George's Indian Residential School, Lytton.
RBCM 14477 E

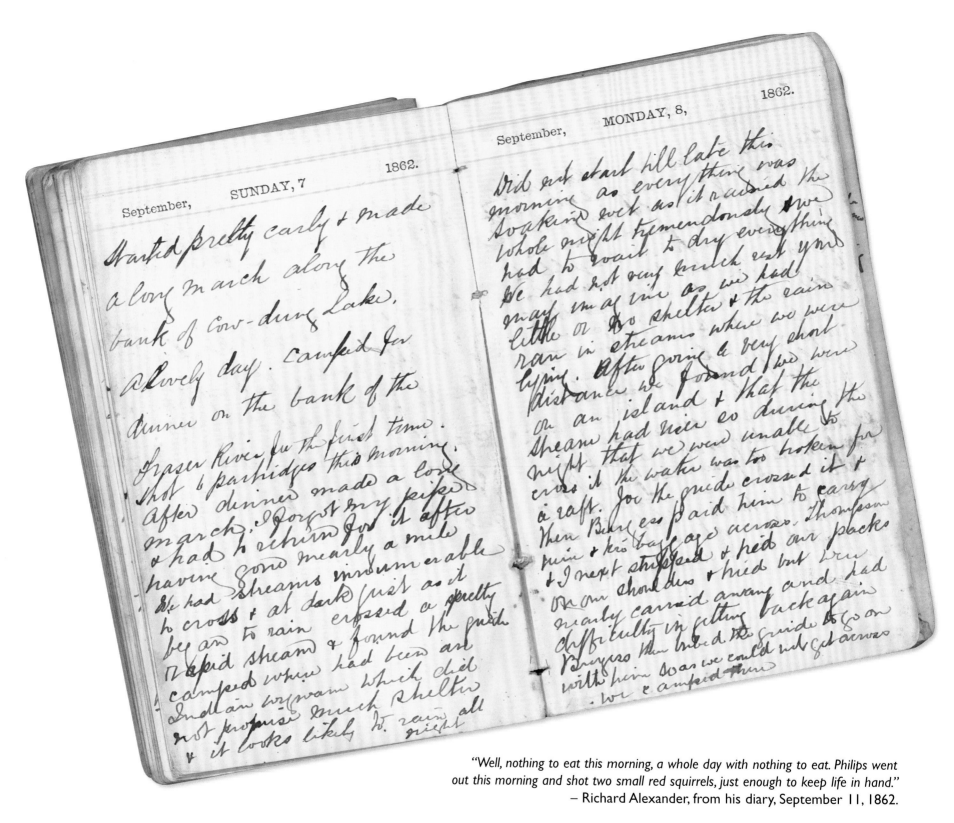

Started pretty early & made a long march along the bank of Cow-dung Lake. A lovely day. Camped for dinner on the bank of the Fraser River for the first time. Shot 6 partridges this morning. After dinner made a long march. I forgot my pipe & had to return for it after having gone nearly a mile. We had streams innumerable to cross & at dark just as it began to rain crossed a pretty rapid stream & found the guide camped where had been an Indian wigwam which did not promise much shelter & it looks likely to rain all night

Did not start till late this morning as everything was soaking wet as it rained the whole night tremendously & we had to wait to dry everything. We had not very much eat you may imagine as we had little or no shelter & the rain ran in streams where we were lying. After going a very short distance we found we were on an island & that the stream had risen so during the night that we were unable to cross it the water was too broken for a raft. Joe the guide crossed it & then Burgess paid him to carry mine & his bags across. Thompson & I next stripped & tied our packs on our shoulders & tried but were nearly carried away and had difficulty in getting back again. Burgess then bribed the guide to go on with him so as we could not get across we camped there

"Well, nothing to eat this morning, a whole day with nothing to eat. Philips went out this morning and shot two small red squirrels, just enough to keep life in hand."
— Richard Alexander, from his diary, September 11, 1862.

"Spent our last dollar getting breakfast this morning."
— Richard Alexander, from his diary, November 7, 1862, at Harrison Lake.

Richard Alexander's diary.
Written during his journey to
British Columbia in 1862.
BC Archives E/B/Al3.1

Golden Dreams and the Good Life

Richard Alexander came to BC looking for gold in 1862. Just 18 years old, he arrived in New Westminster starving and broke.

Most people who came to BC hoping to strike it rich arrived by ship. A few took a more difficult route, travelling over land from the east. Alexander made the trek from Ontario with four fellow overlanders on foot, by horseback, cart and boat. It took seven months. One of his party drowned in the Fraser River. The other four arrived in New Westminster with nothing but their clothing – in Alexander's case, the hide shirt shown here.

With no money to launch a gold-mining venture, Alexander found other work. He abandoned his golden dreams, but made a good life for himself in the new town of Vancouver.

Richard Henry Alexander (1844–1915).
John Savannah photograph; BC Archives A-01072

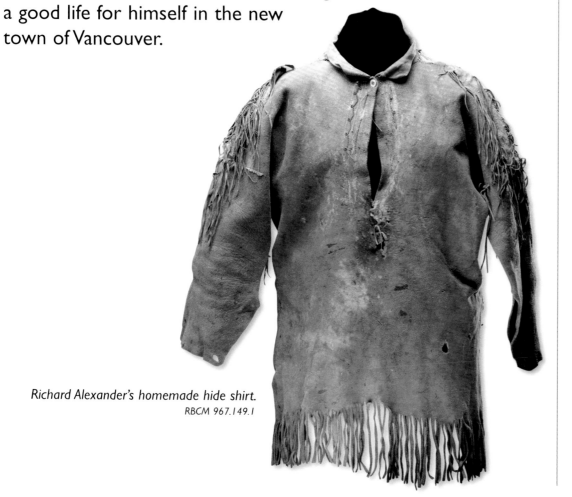

Richard Alexander's homemade hide shirt.
RBCM 967.149.1

A real success story

After arriving in BC penniless and starving, Richard Alexander did much more than survive. He found odd jobs here and there, and then steady work at the Hastings Saw Mill in Vancouver. There, Alexander developed business skills and eventually became manager of the mill.

The mill thrived under Alexander's management, and the city of Vancouver grew rapidly around it. Alexander helped establish the first post office and school. He served as a term as a city councillor and continued to support the city's development throughout his career.

Land of Immigrants

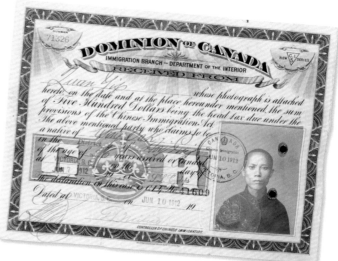

Most British Columbians have come from somewhere else, or their families have. Many have come to make their fortune or a better life for themselves and their children.

Every new arrival brings something with them, whether it's a piece of furniture, a sentimental heirloom, an idea or an expectation. These things – if expressed, if preserved – become part of our collective heritage.

Chinese head-tax certificate. Between 1885 and 1923, more than 82,000 Chinese immigrants paid a tax to enter the country. The Canadian government kept raising the tax to discourage Chinese people from entering the country. It began in 1885 at $50, then climbed to $100 by 1900 and peaked at $500 in 1903. The tax was only removed in 1923 when the federal government passed legislation that prevented almost all Chinese immigration to Canada.
RBCM 982.134.378

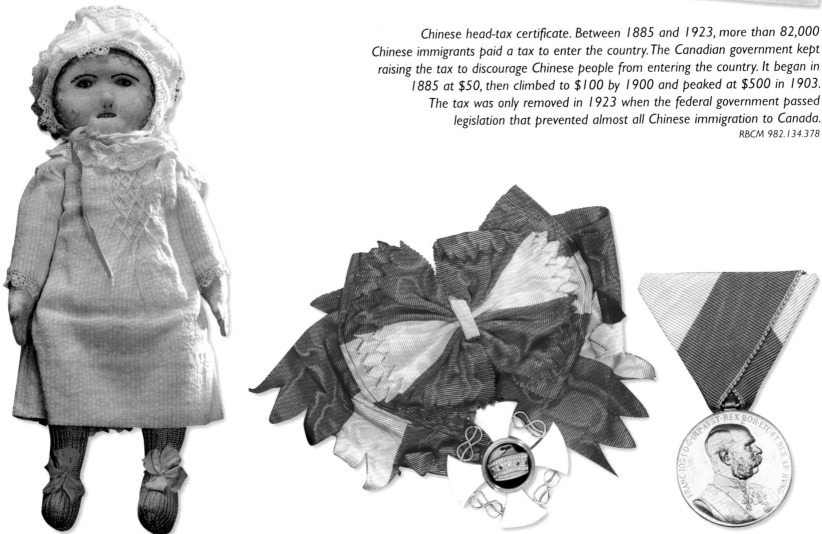

Child's doll, from a Doukhobor family that lived near Nelson. The first group of Doukhobors, about 7400, came to the Canadian Prairies in 1899 to escape persecution in Russia. Many of them moved on to BC in 1908.
RBCM 967.164.1

When Albert de Mezey came to Canada he brought a set of medals that meant a great deal to him. His father, Alexander Mezey Von Szathmár, received them during his career as ambassador for the Austro-Hungarian Empire, between 1878 and 1898. Shown here are the Italian Order of the Crown (left), awarded in 1897, and the Memorial Medal of Franz Joseph (right), issued in 1898 to commemorate Austro-Hungarian Emperor Franz Joseph's 50th anniversary.
RBCM 989.71.6a, 989.71.7

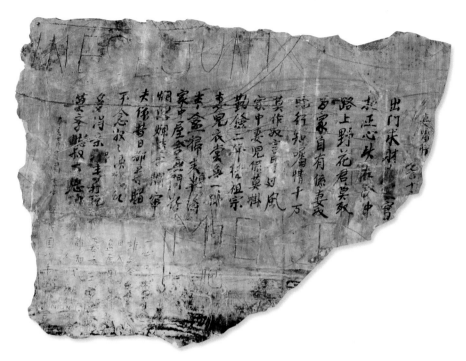

My Wife's Admonishment

You go abroad to seek wealth because we are poor.
In your sojourn, do not sow your wild oats.
Before you departed, I enjoined you to remember
You have a wife and children at home.
Please work diligently and be frugal with money.
Two years hence, return home to sweep your ancestors' tombs.
Remember, our backs are bare;
Not half a cup of rice can be scooped from the pot.
All our housewares are worn and torn;
Our house is dilapidated.
Your gambling has driven us to poverty.
In tears, I beg you to repent.
You are fortunate to have an elder brother to pay your head tax.
Always remember your gratitude to him.

July 11, 1912

I am in prison because I covet riches.
Driven by poverty I sailed over here on the choppy sea.
If only I did not need to labour for money,
I would already have returned home to China.

Wall fragments from Victoria's immigration building with Chinese
poems scratched into them (English translations below).
RBCM 2000.41.1-3

Disappointing arrivals

In the 1910s, some newly arrived Chinese immigrants had to wait in cells while government officers sorted out their paperwork. Like others, they had come with golden dreams, but instead they found themselves confined in oppressive darkness.

Poems scratched on the walls of Victoria's immigration building expressed the despair of people trapped on the border of a country that seemed not to want them. Some returned home; others gained entry and made the best of it here.

Chinese star gods bring favour into a home. These household gods, brought to Canada from Hong Kong in 1967, are the most common in Chinese tradition. From left to right: Luk (Lu Shen) *brings success and influence,* Fuk (Fu Shen) *brings happiness and wealth, and* Sau (Shou Shen) *brings health and longevity.*
RBCM 997.90.1-3

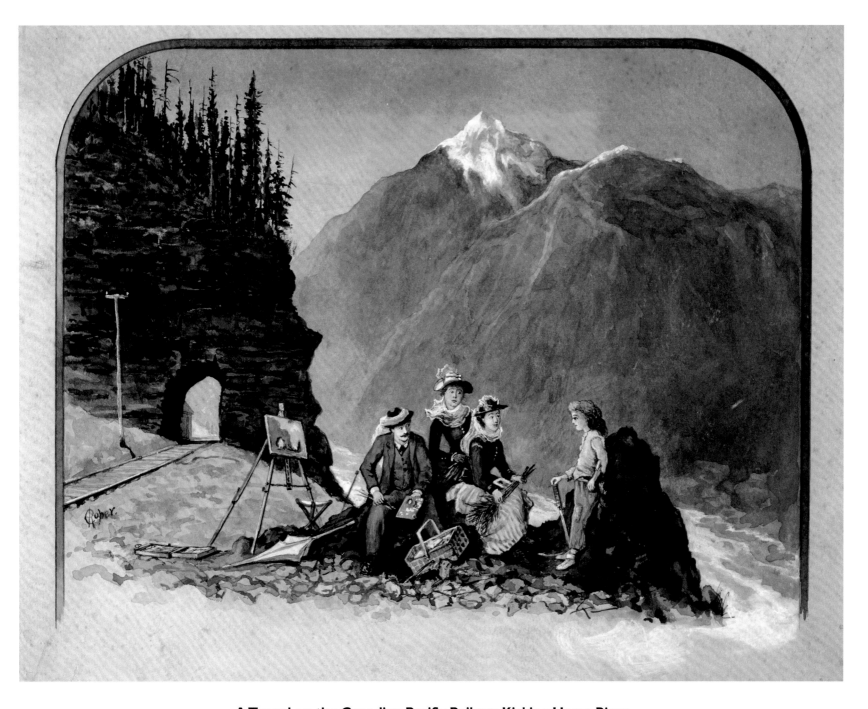

A Tunnel on the Canadian Pacific Railway, Kicking Horse River
Edward D. Roper, about 1887.
BC Archives PDP04450

Edward Roper (1833–1909) was a British artist, writer and naturalist. He travelled often and visited BC in 1887, when he painted this scene. Roper was staying at the nearby CPR hotel in Field, and the mountain in the background could be Mount Field. The group in the painting might possibly be the artist himself at work, two female companions that he mentions in one of his books about his travels, and an "ancient Irish gentleman", also mentioned in his book, who lived nearby and thought that Roper's work was a "great waste of time".

Changing Places, Changing Styles

*T*he Lee family came to British Columbia in about 1900 and settled in Victoria. Over the next 20 years the family grew and the style of their clothing changed, especially with the younger ones.

It makes sense. Most people like to fit in, wherever they live. And since we present ourselves best with the clothing we wear, most of us like to dress in the fashion of our generation.

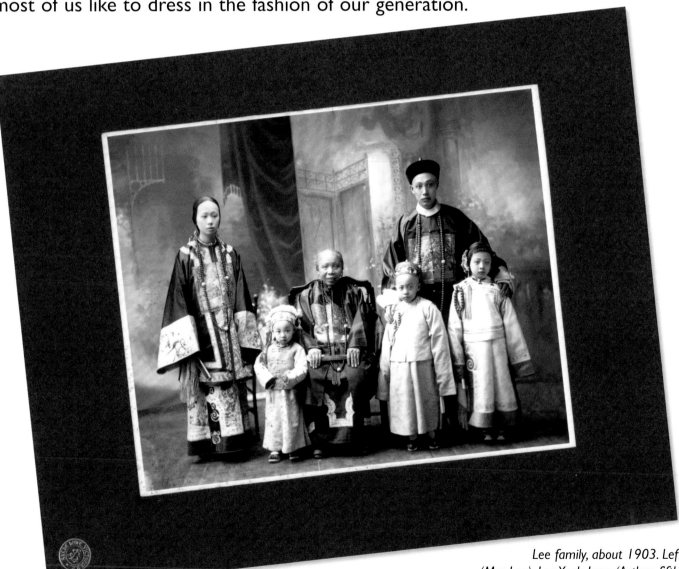

Lee family, about 1903. Left to right: Seto Chang Ann (Mrs Lee), Lee Yook Lum (Arthur, fifth son), Mrs Lee Yook Quan (Lee Mong Kow's mother), Lee Yook Quan (Alfred, third son), Lee Mong Kow, Lee Yut Wah (Ida, second daughter).
Skene Lowe photograph; BC Archives A-02348

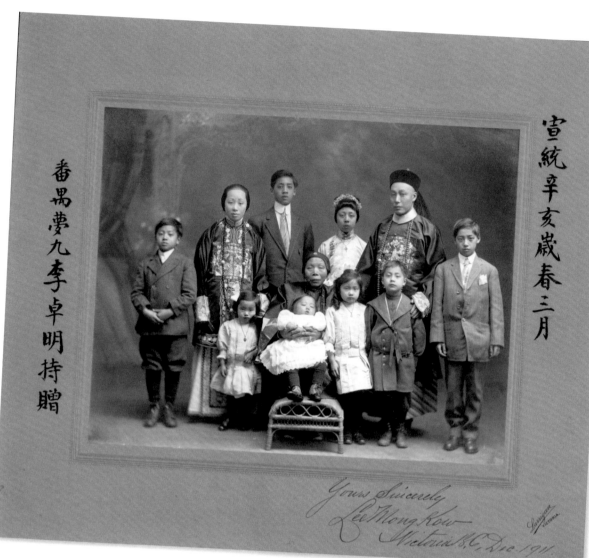

番禺夢九李卓明持贈

宣統辛亥歲春三月

Yours Sincerely
Lee Mong Kow
Victoria B.C. Dec 1911

Lee family, 1911.
Larrigan photograph; BC Archives F-08202

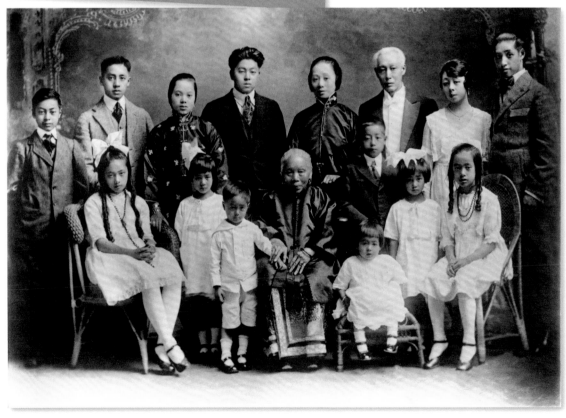

Lee family, about 1920.
BC Archives D-05823

Growing Up in Whonnock

by Joan South

*M*y mother, Elizabeth Eastman, came with her family to BC from Toronto in the early days of train travel and settled in New Westminster. She was eight then, old enough to remember the excitement of the trip and how different it was to live in a town so new and growing. The weather was colder then, she said, and she remembered the sailors from a visiting British warship sliding down New Westminster's steep hills out on to the surface of a frozen Fraser River.

Later, when she was in her teens, her father became active in the real estate boom. She remembered that he would leave the house on foot very early in the morning to lay out little square lots all over what is now Coquitlam, and how she enjoyed driving the pony-and-trap out in mid morning to take him his hot lunch.

After World War I, with a husband and children now, my mother moved to Whonnock, a small farming and fishing settlement on the north side of the Fraser. They took up a soldier settlement farm of about 12 acres (five hectares) and there we children grew up.

Whonnock was a wonderful place to be a child. There was always something going on that we could join in on or watch. In spring there were the Scandinavian fishermen rushing around getting ready for the big salmon runs on the river. The more adventurous of them, those with their gill nets in better shape, or larger, would head down the river to fish in the straits or even on the outside, west of Vancouver Island. The others would wait for the runs to come up river and there would be the wonderful, restful sound of the old one-lung engines as the boats would make their way up river to begin a new drift.

There were tugboat operators too, who would cast their booms adrift while they came to the stores, then chase the logs down river, cursing if they had tangled on the shore. Then there was the excitement of the *Samson*, the old sternwheeler that would often come into dock to buy our fresh eggs and mother's good butter. One not-to-be-forgotten day, my brother took me on board the *Samson*. I can still remember the feel of the hot deck boards on my bare feet and the thrill of pulling the cord for the warning whistle.

A large group of English retirees lived in Whonnock, too, and they held lots of summer garden parties with tennis games and tea and cookies for us to hand around. The bad side of those garden parties was having to wear a dress and cram shoes on my summer-hardened bare feet.

As well as the mixed farming that most families did, there was a large group of Japanese berry farmers down in Happy Valley. Most of the women spoke no English, and I remember afternoons full of laughter as my mother patiently instructed a group of giggling young Japanese women in the basics of the language. In return they offered to teach us needlework, and after our fall fair where samples of their beautiful, delicate embroidery took all the prizes, there were many takers of this offer.

One of the many shortcuts from the stores near the river to the farms on the hills, came up our road close to the house. Once I remember coming around a corner to see two older Japanese women standing quietly in the road. Tears were streaming down their faces as they looked at the curtain of wisteria blooms hanging down our house wall. That was the first time I really thought about how hard it must have been for them to come to a strange land of such different customs.

Joan South is a retired teacher, an avid gardener and a long-time volunteer at the Royal BC Museum.

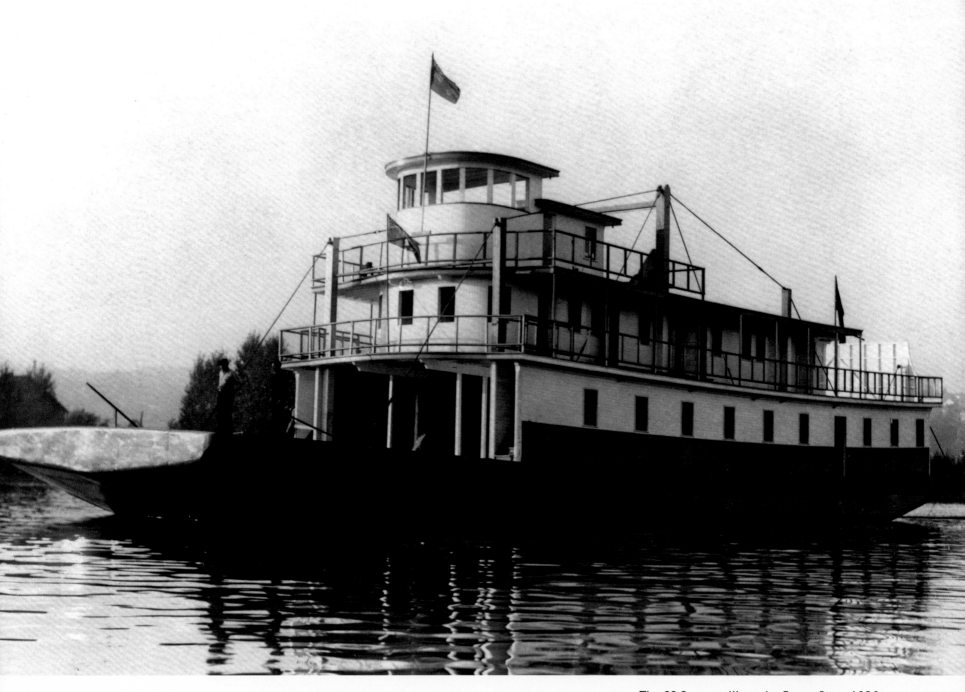

The SS Samson III on the Fraser River, 1930s.
BC Archives E-09053

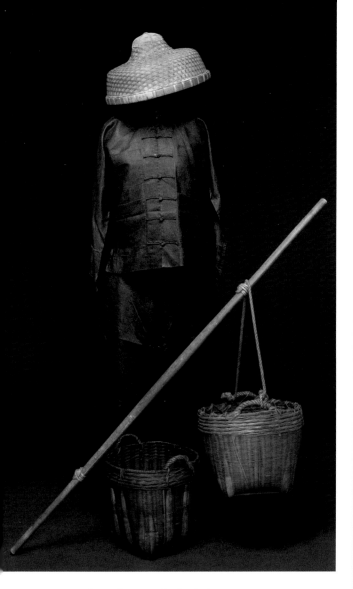

A produce pedlar's clothes, carrying pole and baskets.
RBCM 996.7.1, 996.7.2

Fresh Food Delivered to Your Door

*I*n the early decades of British Columbia, many Chinese-Canadians operated small farms in and around the cities. Pedlars often used poles and baskets to carry their produce from door to door. You can carry so much more on a pole, but it must have been hard to carry all that weight and balance it, too.

It must have also been a good business. In 1901, Victoria had 197 market gardeners growing vegetables and small livestock (mostly chickens), and delivering them door to door. After Vancouver made a law to reduce the number of pedlars in the city, many Chinese grocery stores opened for business.

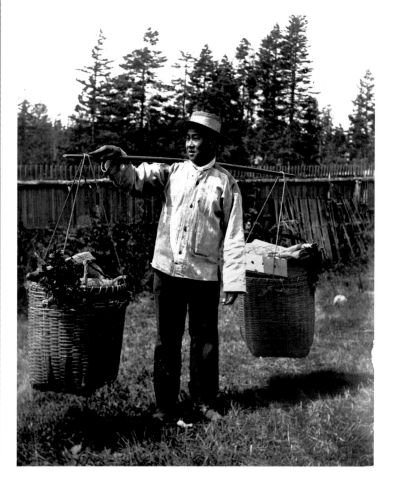

Pedlar with a full load of produce.
BC Archives I-63406

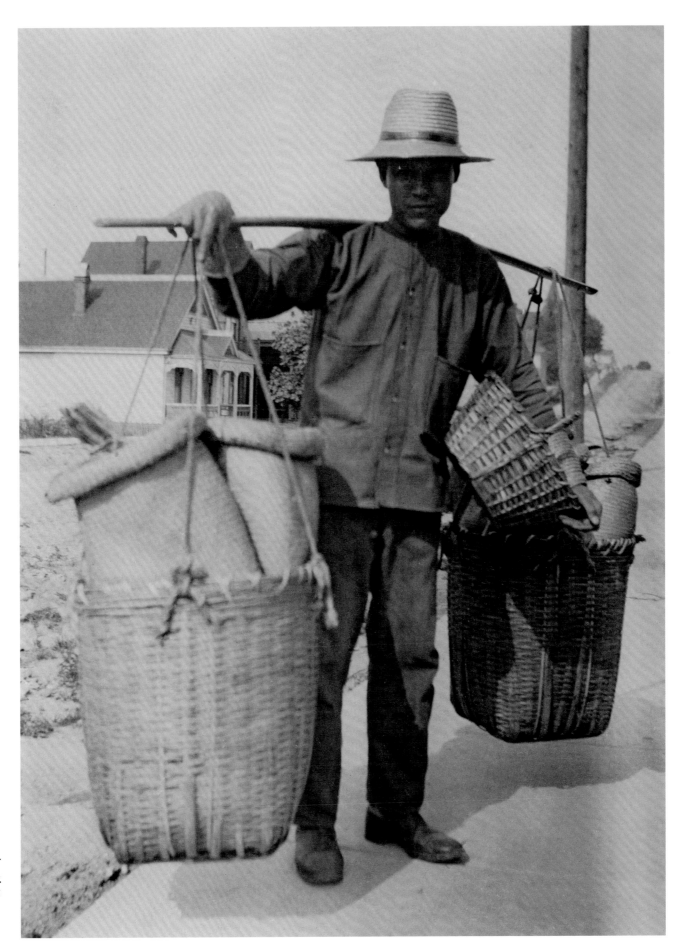

Sam, a pedlar in Vancouver.
BC Archives B-03625

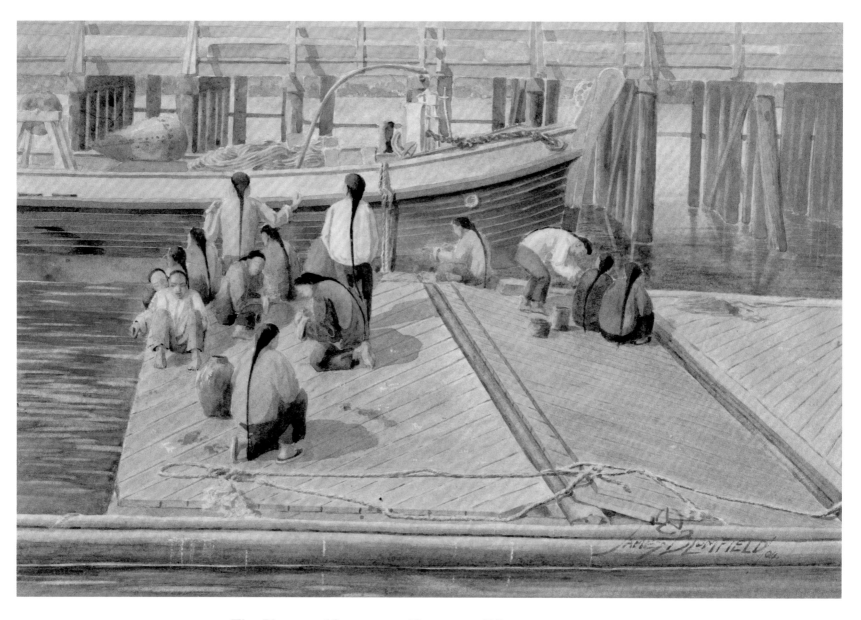

The Pleasant Afternoon at Vancouver, BC
James J. Blomfield, 1904.
BC Archives PDP06289

James J. Blomfield (1871–1951) usually painted landscapes without people. He travelled a lot and while in Canada lived in BC and Ontario. This scene likely took place in False Creek or Vancouver Harbour on a calm day.

Blomfield also created stained-glass art. He made stained-glass windows for the BC legislature and Government House in Victoria, and the Queen Victoria window in St Paul's Anglican Church in Vancouver.

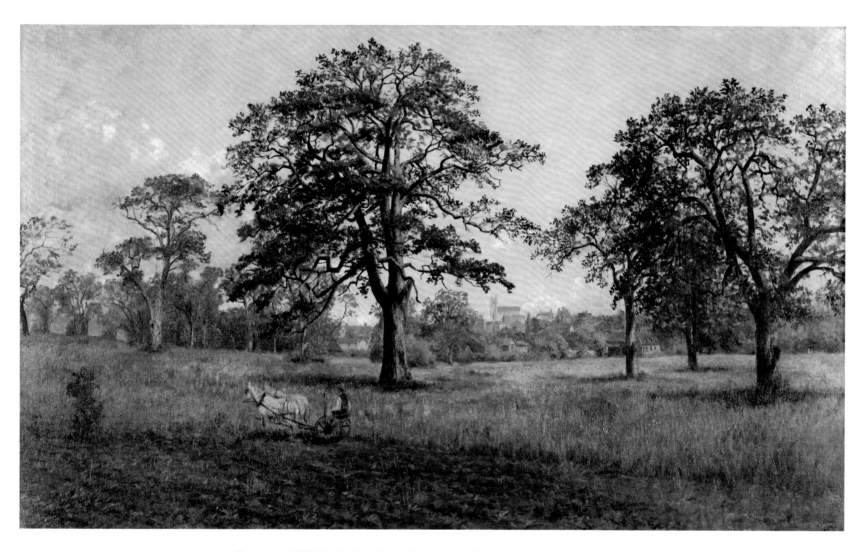

Beacon Hill Park Looking Towards Church Hill
Thomas Mower Martin, about 1890.
BC Archives PDP00187

Governor James Douglas reserved 74 hectares around Victoria's
Beacon Hill as a park in 1858. The province transferred it to the
city of Victoria in 1882. It has remained Beacon Hill Park ever since,
with no commercial enterprises allowed. The man with horses may
be part of maintenance work done in the park starting in 1888.

Thomas Mower Martin (1838–1934) came to Canada in 1862
and settled in Ontario. In the late 1880s, he travelled to BC
with Frederick Bell-Smith (see page 88). They came courtesy of
Canadian Pacific Railway, when it asked Canadian artists to paint
the magnificent scenery in the west to promote ticket sales.

Pressing News

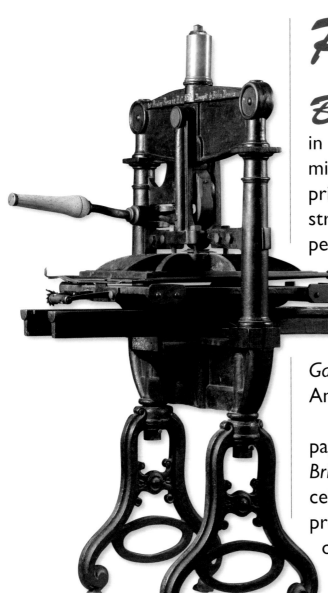

A platen press uses a plate instead of a roller to press paper to inked letters.
RBCM 965.5427.1

Bishop Modeste Demers brought this platen press to Victoria in 1856, intending to use it to print a chronicle of the Catholic mission. It was already about a hundred years old, long past its prime, and the bishop found it too difficult to operate. After struggling with it for some time, Bishop Demers let other people have a try.

Paul de Garro used it to print a French-language newspaper, *Le Courier de la Nouvelle Caledonie*, a tri-weekly that ran for just nine issues. The press was also used to publish the first issues of the *Vancouver Island Gazette* and the *News Letter*. In 1858, the bishop sold it to Amor de Cosmos, who had just arrived in Victoria.

De Cosmos was a photographer and journalist (see also page 102). He printed the first issues of his newspaper, the *British Colonist* (parent of Victoria's *Times-Colonist*, which also celebrates its 150th anniversary in 2008) on the old platen press. In 1862, he upgraded to a cylinder press and let the old one sit idle for a few years.

In 1865, George Wallace, a former reporter for the *Colonist* bought the press from de Cosmos and took it to Barkerville where he started the *Cariboo Sentinel*. The newspaper and the press survived three owners and the Barkerville fire of 1868. But the paper folded in 1875 and the little press moved on to Emory, another gold-rush town. When Emory floundered in 1884, the printing press went to Kamloops.

It worked there for another six years. By 1890, the more efficient cylinder presses had become available to even the smaller community newspapers. The little platen press had come to the end of its working life, and like so many people, it returned to Victoria to retire. It now resides in the collections of the Royal BC Museum.

The Beginning of BC Books

*J*ust before Amor de Cosmos bought Bishop Demers' printing press to start the *British Colonist*, another new arrival in Victoria, Alfred Waddington, used it to print the first non-government book in BC. Waddington landed in Victoria with plans to prospect for gold in BC's interior. Instead, he found what he considered an unfairly negative attitude toward the gold fields.

Determined to set things right, he published a booklet called *The Fraser Mines Vindicated*, promoting BC as a prospector's paradise. He argued against statements in newspapers, mostly in the USA, like "the gold mines are a humbug". The book appeared in December 1858; the colonial government of Vancouver Island had published two book-length documents earlier that year, but Waddington's was the first privately published book in BC.

Alfred Waddington never panned for gold, but he stayed in the region, promoting gold mining and road building in BC until he died in 1872.

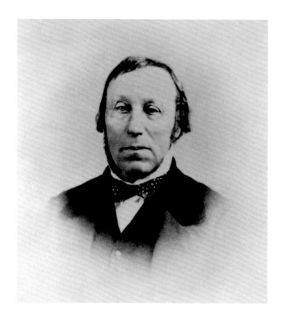

Alfred Waddington, 1864.
BC Archives A-01885

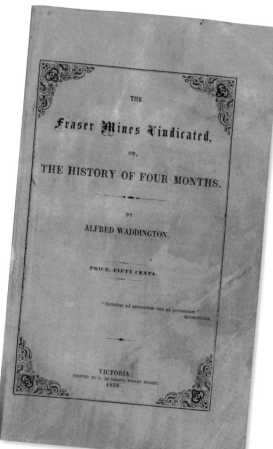

The Fraser Mines Vindicated
or The History of Four Months
by Alfred Waddington, 1858.
BC Archives NW971.35F/W118

Making BC books

Alfred Waddington's self-published book marked the beginning of book publishing in BC. Yes, it was small, more of a booklet, a small one at that. But *The Fraser Mines Vindicated* was printed and bound as an independent document, and it's been reprinted as a hardcover book.

For about a hundred years after Waddington's first edition was printed, book publishing in BC remained a sideline for printers and regional organizations, and for self-publishers like Waddington.

The first companies dedicated solely to publishing books appeared in the 1960s, after a 1958 Centennial project encouraged publishing in BC. Today, more than 40 BC book publishers produce thousands of books each year to satisfy the varied appetites of Canada's most avid readers.

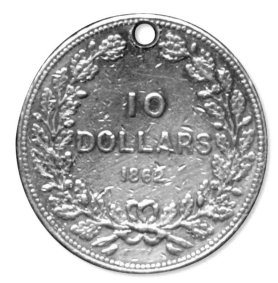

Claudet's coins

The gold and silver test coins that Francis Claudet made in BC's mint stirred up some excitement around New Westminster. The colonial treasurer, William Gosset, proudly showed them to John Robson, editor of the city's newspaper, the *British Columbian.*

"He had the coins in his hands," Robson said, "jingling and admiring them, as a child would a new and attractive toy." They impressed Robson so much that he went to Claudet and had a coin minted for himself.

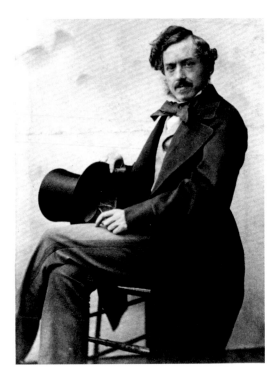

Captain William D. Gosset,
provincial treasurer, 1858–62.
Francis Claudet photograph; BC Archives A-02094

New Westminster Mint, 1860.
Francis Claudet photograph; BC Archives B-02258

Some of the Rarest Coins in the World

*D*id you know that BC had its own mint? It stamped out a few coins and then shut down.

In 1861, the colony had a serious problem: its people did not have enough cash to use when buying or selling to each other. So the government bought coin-stamping equipment from California and got the mint ready to go in New Westminster. Then a shipment of cash arrived from Britain, so the governor ordered BC's mint to close.

The manager, Francis Claudet, ran the mint just long enough to stamp some test coins plus a few more from gold that people brought in. The British government displayed some of the BC-minted $10 and $20 gold coins at an exhibition in London in 1862, then melted them down for bullion. No one knows exactly how many more coins Claudet produced. They were rare then and even rarer now.

Francis G. Claudet, superintendent of the government assay office, about 1870.
BC Archives A-01166

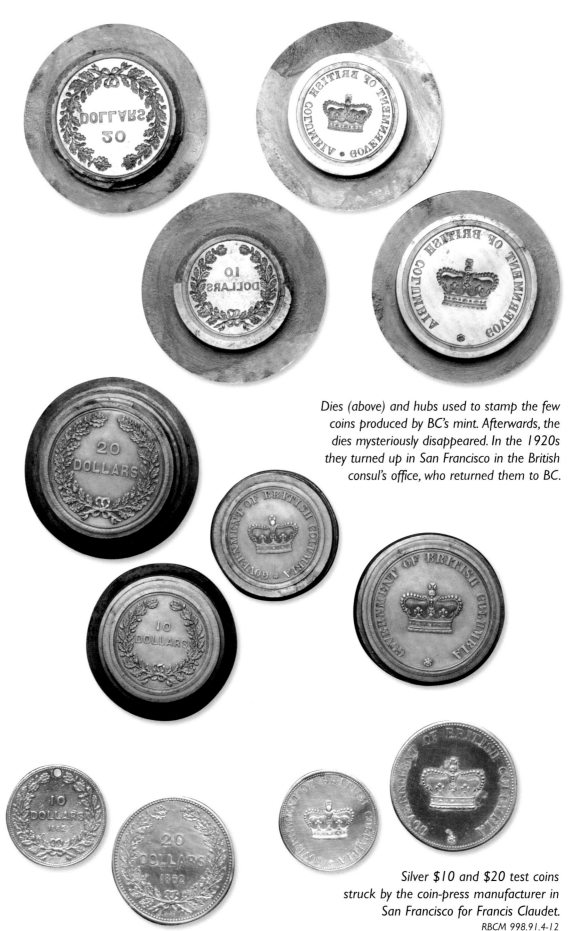

Dies (above) and hubs used to stamp the few coins produced by BC's mint. Afterwards, the dies mysteriously disappeared. In the 1920s they turned up in San Francisco in the British consul's office, who returned them to BC.

$10 and $20 coins designed by Colonial Treasurer William D. Gosset and engraved by Albert Küner of San Francisco. The $10 coin was privately minted for John Robson. (Robson later entered politics and served as the ninth premier of British Columbia from 1889 to 1892.)

Silver $10 and $20 test coins struck by the coin-press manufacturer in San Francisco for Francis Claudet.
RBCM 998.91.4-12

N.B Please let me know next time you write if I may take a bit from my purse to spend on Christmas cards.

For

Dear Mama

Rec.d at New West.r 1880 on my birthday —

Written by Artie Crease also Dr 8 yr 8 m. old.

Pentrelew 28th November 1880
?

My dear Mama

I wish you many happy returns of your birthday. Mr Ward has got a new cow & he has sent both his horses out to Cedar hill for the winter. The horses which were in the cart that came for them looked so handsome, they arched their

necks so prettily. Yesterday I went to play with the Wards, we made fires & burned up all the rubbish & leaves round their place. We made a new rabbit hutch & put 10 young rabbits in it. They have 17 rabbits now, but 3 belong to Hugo Beaven 1 of them weighing 10 lbs. One of the Wards nurses is very ill. There has been some

thick ice & it has been freezing every night & it is freezing now. Tomorrow if I am a good boy Mary is going to drive me out to the "Royal Oak" with Susy. Now I must say goodbye

I remain

your loving son

A D Crease.

Please give my love to papa here is yours x x t 0 0 0 c c 0 0 0 0 0 0 0 0 Y Y t t x t t x x x P Y Y

here is Papa's 0 0 0 x x t t 0 0 0 0 0 0 0 0 0 0 0 0 0 x x x t t t t t t t x x x x x t t

Letter From Home

A short letter from a young boy to his mother can say so much. In 1880, eight-year-old Arthur Crease wrote to his "dear Mama" when she was away from home.

Sarah Crease was on a rare vacation away from the children. She travelled through the Cariboo with her husband, Supreme Court Judge Henry Crease, while he presided over criminal cases on his regular fall circuit of BC courts.

Arthur's news from home concerns his neighbour's horses and rabbits, playing with friends, and the icy cold weather. Mama and papa have gone far away from his small world, and it's clear that he misses them.

Arthur Crease at about six years old.
BC Archives B-01397

Letter to home

Young Dirk Fraser attended Vernon Preparatory School from 1938 to 1941. He wrote many letters to his mother and sister, telling them of his adventures at the boarding school. In one letter, he describes sliding on the gymnasium floor and getting a large wooden splinter in his belly. Dirk's description includes every detail of the accident and the splinter's removal. The letter even includes the splinter and a scale to show its size.

Detail of Dirk Fraser's letter in
1940, showing the splinter.
BC Archives MS-2805, box 1, file 2

Arthur Crease's letter to his mother,
November 28, 1880.
BC Archives MS-2879, box 69, file 1

Gibraltar Bluff, Paul Lake, from Echo Lodge
Alfred William Allen, 1930s.
BC Archives PDP04453

Alfred Allen (1886–1974) was a painter and decorator in Kamloops,
active in the Kamloops Art Club. Built in 1922, Echo Lodge is still a
popular fly-fishing retreat. Paul Lake became a provincial park in 1961.

Kicking Horse Pass
(about 5000 feet), 1887
Lucius Richard O'Brien.
BC Archives PDP04901

In 1858, Captain John Palliser of the Waterford Artillery Militia led an expedition to find passages through the Rocky Mountains for the British colonial authorities. While following the route of a river in this region, one of the horses kicked the expedition's doctor, James Hector, in the chest and almost killed him. Later, the waterway was named Kicking Horse River and the pass through the mountains Kicking Horse Pass.

Ontario artist Lucius O'Brien (1832–99) painted the pass while visiting the area with officers of the Canadian Pacific Railway.

George Edwards, otherwise known as Bill Miner, 1906.
Mary Spencer photograph; BC Archives B-03597

The Short Lives of Train Robbers

The famous train robber Bill Miner teamed up with Lewis Colquhoun and Shorty Dunn to hold up a train at a place called Ducks, near Kamloops, in 1906. But the robbers didn't get far. The BC Provincial Police captured them, and they were convicted and sent to the BC Penitentiary in New Westminster.

The robbery at Ducks wasn't Miner's first. He'd been robbing trains in the USA before coming to BC in 1903. He and two other men robbed a train near Mission in 1904, the first ever train robbery in Canada. Then he returned south and teamed up with Shorty Dunn to rob a train outside of Seattle in late 1905.

Colquhoun, a former school teacher, was a friend of Dunn. Chances are he regretted turning to a life of crime. He died of tuberculosis in 1911 while serving time in BC Pen.

Bill Miner escaped in 1907 and fled south of the border to continue robbing trains until 1911, when he was arrested in Georgia. He escaped prison once again, but was recaptured. Miner died in a Georgian prison in 1913.

Shorty Dunn served his full sentence in BC Pen. When released, he moved north to the wilds of central BC where he lived the honest life of a trapper until he accidentally drowned in 1927.

Shorty Grell (a.k.a. Shorty Dunn) at Eutsuk Lake in 1922. After being paroled in 1915, he lived peacefully in the area around Ootsa and Eutsuk lakes.
Frank Swannell photograph; BC Archives I-58840

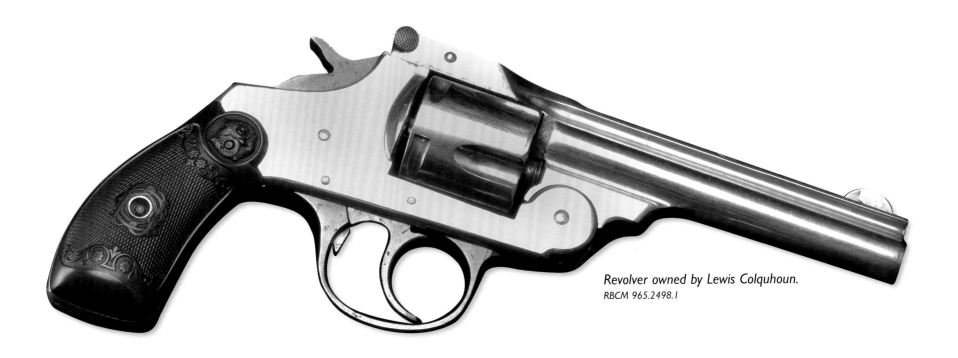

Revolver owned by Lewis Colquhoun.
RBCM 965.2498.1

Bill Miner left this pocket watch behind
when he escaped from BC Pen in 1907.
RBCM 963.27.1

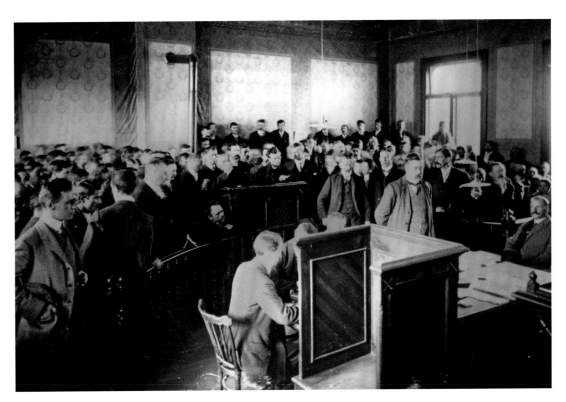

Bill Miner being brought into court for his
preliminary hearing on May 14, 1906.
BC Archives B-02860

The Day My Mother Met Bill Miner

by Allan Shook

*M*y mother was born on the Gilbert Plain in Manitoba near Daphne on December 26, 1898. Named Alice Maud, she was the ninth of ten children born to James and Jean Ryder. My grandfather, who had been raised in Ontario, was always moving westward. He would buy a rundown farm, build it up, sell it and move on. The family eventually settled in the Mount Lehman area, near Mission, with a 160-acre (65-hectare) piece of property.

I don't know what month Bill Miner robbed the train at Silverdale, but it was when some of the trees were bearing fruit. My grandmother and her two little girls were out picking fruit when a man walked up to them from the standing timber and asked for some from their basket.

Recognizing the man for who he was, my grandmother was too terrified to speak. Miner looked for a moment at this woman and her little girls, grunted something, reached into the basket, stuffed his pockets full and walked back into the woods.

My grandmother rushed to the house with her girls and told her husband and older boys of this encounter with the infamous train robber. Grandfather went out to have a look and found Bill Miner and his friends camped in the standing timber not far from the river.

My grandfather forbade the family from telling anyone about Bill Miner camping on his property. He feared that, if the police came and arrested the gang, Miner or his friends would return one day and burn down the family home – this practice was not uncommon in Ontario when he was a child there.

Grandfather reasoned that after robbing the train, the gang had rowed across the river in a boat they had stashed on the Silverdale side. They hid the boat at the mouth of a creek on the Mt Lehman side, concealing it under the overhanging boughs of trees, and set up camp to wait until things cooled down. When the coast was clear, they left.

Allan Shook is a retired carpenter and father of three. He spends his time prospecting for precious metals, gardening and watching wildlife.

Farmlands around the Fraser River, near Mission, 1949. The riverside was more forested four decades earlier when Miner and his gang laid low near here.
BC government photograph; BC Archives I-21468

A Life-Changing Journey

In April 1880, at age 26, Helen Kate Woods left her home in Victoria to travel into the northern wilderness. She and her younger brother, Edward, went to visit their sister, Alice Tomlinson, the wife of a missionary in Ankitlast, a small settlement on the Skeena River.

For the final leg of the journey, a 16-day trek from Kincolith on the Nass River to Ankitlast, Kate and Edward needed the help of several Nisga'a and Gitxsan guides. They travelled overland, mostly on foot, sometimes wearing snowshoes, following the frozen Nass River and First Nations trading trails. This trek changed Kate's life.

While living in the comfortable surroundings of the well-to-do family residence in Victoria, Kate had rarely come so close to First Peoples, and her experiences with them were associated with an urban environment and, at a distance, the Songhees Reserve. Now she had to live and eat with her guides, take their instructions, and depend on them for her survival.

In her diary, Kate Woods wrote that she developed a great respect for her guides' knowledge of the land and their abilities. She learned their names and grew to enjoy her time with them, despite the harsh conditions. Kate's view of First Peoples changed forever.

Helen Kate Woods, about 1880.
Family collection

"Near Salmon House, Anhaun River, April 22, 1880."
Sketch by Kate Woods, from her diary.
BC Archives PDP01696

Valley of the Loop, Cheops in Background
Frederick Marlett Bell-Smith, 1888.
BC Archives PDP03874

At first glance this seems a peaceful scene: a gentrified couple
out for a stroll. But they cross a rushing mountain stream, very
dangerous, especially dressed as they are – one unexpected tilt of
the boardwalk and into the frigid rapids they could go.

Frederick Bell-Smith (1846–1923) first came to BC on a free rail
pass, when the CPR wanted eastern-Canadian artists to paint the
magnificent scenery in the west to promote ticket sales. Bell-Smith
returned several times to the Rocky and Selkirk mountains. This
scene is in Glacier National Park – the people in the painting could
be guests at Glacier House (see page 144), a CPR hotel in the park.
The "loop" in the title of the painting refers to a section of rail line
that loops through the mountain pass; the mountain, Cheops, was
named so because of its pyramid shape.

Magical Atlin
by Wayne Merry

*T*hirty-five years ago, while Cindy and I explored northern BC roads with our two little boys, we drove over the hill into Atlin, gasped and said, "My God, this is Brigadoon! It's magic! We've got to live here!"

In the middle of the winter two years later we left our jobs and a modern, comfortable house in Yosemite National Park, and drove an old truck up to Atlin over icy roads. We moved into a house built late in the gold rush, with no insulation and no running water. We burned ten cords of wood that first winter. Our friends said, "Are you absolutely nuts?" Some are still convinced that we are.

But they are the ones who have never been to Atlin. We've never regretted it. It is one of the most beautiful places on earth.

In a town of 400 with no government, we quickly found that your personal history wasn't nearly as important as what you could do for the community. That meant volunteering. A modern fire department had to be created, a new ambulance service developed. The village's turn-of-the-century gold-rush and First Nations heritages needed preserving. There were all the recreational and social groups, the spring carnival and political issues threatening the environment to be concerned about. There was barely time to do repairs to the house, get in the winter's wood, find a moose and some lake trout and grayling for the freezer, cultivate a big garden, enjoy the wilderness. And to make a living.

To make a living: there was the rub. At that time, you either brought your job with you or just did whatever presented itself in the way of odd jobs. We did a little writing, a little teaching, a little outfitting. Others who had been captured by Atlin's magic were artists or turned to handicrafts and art to bring in a little income.

This is a place where artists thrive, inspired by the stunning surroundings, untroubled by the frantic pace of urban life, gifted with the time to grow. In Atlin you don't worry about keeping up with the Joneses or what to wear for any function. You don't commute. The air is crystalline, the great lake is pure. If there was ever a place for creativity, this is it.

And the artists have become a big part of Atlin. Some who were just starting in the 1970s have earned national and even international recognition. The old court house, built at the turn of the century, houses a thriving art gallery in summer. The artists have to work hard to keep up with demand.

In some ways, Atlin is still like it was 40 years ago. The kids still play on the streets, drivers stop to help you on the road to Whitehorse, you know all your neighbours and most of the rest of people in town, and you depend on volunteers rather than a government. There's still a tang of woodsmoke in the clear air. You can boat all day in the incredible fjords of Atlin Wilderness Park and rarely see another boat.

Now you can sit in a comfortable house and consult with an agency in Ottawa or an editor in New York on high speed internet, while a moose walks through your front yard. The artists can sell online. You can make a living now. You have the best of both worlds.

And it is still one of the most beautiful places on earth. It is still magic.

Wayne Merry made the first ascent of the face of El Capitan in Yosemite in 1958. He has written two books and many articles, and since 1988 has trained volunteers and RCMP officers across the north in search and rescue, survival and wilderness first-aid.

Mountains across Atlin Lake from Brewery Bay.
Wayne Merry photograph

Cindy Merry enjoying the first summer boat ride through the ice of Brewery Bay, Atlin.
Wayne Merry photograph

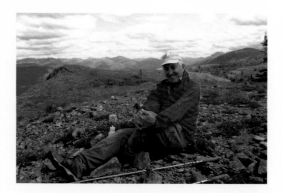

Wayne Merry on Monarch Mountain, southwest of Atlin.
Family collection

Dog Power

Winter brings freezing cold, snow, ice and more snow to most of the province. In the north, snowmobiles provide the quickest way to travel off the beaten track. In the early 1900s, long before the invention of the snowmobile, when even fewer roads existed, the only type of snowmobile was powered by dogs.

Dogsleds were especially important for transporting supplies and mail in winter. This sled belonged to Thomas Harper Reed (1878–1965), who used it from 1920 to 1950, when he lived in northwestern BC. Harper Reed was an Indian agent in Telegraph Creek and lived for a while in Atlin; he also surveyed and operated a small boat transportation service in the north. He was renowned for his knowledge of the landscape and trails in the region.

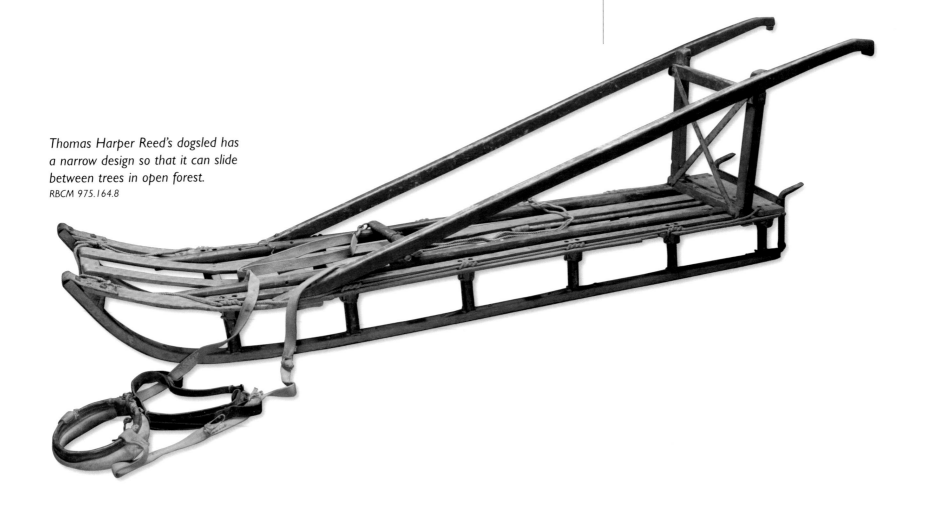

Thomas Harper Reed's dogsled has a narrow design so that it can slide between trees in open forest.
RBCM 975.164.8

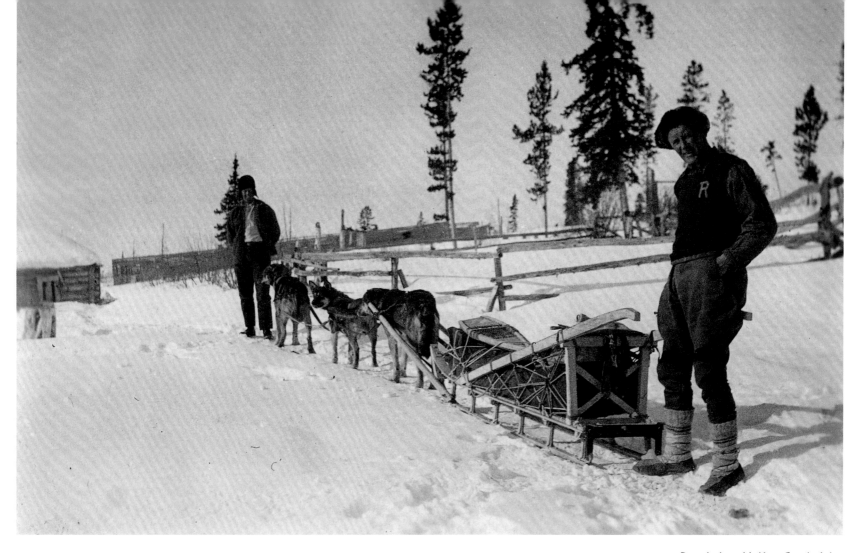

*Dogsled at McKee Creek, Atlin,
heading toward Telegraph Creek.*
BC Archives I-68627

*Dr Meyer at Buckley Lake, heading toward
Caribou Hide on the Klappen Trail, 1939.*
BC Archives I-68626

Alkali Lake Ranch, the Oldest Cattle Ranch in British Columbia

by Liz Twan

*T*he Valley of the Waving Bunchgrass or Paradise Valley are but two of the early names given by the province's first wanderers and settlers to a pretty valley that lies just 50 kilometres southwest of Williams Lake. Situated in this valley is the home ranch of BC's oldest cattle operation, the Alkali Lake Ranch Ltd. The ranch is privately owned and operated, as it has been since its very beginning in the mid 1800s.

The ranch lies along the original river trail that made its way through the Cariboo to the gold fields of Barkerville. Scores of men rode along that trail with the light of gold gleaming in their eyes, dreaming of finding the mother-lode and returning, rich, to their homeland. It is mainly these prospectors and packers

Bronc Twan, manager of Alkali Lake Ranch, ready to rope calves at a ranch branding.
Liz Twan photograph

who recognized the golden prospects along the trail: lush valleys and meadows with grass in abundance and plentiful water. Soon the land alongside the trail was populated by squatters. Shortly after a government office opened in nearby Clinton, the men hurried to file claims on these lands, forming part of the foundation of the ranching industry in British Columbia.

Herman Otto Bowe was one of the adventurers who settled in the valley. He called it Paradise and established a stopping house. By

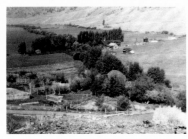

Alkali Lake Ranch in the 1920s.
Twan family collection

all accounts it was a very good one, and as word of mouth spread news about the place, it was often described as being situated below a white patch of Alkali on a nearby hill. There was also a lake nearby and over time the description turned into Alkali Lake.

Bowe and his partner, John Koster, brought in a small herd of cattle. They steadily increased the size of the herd and their land holdings. Both men married local girls (sisters) and raised families. Young Henry Koster and Johnny Bowe eventually became responsible for the running of the ranch. Henry Koster acquired Crown grants for large tracts of land that his father and Herman Bowe had held without deeds. In 1909 they sold the ranch to an Englishman, Charles Wynn Johnson.

Wynn Johnson was responsible for yet more land acquisitions; the ranch increased in size considerably during his years of ownership. At some point he hired a cow boss named Jim Turner, a Texan, who had worked for Joe Coutlee of the Douglas Lake Ranch. Turner began taking the cattle far from home throughout the spring and summer, giving them access to grass that hadn't been grazed in years. It took two years before the cattle accepted the alteration of their life's pattern, enabling the grass around the home ranch to recover and thrive.

Several years of disastrous drought and extremely low cattle prices put Wynn Johnson in difficult financial straits, and he ended up selling the ranch in 1939 to a young man he had met in Vancouver, Mario von Riedemann.

The von Riedemann family consolidated yet more land by purchasing surrounding ranches and acreages. At one time, Alkali Lake Ranch was purported to be the third largest ranch in Canada in terms of deeded area.

In 1977, the von Riedemanns sold the ranch to Kelowna businessman Doug Mervyn and his family, in whose hands it remains today. The Mervyns live on the ranch as owner-operators. Bronc Twan is the ranch manager, and his family history at the Alkali Lake Ranch goes back to the mid 1930s when his mother, Margaret Flockhart, and then his father, Bill Twan, came to work there.

Bill Twan, about 1938.
Family collection

Bill Twan strikes a pose, 1940s.
Family collection

Doug Mervyn was a newcomer to ranching, having previously owned and operated Big White ski resort in Kelowna. He had spent some time in Australia in younger days and always had an idea that he would like the ranch life. Well, he plunged right in and was very interested in new ideas and technology. Bill Twan was the ranch manager until he retired in 1979. His son, Bronc, who was the cow boss, moved into the manager's position within a few years.

Together Doug and Bronc improved the overall efficiency and productivity of the place, trying new methods of doing things and changing some of the old patterns. The old ways were working, but the new ways promised something better. The cattle herd evolved over the years into an Angus-Hereford cross.

In 2007, the Mervyns celebrated 30 years of owning Alkali Lake Ranch. Much has changed since Bowe and Koster started the ranch. We're not in Paradise Valley any more. The cattle industry is in a bit of a crisis. Prices are low, cost of production is high and the future is uncertain for the industry in BC. The optimists are tightening their belts to the last notch and trying to outlast the market downturn; others who are just too tired to keep penny-pinching are selling out. At Alkali Lake Ranch we'd like to be optimists, but economics may force us all to make some difficult decisions.

Liz Twan lives on the Alkali Lake Ranch with her husband, Bronc. A freelance writer and photographer, she has published her work in several magazines and newspapers.

Bronc Twan at the Echo Mountain feedlot, 2008.
Liz Twan photograph

Doug and Marie Mervyn at a branding in 2005.
Liz Twan photograph

Bluebunch Wheatgrass
(Pseudoroegneria spicatum)
Dick Cannings photograph

Cattle love it, so it must be good

Bluebunch Wheatgrass grows all over the hills in the regions around the Thompson River and Okanagan Lake. This wild grass, favoured by cattle, made the interior of BC ideal for ranching.

Today, range managers balance the ecology and economy of the region with a pasture-rotation schedule. This maintains the supply of Bluebunch Wheatgrass and keeps all the hungry cattle satisfied. Meanwhile, forests continue to invade these grasslands because of fire suppression ... and so the balance becomes more delicate.

One of Cataline's Spanish-style Aparejo pack saddles. Cataline trained his mules well. When the corregidor (foreman) rang a signal bell, the mules would go and stand beside their pack saddles, ready to be loaded. Each saddle held up to 300 pounds (135 kg) of cargo.
RBCM 975.140.7

Two pounds of smelly cheese
Jean "Cataline" Caux (1832–1922) ran his freight service from 1858 to 1912. People in central BC relied on Cataline, with his six-man crew and up to 60 mules, for their supplies, sometimes for their survival. And he did not disappoint them. In 54 years of running his pack train, he never failed to deliver a single item. When one of his men thought that a two-pound package of Limburger cheese had gone rotten and threw it away, Cataline replaced the cheese and delivered it.

You Could Bet Your Claim on Cataline

*I*t's 1878, and you've registered your gold-mining claim at the south end of Babine Lake. All you need are supplies and equipment to keep you going for the next six months. The store owner at Burns Lake looks over your long list and shakes his head.

"You're better off talking to Cataline," he says, pointing to a corral across the street. "Over there with all those mules, the big man wearing the white shirt and broad-rimmed hat."

Cataline greets you heartily, with an accent that could be French or Spanish. He glances at your list and asks where your claim is. "I can deliver there," he says.

And you know he will. Cataline's been running his pack train for 20 years. He's well known for his keen memory – and for delivering everything ordered.

Jean Caux's Pack Train loading at Harvey Baileys for Babine Lake 1897.

Cataline (centre) at Ashcroft in 1897, on his way to Babine Lake.
BC Archives A-03049

Prospectors on the Trail
Edward Mallcott Richardson, about 1863.
BC Archives PDP00104

British sculptor and landscape artist Edward Richardson (1839–74) came to BC in 1862, likely attracted by the gold rush. He got some work in Victoria and then sketched scenes along the Harrison-Lillooet trail to the Cariboo gold fields, but he found it difficult to make a living here. In 1865, he raffled off his paintings and returned to Britain.

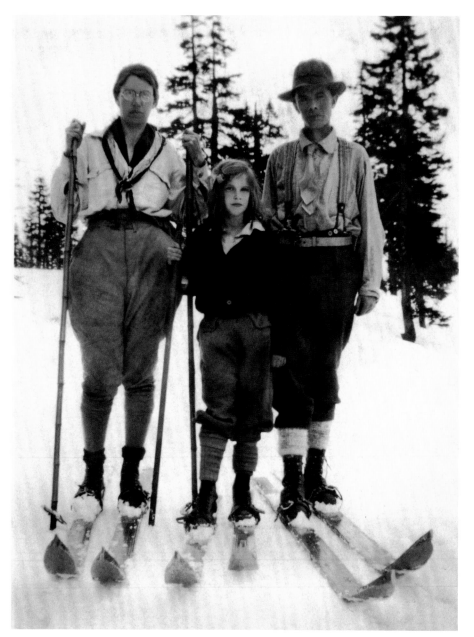

The Mundays on Mount Seymour,
North Vancouver, 1931.
BC Archives I-61526

Skiers on Mount Seymour, 1931,
including Edith Munday (third from right)
and Don Munday (far right).
BC Archives I-61525

Living the High Life

Have you ever climbed to the top of a mountain? In 1921, Edith Munday reached her first mountain peak at 12 weeks of age. Okay, her parents carried her up, but it still counts.

Edith's parents, Phyllis and Don Munday, belonged to an active group of mountaineers, based in Vancouver. From about 1910 to the 1940s, they climbed more than 125 mountains all over the province – many were first ascents.

Edith grew up in a small cabin, built by her father, on Grouse Mountain. There she learned how to ski and to identify the local birds by their calls and flight patterns. Edith climbed many more mountains with her parents, walking on her own when she was old enough.

The skiing's free if you don't mind the hike

In the 1930s, the Mundays took up skiing, a new activity on the coast. Skiing had arrived in southeastern BC in the 1890s, brought by Scandinavians who came to work in mines near the Columbia River. The first ski club in Canada began at Rossland in 1896.

Anyone who took up skiing in its early days had to really love it, because there were no roads to the mountains, and no gondolas or chairlifts to take you to the top. Strap your skis onto your back, step into your snow shoes and start climbing. The snow's great up there.

Edith Munday's snowshoes.
RBCM 977.88.12 a-b

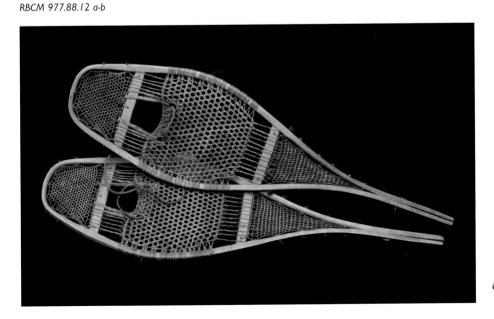

Edith Munday's skis.
RBCM 977.88.19 a-b

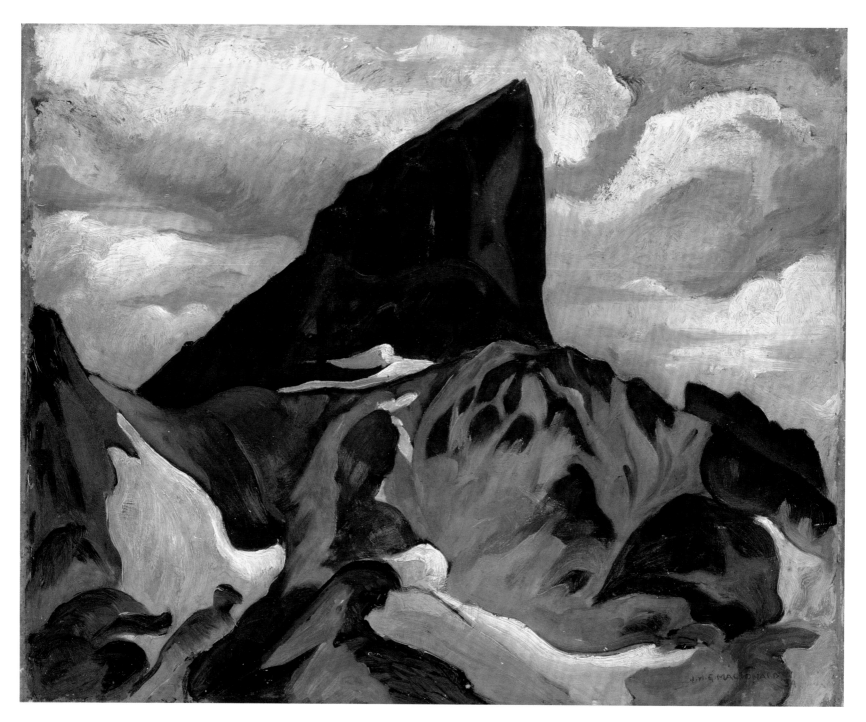

The Black Tusk, Garabaldi Park
James Williamson Galloway Macdonald, 1934.
BC Archives PDP02138

The Black Tusk rises over Garabaldi Provincial Park, a popular hiking destination near Whistler Mountain. The tusk is the remains of an extinct volcano. William Gray and his party recorded the first ascent of the Black Tusk in 1912.

James Macdonald (1897–1960) came from Scotland in 1926 to head the design department at the Vancouver School of Decorative Arts. He exhibited his landscapes at the Tate Gallery in London and throughout North America.

Chilcotin Time

by Sage Birchwater

The Chilcotin has often been dubbed a backwater of time. Separated from the Cariboo by the Fraser River, it's a high rolling plateau 1000-plus metres in elevation that extends westward to the Coast Mountains some 300 kilometres away. It's a place where the rush of history has consistently been deflected while the rest of the world raced on. It's always been that way. When you cross Sheep Creek Bridge over the Fraser River west of Williams Lake, you are well advised to park your rat-race paraphernalia and pick it up on your return. Back in the 1950s people said that coming to the Chilcotin was like stepping back in time 50 years. This wasn't said out of disrespect, more out of wonder.

When fate plunked me down in Williams Lake in the spring of 1973, it was impossible to journey from the Fraser River to Anahim Lake without coming across several horse-drawn, rubber-wheeled Bennett wagons, driven mostly by First Nations people, making their way along the Chilcotin Highway. In those days there was no pavement on Highway 20 from the top of the Sheep Creek Hill to Hagensborg in the Bella Coola Valley. There was an ambience of unrushed self-reliance.

Off the main drag these folks often lived several days' travel down narrow, rutted roads hacked through the pine and spruce forests. These roads connected a network of lush meadows, fishing lakes and hunting camps. It was there they made a living tending a few head of cattle, hunting, fishing and trapping. Some worked for wages cowboying or feeding cattle. Others took haying or fencing contracts. It was slower to get around in those days and vehicle traffic on Highway 20 was intermittent at best, but ironically people had more time.

I was fortunate to touch the flickering end of an era that predated the convenience of telephones, electricity and paved roads in that country. I spent the summer of 1978 working for a pioneering couple, Bern Mullins and Annie Nicholson, both in their early 70s, who lived according to the old ways in the West Branch Valley south of Tatla Lake. They scratched out a living raising a few head of cattle on property they homesteaded in the 1930s, and they did so without the modern conveniences we consider essential today.

They flood-irrigated their hay fields using shovels and garden implements to direct the flow of water in ditches, and cut their hay using antiquated equipment Bern managed to keep running in his outdoor shop next to their cabin. He had a big vice bolted to one metre-wide stump and a big anvil bolted to another. The work area was sheltered from the weather by the spreading branches of an immense fir tree. Annie improvised by dragging a horse-drawn dump rake behind her Toyota Land Cruiser, tripping the dump with a rope she pulled by reaching out the car window.

Up closer to Tatla Lake an old Tsilhqot'in couple, Emily Lulua and Donald Ekks, lived in a small cabin next to a spring. They lived gently, the old-fashioned way on land that wasn't designated federal Indian reserve nor was it surveyed provincial fee-simple property. Government officials left them alone, mostly because they were so authentic, living in a customary Tsilhqot'in manner, moving with the seasons, hunting, fishing and gathering. The closest First Nations community was Redstone some 70 kilometres away, so Donald and Emily were anomalies in a predominantly white community.

Donald and Emily didn't own a vehicle but local people gave them rides when they saw them standing beside the road. They had a second small cabin on the shore of Cochin Lake, some 20 kilometres further up the road toward Tatlayoko Valley. There they set their net in the lake for trout and suckers, and dried their catch on racks next to an open fire. They also tanned the hides of deer and moose into butter-soft buckskin, and Emily sewed the leather into gloves and moccasins and other articles of clothing.

In late summer they set up camp beside the Chilko River near Henry's Crossing, some 30 kilometres to the east past Choelqoit Lake, and dried the migrating sockeye and spring salmon that younger members of their family snagged out of the river.

Donald and Emily's camp at Cochin Lake was only a kilometre or two off the publicly maintained road, but it truly was a journey back in time. Idling through the mud bogs, over roots and around projecting rocks and boulders, easing over a corduroy of poles thrown into the soft mud to give traction, was like a forced meditation. Time almost stood still. Then in the silence of the throbbing truck motor, Emily would suddenly interject to Donald in her Tsilhqot'in language: "Gugh!" as a snowshoe rabbit darted across the road through the underbrush.

It was a simple joy to be sure, just a breath away as you entered their world, yet a century back in time.

Sage Birchwater is a 35-year resident of the Cariboo Chilcotin. In the 1990s he worked with the elders of the Ulkatcho First Nation to write three books on Ulkatcho culture and history, and in 1995 published a biography called Chiwid. *He now writes for the Williams Lake* Tribune.

Emily Lulua at Cochin Lake.
Sage Birchwater photograph

Swannell holding a pair of "bear paws" snowshoes, 1910. He wore these snowshoes when standing at his surveying equipment and the long snowshoes (on his feet) for travelling.
BC Archives I-67807

Charting the Land

*H*ave you seen surveyors on the side of a road, one holding a pole and the other, quite far away, sighting the pole with a scope on a tripod? That's what Frank Swannell and his crew did every summer from 1910 until into the late '30s. But they usually had no roads to travel by.

That didn't bother Swannell and his men. They followed trails made by First Nations traders, by pioneers or prospectors – or they blazed new ones. They climbed mountains and forded rivers, they paddled up streams and across lakes (often in canoes or on rafts they made themselves), and they carried their supplies on horseback or on their own backs.

In this way, Swannell surveyed and mapped huge areas of northern and central BC. He has a river, a mountain and a range of mountains named after him in the areas he surveyed.

Better prospects in BC

Born in Ontario, Frank Swannell (1880–1969) came to BC in the late 1890s. He intended to head north to Yukon's Klondike to prospect for gold, but instead found good work with a land-surveying company in Victoria. Ten years later, he struck out on his own as a private contractor. The provincial government kept him surveying northern and central BC for the next three decades.

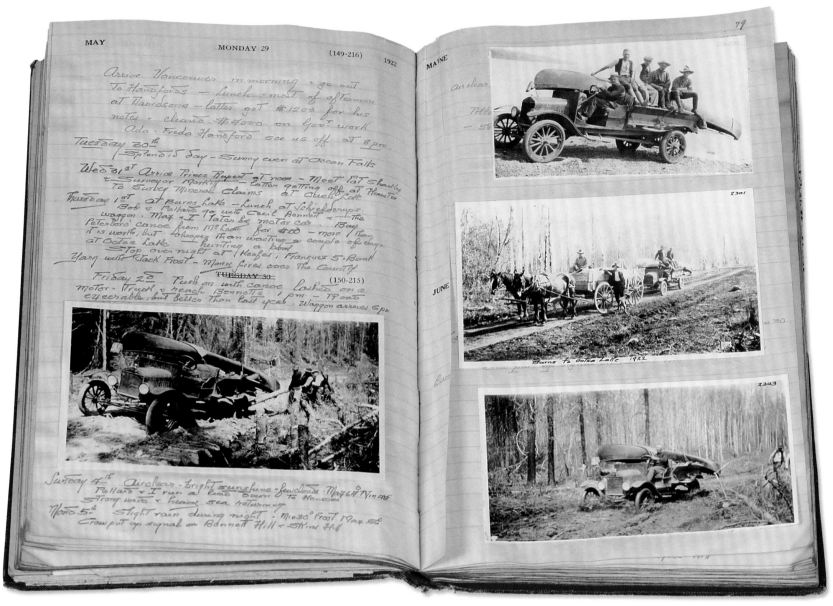

Pages in Frank Swannell's survey diary.
BC Archives MS-0392

Swannell (second from left) and his crew share coffee with an RCMP officer (left) at their camp on the upper Nechako River in June 1922.
BC Archives I-58863

A Photographic Artist

Girl on a beach scene,
taken in the Maynard studio.
Hannah Maynard photograph; BC Archives F-06712

*H*annah Maynard opened Victoria's first photographic studio in 1862. She called it "Mrs R. Maynard's Photographic Gallery". The "R" stood for Richard, her husband. In those days, a woman running a business raised some eyebrows and turned a few noses away. Before too long, though Hannah Maynard earned respect in the community for her photographic portraits. When she retired in 1912, she claimed to have photographed every person that lived in or passed through Victoria.

She also experimented with photographic techniques, such as multiple exposures and photo-sculpturing. She sometimes photographed herself in her artistic creations, usually in two or more poses, often with children and previously made photographs of deceased relatives.

The Maynards

The Maynards came from England to BC via Ontario. Richard was a shoemaker and had a shop in Ontario, but he seemed to prefer doing other things. The gold rush first attracted him to BC in 1859, and he left Hannah and the children in Ontario, while he searched for fortune. Three years later, he brought the family to Victoria, where they settled for good.

While in Ontario, Hannah had learned how to create photographs, a new technology at the time. In Victoria, the Maynards set up side-by-side businesses – Hannah's photographic studio and Richard's shoe shop.

Richard soon learned photography from Hannah and gave up shoemaking. The Maynards created thousands of images of people and places in Victoria and throughout BC. Hannah stayed close to the studio creating portraits, landscapes and experimental imagery, while raising the children. Richard took government contracts to travel around Vancouver Island and the mainland – even to Alaska – making landscapes and official photographs of record.

Amor de Cosmos (1825–97), about 1873.
Born William Smith in Nova Scotia, he moved to California in 1851, where he changed his name to Amor de Cosmos ("lover of the universe"). He came to BC in 1858 and started the British Colonist newspaper in Victoria (see page 76). Later, he entered politics, advocating responsible government and union with Canada. Following BC's entry into Confederation, he became BC's second premier (1872–74), after John McCreight.
Hannah Maynard photograph; BC Archives A-01222

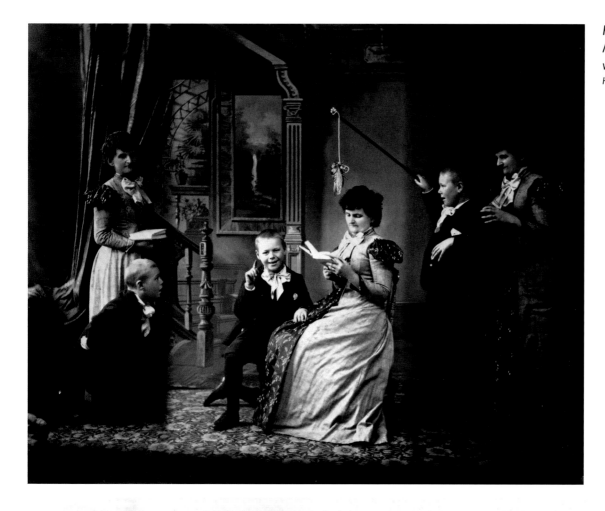

Hannah Maynard and her grandson, Maynard MacDonald, in one of Hannah's experiments with composite photography, about 1895.
Hannah Maynard photograph; BC Archives F-02851

Stereograph of bicyclists in Beacon Hill Park, Victoria, about 1895. When viewed through a stereoscope, this would appear as a three-dimensional image. Notice that everyone is stationary. In the early days of photography it was difficult to make pictures of moving objects, because of the length of time needed to expose a glass plate to light.
Hannah Maynard photograph; BC Archives F-06693

Zeffie Crease's album of tintype portraits, 1878.
BC Archives 198202-26, file 48

Nineteeth-Century Facebook

Even in the early days of photography, like the 1870s, a girl could keep pictures of all her friends in one place. She'd buy a specially-made album for tintype photographs. A tintype is an early method of creating a photograph on a thin sheet of enamelled tin.

Josephine "Zeffie" Crease made this album in 1878, when she was 14 years old. It holds the happy faces of her friends and loved ones, as well as one of herself (top left). Zeffie attended school in her home town of Victoria, but many children of her social standing were sent to boarding schools (usually in Britain) – a tintype album might help them feel less lonely while away. For Zeffie, the album was her way of collecting memories.

Have you ever traded school photos with your friends, or posted them on a social network site? The tradition goes back almost to the beginning of photography – and tintypes led the way.

Group of tintype portraits, possibly assembled by Zeffie Crease.
BC Archives 198202-26, file 28

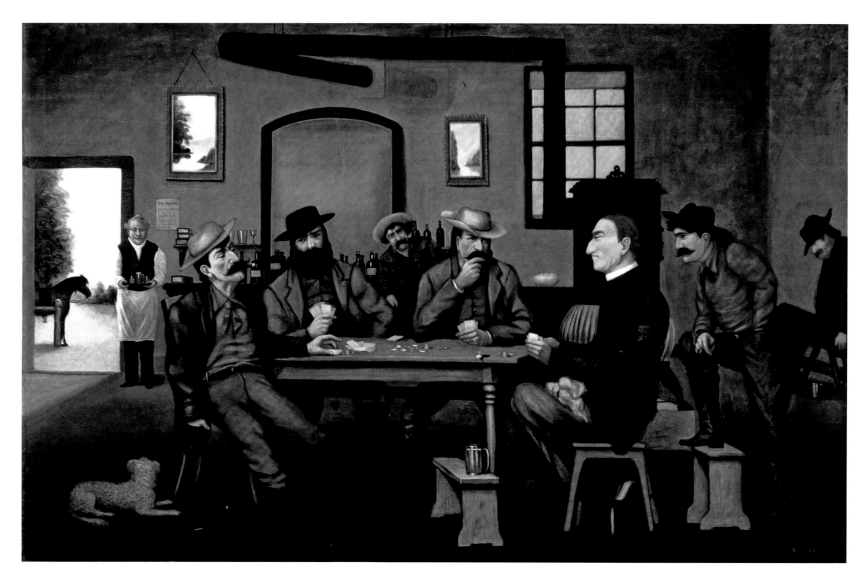

Slim Jim *or* **The Parson Takes the Pot**
Rowland Lee, 1892.
BC Archives PDP2292

Who's the title character in this painting? Is he the priest or the man opposite him? Was Slim Jim a real person or did the artist make up the name? If Lee ever told anyone why he called the painting Slim Jim, the story has been lost.

The alternative title, *The Parson Takes the Pot*, was a name Lee's daughter gave to the painting. At least we know who has the winning hand.

The Mystery of Slim Jim

*W*hy was this painting hung in a hallway of the newly built BC legislature? How could a huge painting about gambling in a saloon hang in the sober halls of government for almost 80 years? Especially when one of the gamblers appears to be a man of the cloth.

A Victoria saloon owner may have commissioned artist Rowland Lee to paint a saloon scene to hang over his bar. For some reason the deal fell through, so maybe Lee offered *Slim Jim* to someone in the newly opened legislature. Perhaps the bare walls needed some decoration ... and the price was right....

It's a tenuous story, at best. All we know for sure is that the painting hung in the hallway outside the legislative library from about 1898 to the late 1970s.

Raise a Glass to Ratz

*H*ere's to Francis Rattenbury, the architect of many grand projects in BC and western Canada. Three cheers for Ratz, for his designs of Victoria's Empress Hotel, the Vancouver Courthouse, and his crowning achievement, BC's legislative buildings, which opened in 1898. Many happy returns....

But Francis Rattenbury took a wrong turn on the road of his life. An affair with Alma Packenham ruined his marriage and social standing in Victoria. He married Alma and fled back to England in 1930. But just a few years later, he fell victim in another lovers' triangle.

A moment of silence, please. Let's remember Francis Rattenbury for his beautiful buildings.

Rattenbury's wine glasses, inscribed with "FR", 1920s.
RBCM 981.137.1a-b

Francis Rattenbury, in the dark suit, observes the moving of the Birdcages as preparations for construction of BC's new legislative buildings begins, 1893.
BC Archives A-02574

Francis Rattenbury's legacy, the British Columbia legislative buildings.
Mark Reber photograph

A modern tragedy

Imagine how a public affair with a younger woman – 30 years younger – could affect one's social status in Victoria in the 1920s. In his mid 50s, Francis Rattenbury divorced his wife and married Alma Packenham, who had already been married twice before. The scandal forced the Rattenburys back to England. And there things just got worse.

The great difference in their ages began to strain their relationship. Francis depended more and more on whiskey to get him through the days, and Alma relieved her boredom by taking on a lover. George Stoner was the family chauffeur and, at just 17, had much more energy than old Francis. Stoner moved into the house, and Alma's affair must have been obvious to Francis, even through the whiskey haze.

Stoner feared that Francis would realize what was happening and fire him. One day, in a jealous rage, he found the old man sleeping in his chair and clubbed him to death.

After a sensational trial, Alma was acquitted and Stoner sentenced to hang. But the public blamed Alma for inciting her lover to commit the murder. Unable to bear the grief and shame, Alma Rattenbury stabbed herself through the heart just four days after the verdict. After a public petition, the Crown commuted Stoner's sentence to life in prison; a model prisoner, he gained release in just seven years. George Stoner lived to be 83; he died on the same day, exactly 65 years after he murdered Francis Rattenbury.

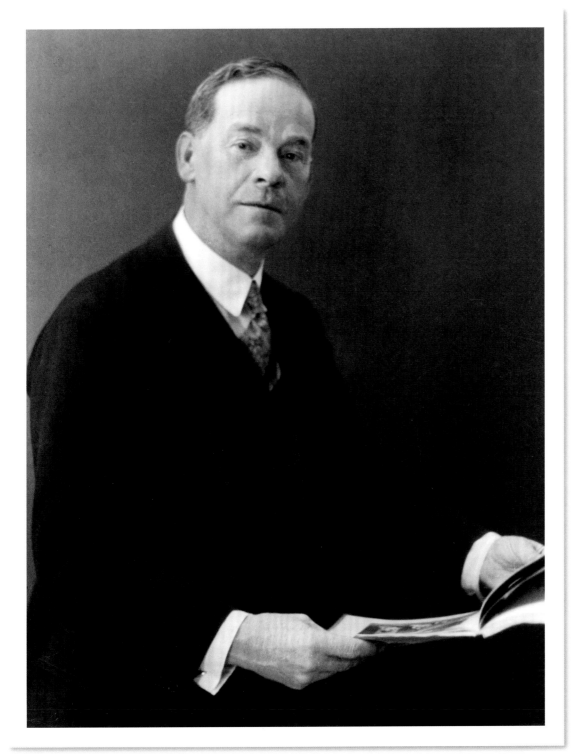

Francis Mawson Rattenbury (1867–1935) in 1924.
H.U. Knight photograph; BC Archives F-02163

Paul George

by Keith F. Broad

His slight frame bends forward as he peers through the living room window of his small home overlooking Burrard Inlet.

"From here you could just see two houses on top of that hill there, and that was it." His gentle voice bubbles up from within a congested chest. He blinks watery eyes, and focuses on the Dollarton Highway just below his home.

"When the new highway went through to Squamish, boy was there ever a mess down there – cars going off the road and every darn thing!" His gaze shifts again and settles on the sandy flats exposed by the inlet's receding tidal waters. Pools of water, in a wasteland of dried kelp and rippled sand, reflect immutable overcast skies.

"We used to dig clams out there. And mussels too. We used to get a whole bunch and take them to the fishers on Campbell Avenue. We got twenty cents a pound sometimes – but mostly it was five or ten cents." A child-like spirit creeps into his voice; his eyes glisten playfully. "We picked up a bunch one time and brought them home. My mother cooked them. Holy smokes they were good too! She was surprised – she had never ate them before either." His voice returns to a bubbly whisper. "That was 40, maybe 50 years ago."

"Our house was all wood, with wood shingles on the roof, and we had a wood stove and most of the time the pipes weren't any good. In the summertime the roof would catch fire. The pipe from the wood stove my mother used to cook on had holes in it, and the roof would just start burning. We'd have to be outside most of the time watching it. Then my brothers and sisters and me, we'd climb up on the roof and put the fire out. The neighbours too, if they were around – they'd come and help. That'd happen about ten times a week."

Paul George, nephew of the famous Chief Dan George, grew up, raised a family and continues to live in an area not much larger than Stanley Park. His mother and father, brothers and sisters, along with countless ancestors lay at rest only a stone's throw from his home.

"I went to school at St Paul's Residential School in North Vancouver, near the big church. I was nine. That was old for starting school. My parents were more or less forced into sending me there. I used to have a problem – I had bad kidneys and used to wet the bed. I was made to walk through the girl's yard with my wet sheets on my head and hang them up there. I can laugh at it now, but at that time it wasn't funny.

"I used to behave myself – I was a good boy. Besides, I was too scared and my hands are too soft! Lots of guys used to get the strap. If they were doing something in school, they'd get the strap and in the afternoon they'd run away. Then, when they come back, they'd get the strap on the back end. Some guys had tough hands. There was three guys I knew who used to go there – put their hands out and 'bang', then put the other out and 'bang'. They never yelped out or nothing. Ten times on each hand. Gee, tough hands! That strap was about four inches wide and two feet long – a big chunk of leather!

"I liked to learn though. There was quite a few good teachers actually."

Children stayed at the school from Monday to Friday and were allowed to go home on the weekends. But families were seldom together, because the school only allowed the children to go home every other weekend, the boys alternating with the girls.

The children were forbidden to speak their native language at residential schools. "It was all right for the teachers and supervisors to speak their language – they all spoke French, but they wouldn't let us speak our language. I spoke English from birth, so did my parents. They went to residential schools too and were forced to speak English, but before they died, they used to talk amongst themselves, you know, in their own language."

"My father used to tell me some of the stories after I got older. But I got to thinking he is just telling me these stories because they sound good. He used to tell me all kinds of stories, like the big sea serpent that stretched across the Inlet up here. Nobody could go up or come down from it – and it was real. I don't know. It was possible, but they say in Squamish they had a sea serpent. Someone crawled up on the sea serpent and stuck a spear up near where the heart was supposed to be. Then he kept on going until he got up to the head part. That's when it took off, and went up over the mountain, and for years that place was just nothing but rock. All the bushes had died when it went over, but it's all grown over again now. So it is up there. I think it is."

Paul's voice tires. His breath rattles deep within his chest. His long thin body sinks deeper into the worn sofa. His seemingly endless stamina flows out and into the world around him, and into the steel blue waters of Burrard Inlet.

"Our ways won't get lost with me, anyways." he breathes, "All you gotta do is ask, and I'll tell ya. I'll tell ya what I know anyways."

Keith F. Broad is an artist in a variety of media; his work can be seen at www.keithbroad.com. He dedicates this story, "To my wife, Cris, the love of my life."

Claude Paul George
Keith Broad, 1995.

Workers Leaving a Factory
Ina Duncan Dewar Uhthoff, 1940s.
BC Archives PDP05543

During World War II, Canada needed ships for the navy. The Victoria
Machinery Depot added a second factory to produce corvettes,
tankers and supply ships.

 Ina Uhthoff (1889–1971) settled in the Kootenay region in 1919,
then moved to Victoria in the mid 1920s. She helped establish the
Art Gallery of Greater Victoria and spent several years as arts
reviewer for the Victoria *Colonist* newspaper. Her studio on
Wharf Street overlooked the dockyards.

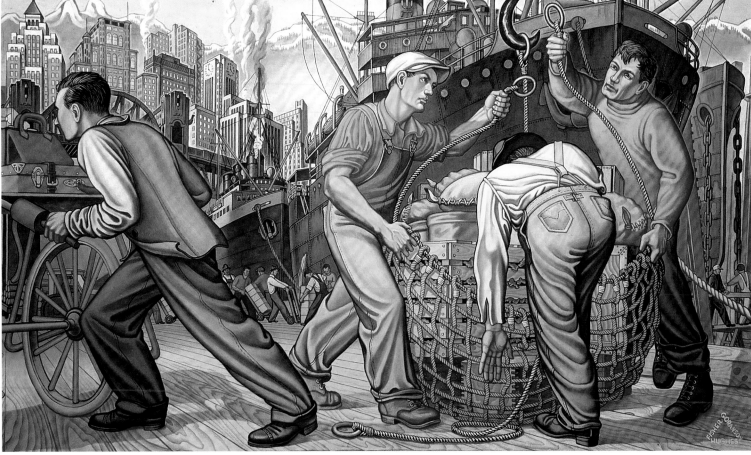

Art for the Province

In 1939, BC took part in the Golden Gate International Exposition in San Francisco, California. The province hired three young artists to paint 15 murals for the BC pavilion. This project, called Art in Action, had Paul Goranson, Orville Fisher and E.J. Hughes paint the murals on the walls while the pavilion was being built.

The artistic trio painted scenes that represented British Columbia for the world to see. Unfortunately, the outbreak of World War II caused the Golden Gate Exposition to close after only nine months. The pavilions and their murals came down, early casualties of war. Lucky for us, the trio painted smaller versions of the murals for display in BC.

Industry
Orville Fisher, Paul Goranson
and E.J. Hughes, 1939.
This two-piece mural shows dockyard and
railway workers in Vancouver's harbour. It's one
of the smaller versions that stayed home in BC.
BC Archives PDP02285 and PDP02286

The British Columbia exhibition at the Golden Gate
International Exposition, San Francisco, 1939.
BC Archives G-02178

A Blacksmith Forges Olympic Pride

by Bonnie Kent

*G*eorge (Geordie) Third had no master plan for the growth of his blacksmith shop. After immigrating to Canada from Aberdeen, Scotland, in 1910, he made his way across the country. When he arrived in Vancouver, he walked across the street from the train station to a blacksmith's shop on Main Street – and there he stayed. That year he purchased the shop for $50 and later joined up with William Dundas to form Third & Dundas. They specialized in shoeing heavy horses and repairing wagons and farm machinery.

Geordie paid his employees every day out of his pocket. After everyone had been paid, if there was any left over, he had made a profit. During the hard times of the 1930s he often got paid with a sack of potatoes or the odd chicken. If they did repairs on fishing boats they often got paid in fresh fish. Once they got a 200-pound frozen tuna that couldn't be taken home whole so they cut it up with the bandsaw and gave away the pieces. If there was any extra food, Geordie's son, Bruce, would give it away in the neighbourhood.

Even at a young age Bruce could always be found around the shop. Geordie made his son a small hammer so he could learn the trade. "Little Hammer" was a handy helper. One of his jobs was to run across the street to the Ivanhoe Hotel and buy a wooden bucket of beer that would sit by the blacksmith's forge. He also went with William Dundas to the experimental farm in Agassiz to shoe horses. The shop worked seven days a week and Bruce was lucky to get off one Saturday morning a year to watch the Pacific National Exhibition parade. Even in retirement he loved to go to the PNE to see the Clydesdales.

In 1946, William Dundas retired and the company's named changed to Geo. Third & Son. The company grew and moved more into welding and structural steel, specializing in building service stations, tank farms and bulk loading facilities. Expo '86 was a boom of exhibition halls and pavilions. The forge was still fired up and no job was too small. When it was time Bruce's sons, Brett and Rob, joined the company – the third generation at Third & Son.

Bruce died in 1999, just before being able to celebrate 90 years in business. Brett and Rob Third have continued the legacy of their

father and grandfather. Geo. Third & Sons continues to thrive in the Lower Mainland, closely linked to the city it grew up in.

Recent work projects include General Motors Place and two event sites for the 2010 Winter Olympics: the speed skating oval in Richmond and the ski jump in Squamish. The Olympics will not only show Vancouver to the world but will also mark 100 years of quality steelwork by a small blacksmith shop that started in the heart of the city.

Bonnie Kent is a retired teacher and the eldest granddaughter of Geordie Third. As a teenager, she enjoyed spending time with her grandfather at the blacksmith shop.

Geordie Third in his shop, about 1910.
Third family collection

Geordie and William stand below their last names, about 1910.
Third family collection

Farming the Ocean from Sointula

Working in a Vancouver Island coal mine in the late 1800s would make just about anyone dream of a better life. Some Finnish miners decided to make their dreams a reality. In 1900, they enlisted Matti Kurikka, a journalist and political philosopher, to help them establish the Kalevan Kansa Colonization Company, and by 1902 the company founded Sointula, a communal utopia on Malcolm Island, just off the coast from Port McNeill.

They intended to be farmers. Malcolm Island appeared to have an abundance of land suitable for agriculture. But they soon discovered that the island did not suit farming, and the company went bankrupt in 1905. So the people of Sointula took up fishing – and they found the sea much more productive.

Sointula fishers earned a great reputation for their knowledge of the sea, their productivity and their innovations. In 1931, a Sointula boat builder invented the gill-net drum, an important contribution to west-coast fishing.

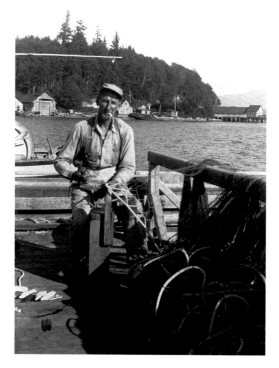

Alec Pouttu repairing a seine net. Nets are essential tools in fishing, and so it's important to keep them in good repair.
RBCM 984.33.2a

Net-mending bench
Alec Pouttu's made it more for decoration than function, but it still works. The upright fish spread the net, exposing flaws in the mesh, making it easy to repair.
RBCM 984.33.1

The Lighthouse Keeper's Settee

Captain Richard Carpenter (1841–1931)

"My great grandfather, Captain Carpenter, was a chief in his day and kept the potlatching going. When any of the chiefs [in Bella Bella] were going to put up a feast for a potlatch, they would ask him to build objects for them to give away.

"He was especially known for his boat building skills. He built many canoes, including a very big one that he gave to a Tsimshian family as part of his daughter's dowry and is now in the American Museum of Natural History. He also built sailing schooners just by copying the sailing ships, asking how such large boats were built and running his hands along a boat to see how it was constructed. In all, he built four, maybe six schooners. They were used for Sea Otter hunting. Two of them were still at Bella Bella when I was a kid.

"He had different Heiltsuk names, including *Dukwatia* [*Du'k͟ʷlwayella*] but most people called him *Wúx̌vúas*, a name that refers to the sound of a fog horn, because he was the lighthouse keeper at Dryad Point. My father, Basil Carpenter, and his brothers spent quite a bit of time with Captain Carpenter when they were home from school during the summer. He built them a little canoe that they paddled back and forth to the lighthouse. My dad told me that Captain Carpenter was quite an eccentric character."

— Steve Carpenter, Bella Bella, 1999

A Heiltsuk man named Captain Richard Carpenter ran the lighthouse for a while at Dryad Point, just north of Bella Bella. He took the job in about 1900, for a dollar a day.

Captain Richard Carpenter was also a Heiltsuk chief, boat builder and artist. He had some of his carvings with him at the lighthouse, including a large chief's settee. Today, museums around the world display Captain Carpenter's carvings.

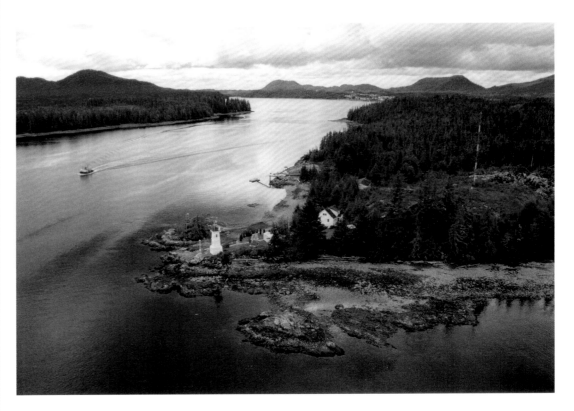

Dryad Point in the 1990s, with Bella Bella in the background.
Chris Mills photograph

Heiltsuk settee at the Dryad Point lighthouse, 1900. The man standing behind it may be Captain Carpenter.
C.F. Newcombe photo; RBCM PN 2333

Chief's Settee
Captain Richard Carpenter, Heiltsuk, late 1800s. Carpenter carved his family crests into the settee, Eagle on the back and Killer Whale on the sides. C.F. Newcombe (see page 119) purchased the settee for the provincial museum in 1911; he bought it from a man who had acquired it from the Bella Bella lighthouse in about 1900.
RBCM 1856

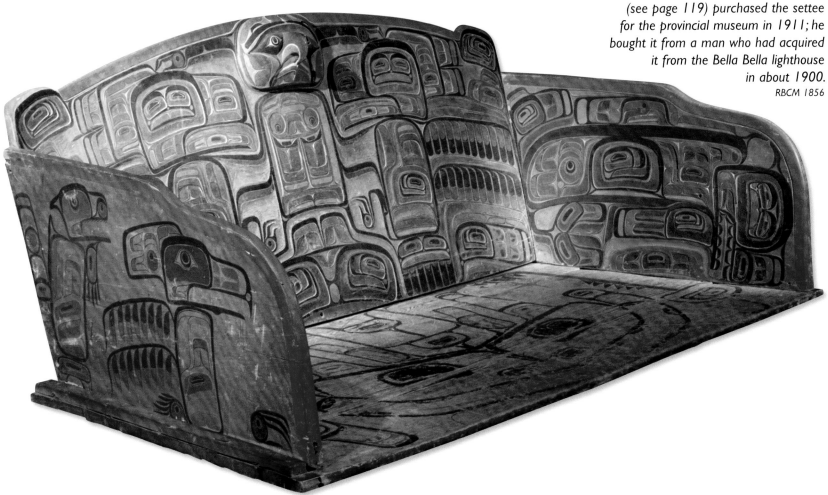

Wealth, Prestige and Generosity

Serving dishes display the crests of a chiefly family and are part of the property associated with a specific big house. A family brings out these dishes at feasts to show the wealth, prestige and generosity of the chief.

In 1912, anthropologist Charles Newcombe visited the Kwakwaka'wakw village of 'Mimkwamlis on Village Island and purchased these feast dishes. He photographed the dishes inside the house before removing them, and recorded the name of the house as *Odsistalis*, which means "he [the owner] is a very rich chief". The house was built by Harry Hanius and *Ma'xwa*.

One of each pair of feast dishes purchased by Newcombe in 1912: Killer Whale (above) and Wolf.
Kwakwaka'wakw; RBCM 2014, 2015

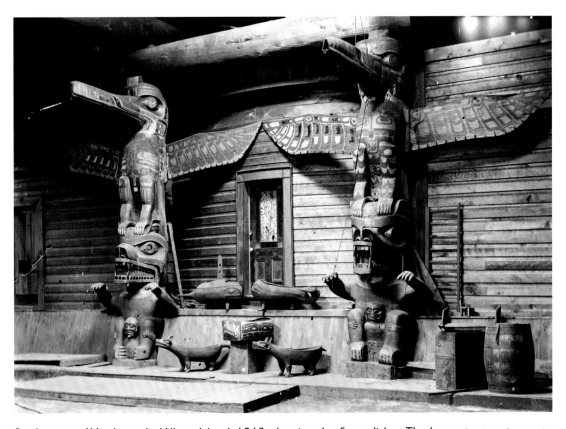

Big house at 'Mimkwamlis, Village Island, 1912, showing the feast dishes. The house posts represent Huxwhukw (Cannibal Bird) and Grizzly Bear, crests of the chief. The birds' beaks and the bears' forepaws could be moved with strings during the dance ceremony at important feasts.
C.F. Newcombe photograph; RBCM PN 29

A dedicated collector

Dr Charles Newcombe's personal interests led him to become a collector of First Nations objects. Born in Newcastle, he began his professional career in England as a medical doctor and psychiatrist. He came to BC with his family in 1889, settling in Victoria. Newcombe became BC's first psychiatrist, but he spent most of his time pursuing his interest in natural history. He had gained considerable wealth from investments in Britain, so he could afford to indulge in an amateur career – and BC offered many opportunities.

Newcombe amassed a large natural history collection before his interests turned to ethnological collecting. He collected First Nations objects for George Dawson (Canadian Geological Survey) and for the Field Museum in Chicago; then he began purchasing them for the new provincial museum, as he did these feast dishes.

Charles Newcombe contributed greatly to the historical record of British Columbia. He organized the provincial museum's ethnology collection in 1909, and upon his death he donated his own natural history and ethnology collections to the museum and the people of BC.

Charles Frederic Newcombe (1851–1924) in 1905.
BC Archives A-02370

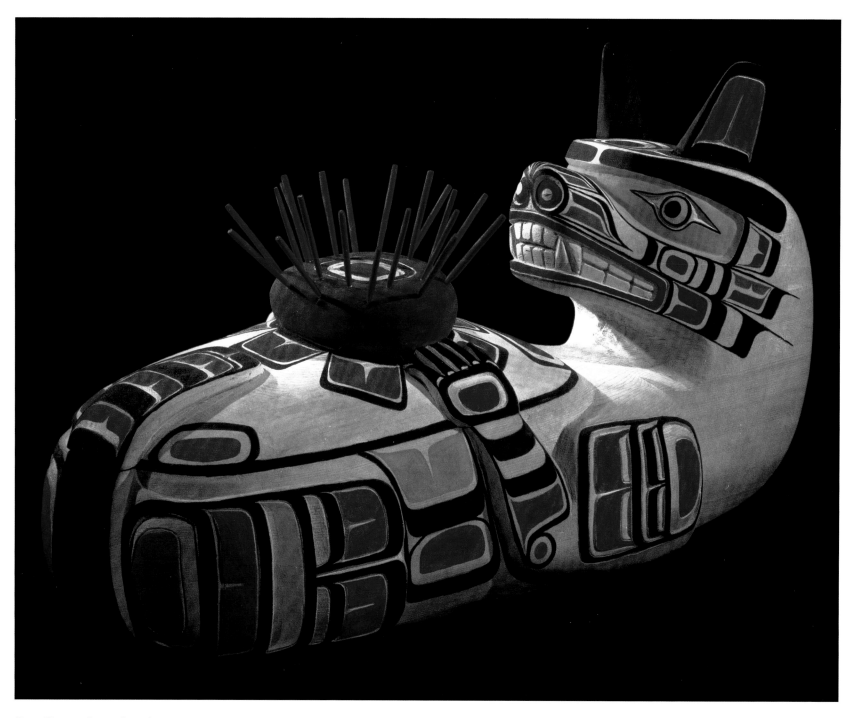

Sea Otter feast bowl

Henry Hunt, Kwakwaka'wakw, 1980.

When Hunt made this feast bowl, recovery programs had re-established Sea Otters on parts of
BC's coast. He posed the otter in its natural eating position, holding a sea urchin on its chest, and used
Kwakwaka'wakw artistic conventions to show the animal's cultural importance to First Peoples of the coast.
RBCM 16613a, b

Gone and Back Again

Sea Otter (Enhydra lutra).
Jared Hobbs photograph

Sea Otters completely disappeared from BC's coast for a while, but they're back now.

The otters did not leave willingly. They were slaughtered – wiped out – all because people loved their beautiful, luxurious fur. In the 1800s, a single Sea Otter pelt that sold in Asia was worth a sailor's annual wages. Fortunes could be made if the hunting was good. Hunters caught, killed and skinned Sea Otters by the thousands, until none remained.

Luckily, the hunters had difficulty killing all the Sea Otters in more remote northern areas. The otters that now live along the west coast of Vancouver Island are descendants of a small group relocated from Alaska.

Almost another swan song

The Trumpeter Swan may look a little awkward on land, but BC's largest waterfowl glides on still water with the grace of a ballerina and flies with elegant ease. Large flocks can be seen every winter in southwestern BC around marshes, lakes and ponds. When you see so many Trumpeter Swans together, it may be hard to believe that this majestic bird barely survived extinction.

Commercial hunting and habitat destruction from construction projects in wetlands claimed all but a few swans. In the early 1900s the North American population had fallen to less than 150 – almost the point of no return.

But it did return, thanks to serious conservation efforts. Curbs on hunting and the preservation of swan habitats have brought Trumpeter Swan populations back to healthy numbers. This bird's success shows that recovery programs can work.

Unfortunately, a serious threat remains. Trumpeter Swans feed by grazing on plants growing on shallow lake bottoms, which makes them susceptible to poisoning from lead shot. After many years of hunters firing their guns over water, millions of lead pellets have accumulated in the mud below the surface, and now hundreds of swans are dying from lead poisoning every year. Conservationists are trying to locate and remove lead from wetlands where swans gather; but, as you can imagine, it's not an easy task.

Trumpeter Swan (Cygnus buccinator).
Ralph Hocken photograph

Life Cycles

"The task of my generation is to remember all that was taught, and pass that knowledge and wisdom on to our children."

— Susan Point

Susan Point's painting, *Survivor*, portrays the life cycle of the salmon. The salmon faces in four directions: swimming down the river, in the ocean, up the river to spawn, and then dying where it began its life. The painting also has a personal meaning to the artist, of loss and survival.

Traditional Coast Salish designs are made by carving away negative spaces to create a balance with positive spaces. Susan Point adapted this style to paint on canvas. She has based much of her work on the designs from objects traditionally made or used by Coast Salish women. Since she began her career in the 1980s, she has found the spindle whorl a great source of inspiration.

The image carved into the side of a spindle whorl often has a spiritual meaning for the weaver. In Coast Salish culture, the design can be intentionally ambiguous, because the meaning is personal and private, similar to this painting.

Coast Salish spindle whorl, possibly made in the early 1900s.
RBCM 10352

Survivor
Susan Point (1952–), Coast Salish, 1992.
RBCM 19571

When Fish Owned the Capilano

by Gail Mackay

*T*here was a time, in the recent past, when you could catch a fish in any of the creeks and rivers on the North Shore. The runoff provided well for the land and sea animals, and also for the men who fished the Capilano River every day after work to catch a fish for the family dinner. The Capilano River was the fulcrum of our lives, and we lived by its seasons.

My sister and I loved a swim in the salmon pools in the summer, even though the water could make you hypothermic. After a swim, we would sit on the hot granite boulders, drying and shivering, munching new-crop Mackintosh apples, and sharing a nickel cream soda which we had bought at the Red-and-White.

The grand finale of our childhood summers was the spectacular Capilano River salmon run.

Just as the poplar trees turned August-yellow, and began to drop their leaf-boats in the rushing water, the salmon began to gather at the mouth of the Capilano. The first few scouts made their way into the mid-stream rapids, and very quickly the others followed, passing the last of the feeding harbour seals.

The run not only made it impossible to swim in the river, but you couldn't even wade in the shallows – there was simply no place to balance. Silver bodies moved side by side, forward, upward, jet-propelled, substantial and enormous, their flanks flew through the air and smashed into the rapids. There were so many salmon in the watercourse that many jumped onto the gravel at the river's edge. When we stood too close to the surge, we would be splashed by passing fish.

We quickly learned to leave our favourite swimming holes to the salmon. I'd been smacked more than once by a large speckled fish tail, and I still remember the sensation of a huge salmon, red-nosed and roaring and slapping, jumping across my bare back. Black Bears came quickly to the river to take their share of the harvest. We were not afraid to be near the bears – they simply ignored us.

And still the fish came, dilating and engorging the water with their bodies. We came to the river every day as school approached, just to watch and marvel at the run.

Then, gradually, the eddies began to clear, become free of the struggle, and the river would soon be quiet. We knew that the salmon would be high in the mountains, in the clear, shallow water where they laid millions of wonderful eggs in the gravel.

The river began, then, to wash away the migration. Unbelievable quantities of salmon carcasses rolled and floated by. The bears had gone, and the salmon pools reeked of rotting fish. We looked forward to the days of heavy rain that would raise the level of the water and then scrub down the river's banks and rocks.

Silently, secretly, the river rose and fell throughout the winter. Wet snow in January placed white meringue tams on the boulders, and cold nights left an ice collar as sharp as a saw blade along the river bank. The melting snowpack in the mountains signalled the change to spring. With the first smell of sweet pitch in the air, and the first uplift of warm sea breeze in the river valley, a kind of magic graced the Capilano River.

Filling the river, from surface to gravel bed, lovely schools of silver minnows flashed like sequins below the clear surface. They responded to our shadows, as if we had touched them with electricity. They rolled like a constellation and chased each other, always facing upstream.

The tiny fish grew every day, and eventually became big and strong, leaping out of the water to pick off the evening bugs hovering above. Then we could see that there were fewer salmon in the river. They were making their way to the mouth of the river where they would disperse into the Strait of Georgia.

All those magnificent summers watching the silver salmon run in the Capilano River ended with the building of the Cleveland Dam.

An incurable British Columbian, Gail Mackay has written many articles about living on the coast. She spends much of her time doing charity work, sewing and quilting.

Entrance to Capilano River
Attributed to Josephine Crease.
BC Archives PDP02996

Capilano Suspension Bridge, 1905.
BC Archives A-07458

Coast of Vancouver Island, Straits of Juan de Fuca
Alexander John Ballantyne, about 1865.
BC Archives PDP0167

Alexander Ballantyne (1845–1878) joined the Royal Navy when
he was 14. He served as a lieutenant aboard HMS *Sparrowhawk* in
the Pacific from 1865 to 1870. Trained as a naval artist, Ballantyne
painted precisely and accurately. This work shows Songhees people
in a canoe, and looks across Juan de Fuca Strait to the Olympic
Mountains in Washington.

From Axe to Chain

\mathcal{W}hat would a logger in the late 1930s have thought at first sight of a chainsaw — especially a beast like this one? For 70 years, since commercial logging began in BC, lumberjacks brought trees to the ground with axes and saws powered by their own muscles. How could this unwieldy machine do better?

Well, you still had to make the undercuts with axes, but the two-man chainsaw could straight-cut through a trunk in minutes. It could also buck logs much quicker than a manual saw.

In logging operations throughout the 1940s, the thudding of axes got drowned out by the fierce buzzing of chainsaws. And ever since, the chainsaw has been the faller's primary tool.

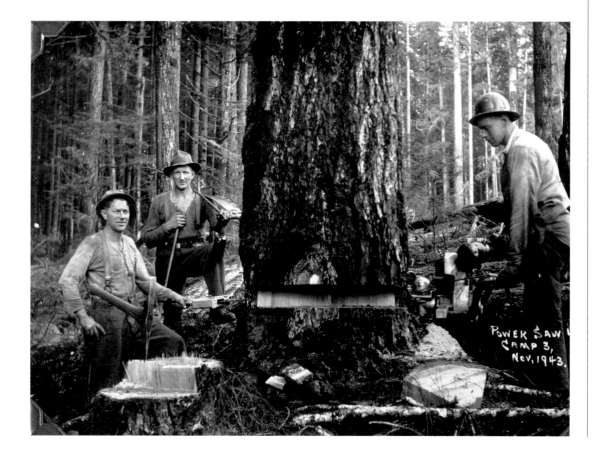

A new buzz in BC

Power saws made by the German company Stihl dominated the BC market in the late 1930s. But the declaration of war in 1939 erased Stihl's patent protection on the chainsaw. This allowed BC companies to use the technology to create their own designs. In 1945, Burnett Power Saws and Engineering began producing saws in Vancouver, including the B-6 two-man chainsaw shown on the next page.

Two-man chainsaw cutting through a tree near Cowichan Lake, Vancouver Island, 1943.
BC Archives E-02892

Keeping warm and dry

After a hard day's work in the forest, the next best thing to a good meal is a warm place to rest. This stove may have been designed for cooking, but it was fired up to heat a bunkhouse for loggers and other workers far from home.

The stove also worked for drying wet clothing – if you could stand the smell. In 1913, Fred Lade wrote about his visit to a mining camp at Anyox: "The Labourers would hang their dirty socks around that stove to dry without washing them. God, what a stink. I don't mind smelling like a horse or bunking in a horse stall but those shacks were just too much for my stomach."

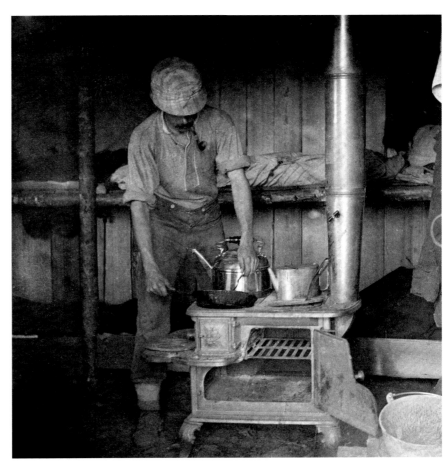

Cooking in a North Vancouver bunkhouse, 1895.
BC Archives I-60791

Albion bunk stove.
RBCM 980.172.1

Burnett model B-6 two-man chainsaw, 1945. The chain assembly could be rotated 90°. One logger controlled the power while the other held on to the other end and pulled it through the trunk.
RBCM 971.61.1478

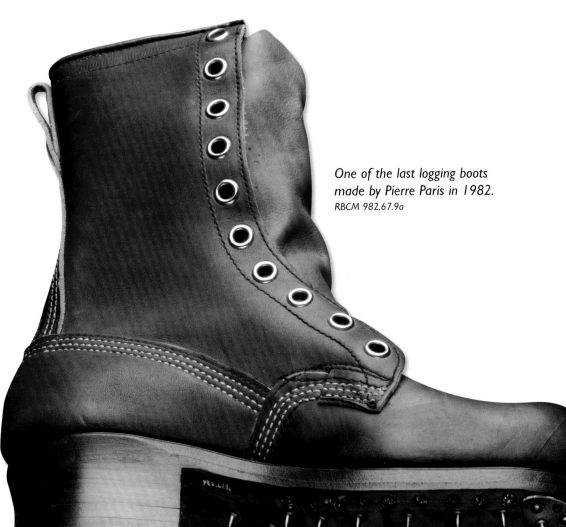

One of the last logging boots made by Pierre Paris in 1982.
RBCM 982.67.9a

These boots are made for loggin'

For loggers, miners, hikers and many others in BC, the best boots of the 20th century were not made *in* Paris but *by* Paris. In 1907, Pierre Paris began making custom-fitted boots for loggers in his Vancouver shop.

Paris designed a special order pad, so that a logger anywhere in the province could order boots by mail. Draw an outline of each foot on the pad, then answer all the questions about foot shape, weight, etc. A few weeks later, fitted boots would arrive.

The system worked. Paris expanded his service to include all kinds of industrial and recreational boots and orthopedic shoes. The company made its last logging boots in the early 1980s, and now makes only orthotic footwear.

Pierre Paris staff reused the company account book to document foot patterns, as on the left-hand page.
RBCM 982.67.3c

Pierre Paris order form.
RBCM 982.67.2a

Travelling Dentist

Remote towns and villages along BC's coast depended on supplies and services from ships that made regular stops. In the 1920s and '30s, Dr Reginald Davey travelled aboard the SS *Venture*, stopping by to take care of any aches and pains in the teeth.

Dr Davey carried with him his tools, including a foot-powered drill and a portable headrest that attached to just about any chair.

This won't hurt a bit. Just lean back and say "ahhh".

*Dr Davey's foot-powered
dentistry instruments.*
RBCM 2001.55.1

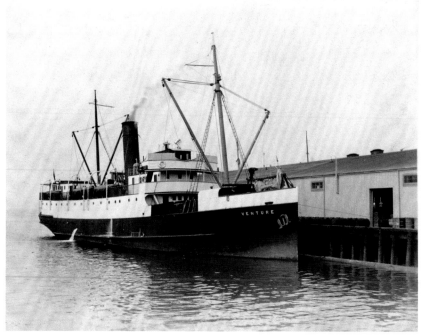

The SS Venture *docked
in Vancouver in 1925.*
H. Brown photograph; BC Archives A-07621

Fit to be Tied

Albert Fuggle also travelled to coastal towns, but over land (by car or train), offering a less essential but more pleasant service. He carried these samples with him when he visited clothing merchants on Vancouver Island in the 1930s and early '40s.

Fuggle specialized in silk ties and handkerchiefs, but he also carried samples of shirts, socks and other men's clothing. Unfortunately, his business collapsed during World War II, when all the silk in North America had to be used to make parachutes.

Men, imagine what you'd look like wearing one of these ties with your best shirt. Made of the finest quality silk, they're very nice indeed, don't you agree?
RBCM 2003.16.2 and 2003.16.6

Making Waves

\mathcal{D}on't be afraid, madam, please sit down. The permanent wave machine is meant for beauty, not torture. It will give you the luxurious curls that you've always wanted, and they'll stay forever. Well, for a few months, at least.

These clips hold the curlers. The wires attached to the clips heat up the curlers in your hair. All you have to do is sit here for one or two hours. You can move a little – as long as you keep your head still. And, whatever you do, don't stand up! The clips get very hot. They can cause terrible burns. Nothing to worry about, though. As long as you stay still, the little cables will keep them from touching your scalp.

Straight or curly, hot or cold

Marjorie Stewart Jointer patented the first permanent wave machine in 1928 in Chicago. She originally made it to straighten hair, and then curls became more fashionable.

The Helene Curtis company soon developed its version of the machine. This one curled women's hair at the James Bay Beauty Parlour in the 1940s and '50s.

The cold perm was developed in 1938, but hot curling machines were still used for some time. Even now, women and men use hot hand-held irons to curl or straighten their hair.

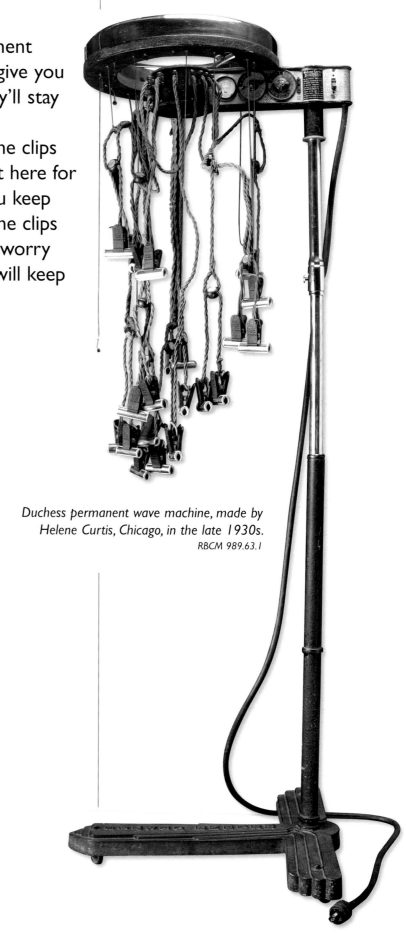

Duchess permanent wave machine, made by Helene Curtis, Chicago, in the late 1930s.
RBCM 989.63.1

Beauty parlour on the Canadian Pacific ship
Empress of Britain, *about 1935.*
BC Archives G-00915

Fort Kamloops
Attributed to John Tod, about 1846.
BC Archives PDP00170

John Tod (1794–1882) ran the Hudson's Bay Company's Fort Kamloops from 1842 to 1849. He moved to Victoria in 1850 and settled on 100 acres (40 hectares) of land in Oak Bay. In 1851, Governor James Douglas appointed him one of the first members of the Legislative Council of Vancouver Island.

Above Okanagan Lake
Edward John Hughes, 1960.
BC Archives PDP00524

E.J. Hughes (1913–2007) is best known for his coastal landscapes, so this painting of interior BC is a departure. In his youth, Hughes belonged to the Western Canada Brotherhood, a trio of artists with Paul Goranson and Orville Fisher, who earned praise for their scenic murals of British Columbia (see page 112). Hughes became a celebrated artist on his own, with paintings in several important national collections. He received the Order of Canada in 2001.

Ogopogo of Okanagan Lake

by Don Haaheim

*I*n 1986, I moved to Kelowna with my wife and family. This vibrant city on the shores of Okanagan Lake has grown at a mindboggling pace. The Okanagan Valley is often called both the Napa Valley and Silicon Valley of Canada for its booming wine making and technology industries. We live just a few minutes north of downtown on Knox Mountain with a clear view of the lake. And there lies a great mystery of an often-seen monster said to be living in the lake waters.

Before the missionary Father Charles Pandosy came to the Okanagan in the 1850s, First Nations legends held that a great undulating serpent inhabited these waters, surfacing occasionally to feast on warm-blooded animals. The Secwepemc (Shuswap) name for this great creature was *N'ha-a-itk* (lake demon), and it was said to have an underwater lair at Squally Point near Rattlesnake Island, directly east of Peachland. Secwepemc lore portrays a greatly feared monster up to 12 metres long, capable of devouring an innocent swimmer.

When non-aboriginal settlers came to this valley in the mid to late 1800s, they first scoffed at such talk, but derision turned to belief as more and more documented sightings occurred – although no one has been eaten in modern times. The first recorded sighting was by Mrs John Allison in 1872, and similar events continue to this day, with five or six sightings reported each year. On October 13, 2007, our local newspaper, the Kelowna *Daily Courier*, printed an article by Chuck Poulsen about the monster. The headline read: "Retired dentist sees Ogopogo – again!" It describes a typical sighting of the mysterious monster:

> *The first time retired dentist Gerry Morrison saw what he thinks is Ogopogo 19 years ago, he kept it to himself. Maybe he was seeing things? Who would believe him? But when he saw the same thing again on Wednesday there was no denying that something very big is out there! Gerry said that he was not seeing things and can tell fact from fiction. He was rowing several hundred metres off the Eldorado Hotel heading for Penticton and at 9:28 a.m., he saw a wake in the water about two hundred metres further out even though it was dead calm and there were no other boats around! It had two or three distinct humps, not fins, and they were three or four feet above the water. Gerry didn't see a head but he estimated that it was at least twenty feet long, dark brown to black, moving slowly south and leaving a wake. It was on the surface for less than a minute but Gerry watched the wake gradually disappear for about two more minutes.*

Ogopogo is a fixture at Kelowna's City Park.
Don Haaheim photograph

I can vouch for Gerry as a former patient of his. I also know of other respected individuals who have seen the lake monster. Each morning I take my Labrador retriever for a walk up Knox Mountain, and I never fail to scan several kilometres of the lake for unusual signs. I have occasionally seen disturbances on the calm surface of the water, but from that height on the hillside, about a kilometre from the nearest shore, it has been difficult to make out the cause.

Am I a believer? You bet. There have been too many sightings by all of sorts of people to not believe that something very large and strange lives in Okanagan Lake. Our local author, Arlene Gaal, has investigated dozens of sightings over the years and written extensively about those experiences. Good reading for those that say it must be a figment of so many people's imaginations.

Don Haaheim is a retired electrical engineer living in Kelowna with Lois, his wife of 45 years. He enjoys writing and has published a fishing book called Willow Stick, Earth Worms.

Ogopogo and Other Legendary Creatures

The legendary lake serpent has haunted Okanagan waters for centuries. In local First Nations stories it was called *N'ha-a-itk* or *Naitaka*, but never *Ogopogo*. That name comes from a vaudeville-style song, performed at a business luncheon in Vernon in 1926, that referred to the monster. Fifteen people reported seeing Ogopogo on one day, August 29, 1955, and many others have sighted it over the years. But no one has ever found evidence to verify the serpent's existence.

A similar creature has been sighted many times in the waters surrounding Greater Victoria. Cadborosaurus takes its name from early sightings in Cadboro Bay. Again, a specimen has never been verified.

Much has been written about sasquatch, the hairy human-like giant of the woods, and some large footprints have been cast in plaster. But it, too, has managed to avoid capture and leave no remains behind for scientific verification of its existence. Quite a few have been sighted in the forest around Harrison Lake.

A lesser known legendary animal is the sidehill gouger, a hoofed mammal that inhabits the slopes above the Fraser and Thompson rivers. It's reported to have

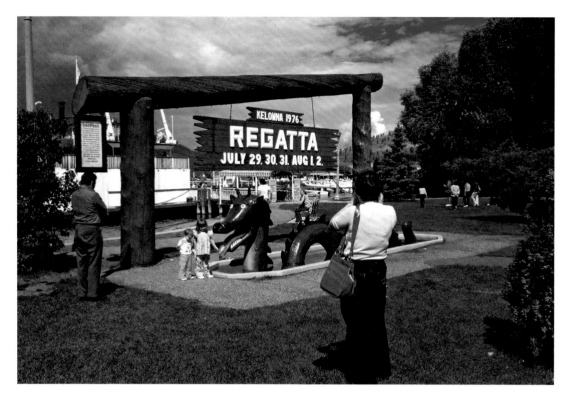

Ogopogo has become a tourist attraction for Okanagan Lake, especially the city of Kelowna.
BC government photograph; BC Archives I-06303

shorter legs on one side of its body so that it can stand straight on the slopes, but it can only walk in one direction and it leaves distinctive tracks, like gouges, on the hillsides.

Drawing of Cadborosaurus, based on descriptions from two people who reported sighting it.
Victoria Daily Times, October 20, 1933

Let the Spirits Speak

In the early 1900s, developer John Moore Robinson asked his spirit guides for advice on where to buy land in the Okanagan. And they told him.

One of Robinson's guides advised him to buy property on a hillside above the southeast shore of Okanagan Lake and call the place "Naramata". So he did.

Robinson wasn't crazy and he certainly wasn't alone in his beliefs. The modern spiritualist movement had started in the USA in 1848 and became very popular in North America and Europe. It got even more of a boost in the next century following the two world wars, when so many ached to speak to loved ones who had been killed.

John Moore Robinson (1855–1934), about 1905.
E.G. Whiten photograph; BC Archives A-02438

John Moore Robinson recorded the conversations with his spirit guides in his journals.
BC Archives MS-2010

Naramata, about 1920.
John W. Clark photograph; BC Archives I-52040

Finding the qi to your house

Feng shui means "wind-water" and it's all about productive and destructive cycles in your living space. Five basic elements – wood, fire, earth, metal, water – interact to produce these cycles. The way they interact depends on the shape of a house and the arrangement of furniture in it.

Harmony in the home begins with good *qi*, the flow of energy. An expert in the ancient practice of feng shui needs to know its direction, so a *Lo Pan* (compass) is a critical tool. According to one feng shui practitioner: "Without a compass, one is only practising interior design and personal preference."

A Lo Pan has 24 divisions, each containing 15 degrees. A division's orientation can affect the prosperity of a house – a few degrees this way or that and you have a completely different house type.

Lo Pan: in the hands of a feng shui practitioner, this compass shows the direction of qi.
RBCM 971.61.1743

Music from Above

*O*nce upon a time, a man named Fred Tibbs built a big house on a tiny island near Tofino, and he lived there all alone. The official name of the island is Arnet, but it was also known as Tibbs, Dream or Castle Island.

"Looking at it from the west, the house was just like a castle in England," explained one of Tibbs's neighbours. "The only thing missing was a princess in the tower, so he painted a beautiful picture of a princess and put her in the window that faces west over the top of his garden."

Fred Tibbs kept mostly to himself, but he wasn't a total hermit, as another neighbour explained: "He had us over to the island sometimes. He'd make cocoa for everybody and light a fire. And then he'd play the grammophone."

Fred Tibbs also liked to play his cornet for his neighbours. He cut the top off a tall Sitka Spruce that stood in the middle of the island and built a crude ladder on the trunk and a chair at the

The ladder-like framework that Tibbs built to climb to the top of the spruce tree.
BC Archives F-03431

Arnet Island, showing part of Fred Tibbs's castle (left) and the towering Sitka Spruce where he played his cornet.
BC Archives F-03430

top. He sat up there often, 30 metres above the ground, playing his cornet so that everyone near his island could hear him.

Tibbs entertained his neighbours with his cornet for about ten years, until his death in 1921. "He used to play 'Come to the Cookhouse Door, Boys' every morning at eight o'clock."

Fred Tibbs with Vera Marshall, about 1920.
BC Archives F-03427

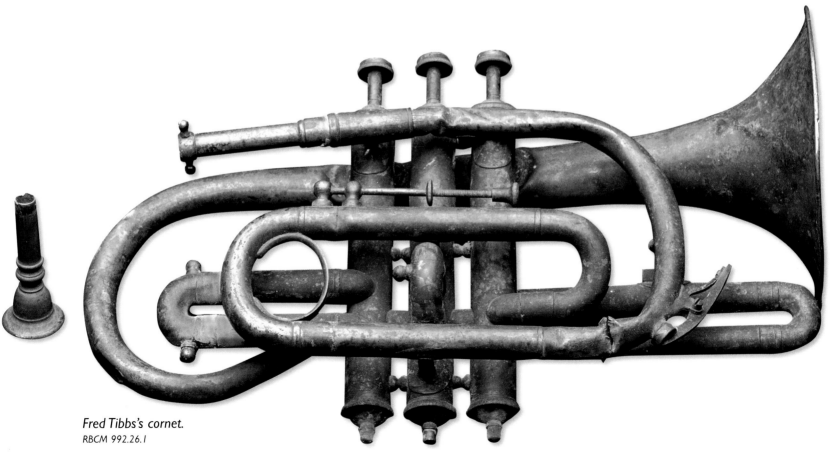

Fred Tibbs's cornet.
RBCM 992.26.1

What's Your High Score?

Daniel Hurst photograph, Acclaim Images.

There goes the ball. Use the body. Tilt! Tilt! Almost there, high score in sight. One great game and you could be the Bally Table King.

In the early days of pinball, the machines had fewer lights and fewer bumpers. This one from the mid 1930s, called Airway, has no lights but it was the first to total your score. It also had a tilt mechanism. But the flipper didn't come along for at least another 10 years.

Back then, you had to go to a pub or saloon to play pinball, and some machines were used for illegal gambling. Police confiscated this one from a pub and used it as evidence.

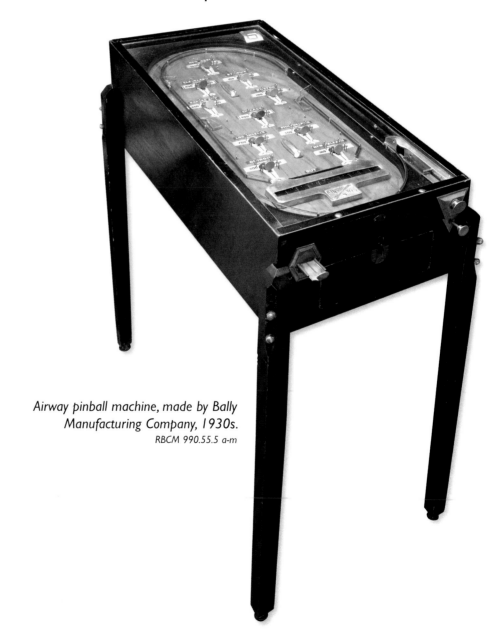

Airway pinball machine, made by Bally Manufacturing Company, 1930s.
RBCM 990.55.5 a-m

The roots of pinball

Pinball machines evolved from a game called bagatelle, which was played in saloons and pubs in the 1800s. Two people played bagatelle using small versions of pool balls and cues. They scored points by using the cue to knock the balls into numbered holes.

The first pinball machine came along in 1871, patented by Montegue Redgrave, a bagatelle maker in Cincinnati, Ohio. It was like solitaire bagatelle, but with marbles shot onto an inclined playing board.

And it got better from there – the lights, the bells ringing up your score....

Who's got crazy flipper fingers?

Before the Ice Age

by Buster Wilson

*T*his story goes back to the early 1960s on the Fort Rupert Reserve.

I was in grade 6 then at Robert Scott School.

One weekend we were watching our older brothers leaning against the radio listening with great interest. We didn't know what they were listening to. We asked, "What are you listening to?"

"It's *Hockey Night in Canada*. Foster Hewitt is broadcasting. It's the Toronto Maple Leafs against the Montreal Canadiens." Oh, so we just sat there listening for a while.

One day my brother asked if we wanted to play the game we were listening to on the radio. So we did.

We got a couple of blocks of wood for our goal posts. Then we made sticks out of ordinary wood from our fences and the poles in our woodshed. This was mud hockey. We used a red-and-blue rubber ball to hit. We didn't know at the time what to use. So we just played and played for hours until we got so dirty with mud.

Every day, right after school we played, and soon the whole reserve got involved. Even this elder named Paul Johnson played. He made his own hockey stick out of a curved branch. It was a funny looking stick. He was fun to play with and great to watch.

Every day after school we just played hockey. Nothing but hockey. Then we made our own nets, too. We didn't know to put blades on the sticks until our neighbour got his first colour TV.

When we went to visit him and watched *Hockey Night in Canada* for the first time on TV, we saw that the hockey players had blades on their sticks. Now we started to make our own hockey sticks with plywood nailed onto them.

We ruined my father's fence by taking the wood to make our hockey sticks. My father wondered why the chickens were running loose. The fence was off. My father got quite angry and he broke our sticks.

We just went and made more sticks. We played more hockey. We used the sticks from our woodshed, and the plywood too.

My brother put two blades on his stick, like he was more of a Bobby-Hull-slap-shot kind of person. His shot could rip the cardboard pads right off the goalie. So we used our father's gumboots for a goalie pads. We ripped the boots to shreds, too. My, our father got so upset that he cut our sticks in half.

We just made more sticks and kept playing hockey. Nothing but hockey every day.

Then this arena was built not too far from the reserve. It was divided into curling, hockey and skating. We all wanted to learn to skate. We did.

One night we asked the arena manager if we could use the ice for skating. He told us we could if we took the plywood curling boards off the ice.

Boy we were so excited and we played hockey until four in the morning. We were tired.

Then hockey was introduced and my three brothers played. My father was so proud of the boys on how good they were playing hockey. My brothers were so skilful and so artistic with the puck.

And that's how we started to play hockey, before the ice age, in my neighbourhood.

Buster Wilson is an artist, storyteller, writer and photographer who lives in Burnaby.

G. Truscott photographs

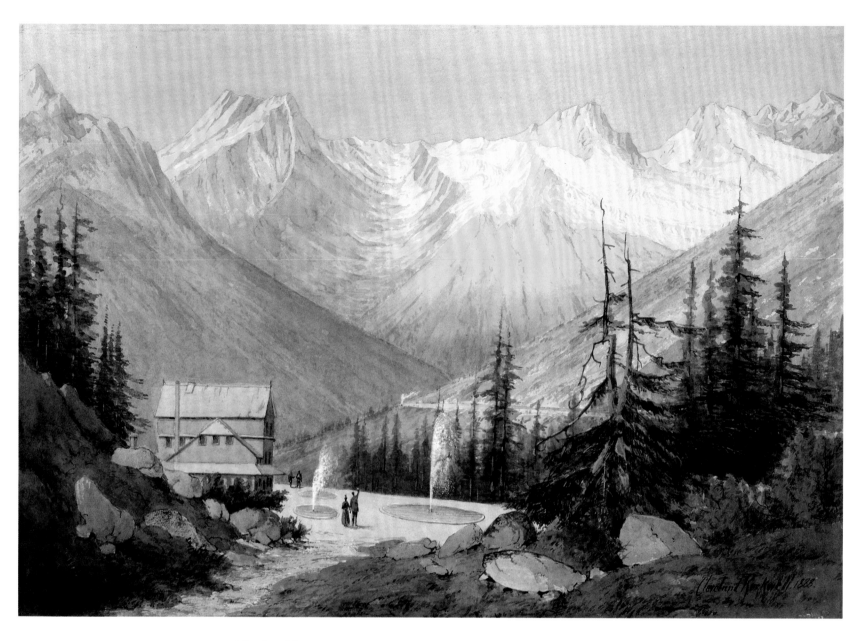

Glacier House
Cleveland Rockwell, 1888.
BC Archives PDP04467

In 1886 the Canadian Pacific Railway built Glacier House as a stopover in Rogers Pass. Named for its location in Glacier National Park, the small hotel offered lodging and meals for travellers. It also became a popular destination for hikers and mountaineers delighted with the new rail access to the park and the majestic Selkirk Mountains (see page 88). Walking trails lined the banks of the Kicking Horse River and led the way to the Illecillewaet Glacier, but many mountaineers made their own trails.

Cleveland Rockwell (1837–1907) surveyed and mapped the Columbia River for the United States Coast Survey. He was known for his paintings of landscapes and flowers in BC and the western US.

Friend for a Century

In Kamloops in the early 1900s, a little girl named Eleanor Goddard caught tuberculosis of the hip. This serious infection made walking impossible and kept her indoors most of the time. Her dolls and other toys helped her cope with this lonely life.

When she was five or six years old, Eleanor's aunt came for a visit from Vancouver and brought her a special gift – a Steiff teddy bear, the latest in toys. Eleanor adored her bear. She named him Theodore, and he became a lifelong friend.

And a very long life she lived. In 2003, after her 100th birthday, Eleanor came to the Royal BC Museum in Victoria to donate her teddy bear. Now, Theodore lives in the museum's collection of children's toys.

Theodore, a Steiff teddy bear produced in about 1908. At 100 years of age, he could be the oldest teddy bear in BC.
RBCM 2003.25.1

Young Eleanor Goddard with Theodore and her dolls on the porch of her Kamloops home, about 1908.
RBCM 2003.25.2

Eleanor, with Theodore, on her 100th birthday in 2002.
RBCM 2003.25.5

The 1955 Philco fridge had hinges on both sides so that you could open the door on the left or right to suit your kitchen design.
RBCM 991.6.1

The 1958 Moffat stove featured a deep-fat fryer for making fries and donuts, or for sterilizing baby bottles.
RBCM 2007.27.24

The Dream Kitchen

North America's population grew at an alarming rate after World War II. From 1941 to 1961, new immigrants and the baby boom doubled BC's population to 1.6 million people. All these new consumers created a tide of great prosperity and an overall feeling of progress. Nowhere was this more evident than in the kitchen.

The kitchen of the 1950s helped a woman feed a large family. It also helped her be the perfect hostess for dinner parties, often a boost for her husband's climb up the corporate ladder. The kitchen had to be equipped with the latest, most efficient, most stylish appliances. New innovations – aluminum pots and pans, heat-resistant glassware, plastic utensils – brought colour and safety to the kitchen workplace.

The golden age of the kitchen had arrived.

GETTING THE MOST FROM YOUR *Gas or Electric Range*

Sunbeam electric percolator coffee pot, 1940s.
RBCM 2005.8.2 a-e

Canadian General Electric K-42 kettle.
RBCM 2006.56.1

Symbol of the modern kitchen

During World War II, the government needed mould and die makers for the war effort. All non-war products had to be made with existing moulds.

Designer Fred Moffat used a car-headlight to make the K-42 kettle. This distinctively Canadian kettle appeared in thousands of kitchens over the next few decades.

Where Did You Go on Your Summer Vacation?

Remember those summertime family road trips around the province? Just about every boy and girl in the 1950s and '60s came home with a bunch of pennants. Proudly displayed on the bedroom wall, they announced all the places you visited.

From Cranbrook to Smithers, Princeton to Dawson Creek, every city, town and park had its pennant. For those of us old enough to have collected pennants, they can inspire fond memories of summer vacations – the fine weather, the fun places, the beautiful scenery, the visits with family and friends.

White Rock B.C. CANADA

Yoho-NATIONAL PARK, B.C. Canada

100 MILE HOUSE B.C. CANADA

PORT ALBERNI, B.C.

CRANBROOK, B.C. CANADA

PRINCE RUPERT BRITISH COLUMBIA

KELOWNA, B.C.

the BEACHCOMBERS GIBSONS B.C.

BARKERVILLE BRITISH COLUMBIA

VANCOUVER B'C CANADA

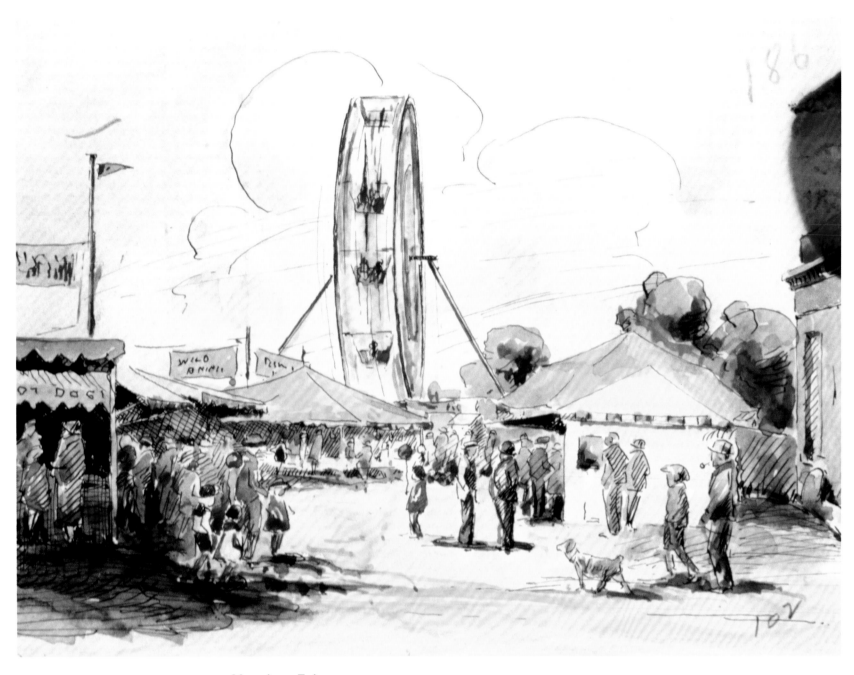

Nanaimo Fair
Cecil Augustus de Trafford Cunningham, 1940s.
BC Archives PDP03871

It's usually just a short trip to the local summer or fall fair – an annual event for families in many communities. How can you resist the lure of the ferris wheel and the friendly competition for harvest prizes?

Along the midway, the aromas of popcorn and cotton candy drift on the air. Barkers bark their invitations to a show. The wheels of fortune clack noisily before coming to rest on a pair of hearts. Children screech with excitement at the prospect of being scared half to death on the latest monster ride. All good fun at the fair.

Cecil Cunningham (1897–1973) painted in his spare time while he worked for the federal government in various cities on Vancouver Island. He painted more often after retiring in 1949.

Princess Patricia and the Ghosts

by Ann Nelson

*W*hat's it like to live in a movie theatre haunted by ghosts? What's it like to get to see movies every day, to never be able to leave your job and go home, and to share your "home" with hundreds of people every day and night? What's it been like, since my son Brian and I were asked in 2002 by the local credit union to adopt the old theatre while it coped with legal stuff? The answer to all these questions is, simply, "It's a hoot!"

How many other little old ladies do you know who get to live with their cat in lovingly restored 1920s professional offices above the foyer and retail spaces of Western Canada's oldest continuously operating vaudeville and cinema house? The Patricia Entertainment Company was founded in September 1913. The theatre was named after Princess Patricia, granddaughter of Queen Victoria, who became the darling of the people when her father, the Duke of Connaught and Strathearn, was Canada's governor general (1911–16).

We also got to turn the whole front corner into a traditional early 20th-century garden. It has hundreds of roses, irises, peonies and other perennials that we share with our neighbours and the numerous visitors to this National Historic District that is the Powell River Townsite. Not only that, but we do indeed get to watch movies on the big screen every day, and be part of people's weddings in our auditorium, and hold parlour concerts, vaudeville and burlesque shows, community Christmas carol sing-alongs, and live theatre, too.

Wow … and the ghosts are all real characters, too: We have the gravelly voiced vaudeville lady who won't let some of our male performers up the stairs to the "ladies'" dressing room. There's the evil, mean and cruel dentist who used to pinch the little kids who squirmed with pain in his office (now my living room), and now flits around the offices and balcony in his white dentist tunic. There's the beloved original owner of the theatre, Myron McLeod, who periodically shows up with thumbs hooked in vest pockets, beaming at us with honest to goodness glee. There are more, too many to mention here.

Brian and I didn't hesitate a moment when we realized that the Patricia was in trouble. To risk the future of one of the community's

Box office and front foyer.
Lilia Cardoso Gould photograph

Brian and Ann Nelson welcome guests to the theatre.
Powell River Peak *photograph*

most cherished heritage icons by allowing it to lose its legal, non-conforming status if sitting empty, to see it sold off for pennies on the dollar to someone who might send it down the same path as so many of Canada's priceless independent movie palaces, to become an auction house, bistro or whatever – that just wasn't going to happen.

The theatre has been part of our lives since 1977 when we came to Powell River. The Patricia is a priceless example of the Spanish Revival expression of the Arts and Crafts movement. It was designed in 1928 by architect Henry Holdsby Simmons (designer of Vancouver's Stanley Theatre, as well), and built with a spare-no-expense exuberance that is rare on this coast.

We've had a lot of help from our friends in recreating the original Girvan studios atmospheric murals, and in restoring, repairing and rehabilitating the whole neglected and cash starved building. Our gift to those friends and neighbours is to keep the old girl alight with good times.

How much fun can you have in a living museum? A whole bunch!

Ann Nelson has worked in the arts, commerce and social change in the US and Canada. She has grown to love being the eccentric old lady of the Patricia Theatre, with her cats and garden, parked for life in paradise.

The Patricia Theatre in 2007.
Lilia Cardoso Gould photograph

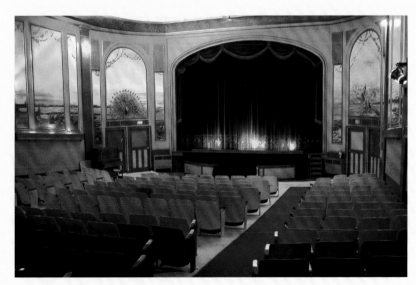

Inside the theatre, featuring the original hand-stencilled French velvet drape and the trademark peacock mural.
Lilia Cardoso Gould photograph

Honk Your Horn for the Hero

It's alive!

The Mighty 90 carbon-arc drive-in projector lit up the Cassidy Drive-In, near Nanaimo, from 1952 to 1992. It produced an intense light by arcing 70 volts of direct current between two rods.

Much like Dr Frankenstein did with his monster, the projectionist used electricity to bring movie film to life. A curved mirror directed a beam of light through the film and lens, projecting the picture onto the huge screen.

The electricity slowly ate up the carbon rod that received the electricity, much like an arc welder. The owners of the Cassidy Drive-In said that one of the reasons they had to close the theatre was that the price of the carbon rods increased from $70 to $2800 per thousand.

*I*s there anything more romantic than watching a movie from the privacy of your car (or your parents' car)?

Hook the speaker onto the window, recline the bucket seats and enjoy the show.... And don't let the windshield steam up – the killer tomatoes are about to attack.

Why, then, did drive-ins disappear? TV? Video tapes? The price of fuel? All three may have contributed to people staying home to watch a movie. By the 1980s, almost all drive-in theatres had given way to housing developments and warehouses. Only a few still operate regularly in BC – hooray for them!

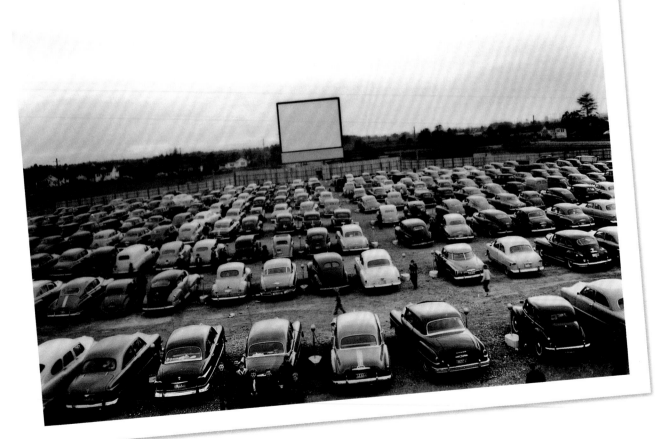

Opening day at the Delta Drive-In, Richmond, in 1952.
Vancouver Public Library VPL 45953

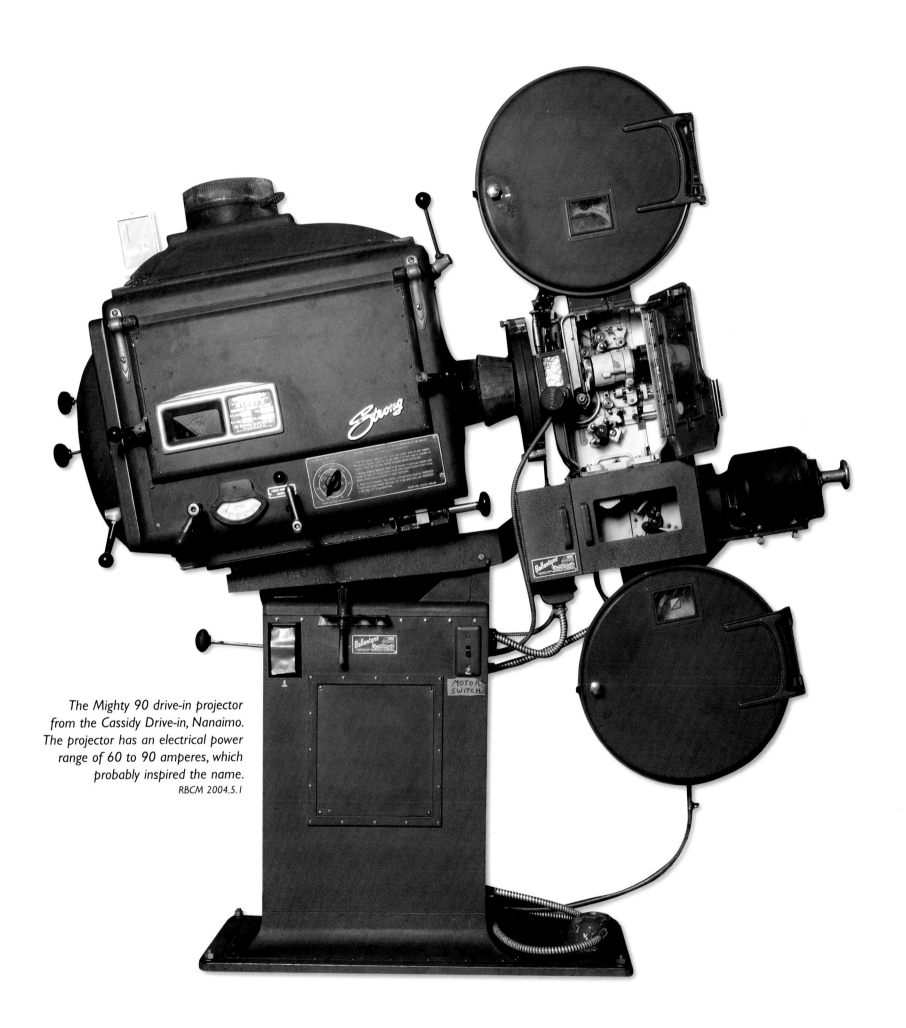

The Mighty 90 drive-in projector from the Cassidy Drive-in, Nanaimo. The projector has an electrical power range of 60 to 90 amperes, which probably inspired the name.
RBCM 2004.5.1

Electric Car for a New Century

The beginning of the 20th century heralded the new age of electricity in southeastern BC. Newly built hydroelectric generators at dams on the Kootenay River powered the new Cominco smelter in Trail and the cities of Rossland and Nelson.

It was no trouble, then, to run the 1903 City & Suburban Electric Carriage. Powered by two rechargeable glass batteries, this pioneering electric car rolled silently down the streets of Nelson over a century ago. In later years, the old beauty has enjoyed a more ceremonial life. Most notably, it appeared in a Nelson parade celebrating the end of World War II and at Expo 86 in Vancouver.

The key for the C&S Electric Carriage.

Careful getting started

Don't try to start this car in the rain. The key is a block of copper with an insulated hand grip. By pushing the key into a slot, it completes a circuit and gets the electricity running from batteries to wheels.

The thing is, you have to be quick, because the electricity can arc through the air when the key nears the slot. And if your hand is wet from rain – well, you know how electricity loves water....

1903 City & Suburban Electric Carriage, no. 2095.
On loan from Rick and Ruth Percy; LI2007.57.1

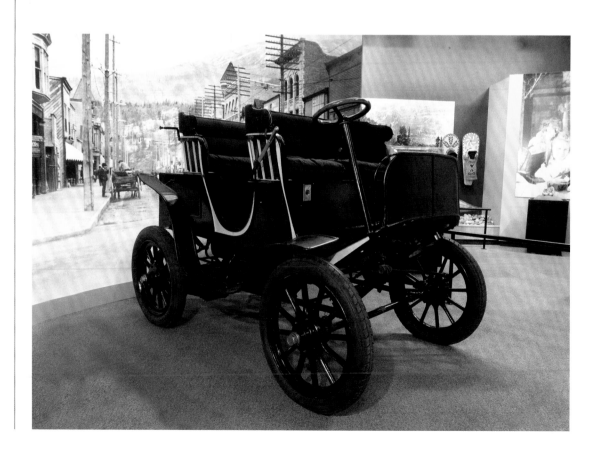

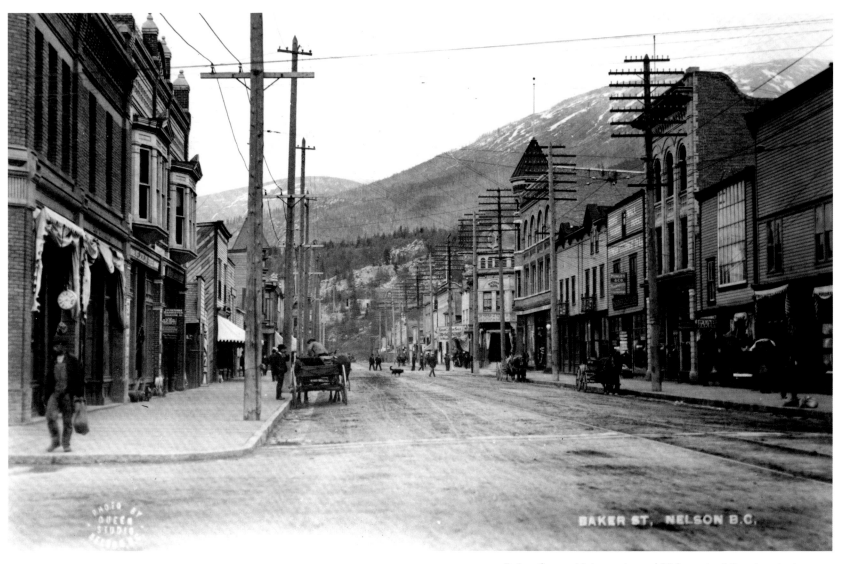

Baker Street, Nelson, about 1901 – wired for electrical power.
BC Archives B-05393

Identification plate for the C&S Electric Carriage.

Some of the first licence plates for cars were made from leather.

Building for the Future

ave you thought about ways you can reduce your impact on the world around you? It's a hot topic in BC. The consensus seems to be that governments and industry need to play major roles in conserving resources and creating renewable energy sources. But all of us can contribute to the effort right in our own homes.

Some people have already made a statement by building homes with environmentally neutral materials and powered by renewable energy sources. Here are three examples of sustainable homes built in BC. All use materials from the earth – cob (clay, sand, straw and pumice) or rammed earth (soil, sand, gravel and clay) – and have systems that recycle waste and make the most of solar energy.

A wall made of cob or rammed earth has excellent thermal mass – it warms up slowly during the day and releases the heat slowly at night. In this way, it evens out daily temperature fluctuations and helps keep the home warm in winter and cool in summer.

"Civilizations have developed many techniques for making the Earth produce more food – some sustainable, others not. The lesson I read in the past is this: that the health of land and water … can be the only lasting basis for any civilization's survival and success."

– Ronald Wright

Ann and Gord Baird stand in front of their Eco-Sense cob house in Victoria. The solar panels on the roof provide power and solar-thermal heating; rain-water can be harvested from the living roof.
John Yanyshyn photograph

Meror Krayenhoff developed SIREwall technology to build rammed-earth houses. He built this house for his mother, Ima, on Saltspring Island.
John Yanyshyn photograph

Recipe for rammed earth

Mix together soil, sand, gravel and clay. Add a stabilizer, like cement, and enough water to dampen the mixture. Then do as the name suggests: pour a layer of 10 to 25 cm into a form and ram it down; use a tamping tool to compress the mixture to half that height; then add some more and ram again.

Rammed earth has been used for centuries to build houses. Traditionally, it has been stabilized with lime or animal blood, but builders now use cement. When rammed earth dries and hardens, it's as strong as rock, but it will take a nail or a screw. By using forms, you can make straight or curved wall sections.

No ordinary brick — this sample shows what rammed earth looks like, but wall sections of rammed earth are solid forms, not bricks and mortar.

Eva and Marcus Gasper's SIREwall rammed-earth home on Saltspring Island is off the power grid, using passive solar heating and solar panels for electricity.
John Yanyshyn photograph

Manual tamping tool for ramming the earth.

Appendix 1: Splendid Diversity

Artist Carol Christianson created a mural for the Free Spirit exhibition shown at the Royal BC museum in 2008. She entitled the mural *Splendid Diversity – 36 More Wonders of the World*, and describes it as "a stylized composite of 36 scenes of BC selected for their spectacular beauty and their ability to represent the major regions of this province. It takes us on a tour of the highlights, from black smokers in the ocean depths to Rocky Mountain peaks to BC's corner of the Great Plains."

The opening and closing pages of this book feature 8 of the 36 scenes in the mural:

Carol Christianson has worked in museums for more than 35 years, with some of the most respected museum designers, artists and artisans in the world today. Her work can be seen at the Royal BC Museum, the New York State Museum and Chicago's Field Museum. She lives in Victoria.

"Floe Lake, The Rockwall, Kootenay National Park"

Appendix 2: Dedication Story

This book is dedicated to my mother, Laura Truscott. She lived almost all her life in BC, and in her time crossed the width of the province. She raised herself up from the poverty of the Great Depression and gave her children the ability to prosper. This is why she's a hero, like many other British Columbians of her generation.

Catherine Laura Terrion was born in 1912 in a farmhouse on her parents' homestead near Pincher Creek, Alberta, the third of eight children (though three died in infancy). She spent her early childhood on the farm. Laura's father, Patrick Terrion, had been a teacher in the small mining town of Michel on the BC side of the Crowsnest Pass until poor hearing forced him to give it up and become a farmer. In 1920, the family moved back to Michel, where Patrick found employment as a check-weighman at the Crowsnest Coal Company's mine.

The younger Terrion children attended the small school (where their father had once taught) until Grade 8. The closest secondary school was in Fernie, more than 30 kilometres away, and not many of the mining families in Michel, including the Terrions, could afford the travel or the lodging for their children. So, for most children in the town, school ended at Grade 8 and it was time to contribute to the family income or help in some other way.

Laura got her first job at age 15 cleaning rooms in the Michel Hotel. Two years later she left town to find work in Trail, a bustling city compared to Michel. There, she met Frederick Truscott, who worked in Trail's smelter. Fred had left Cornwall, England, about eight years earlier, at 18 years old, and landed in Ontario. He worked his way westward as far as Trail. He and Laura fell in love and married in 1932.

Fred continued to work at the smelter until 1935, when a serious accident gave him severe acid burns to both legs. It took years to recover, and the injuries

prevented him from enlisting in the Canadian armed forces that fought in World War II. (Laura's only brother, James, served in Europe as a medic and died of tuberculosis in England while on his way home in 1945, leaving his wife and two young children.)

Laura gave birth to Gail, the first of four children, in 1938, and four years later the family moved to Vancouver with hopes that Fred would find work in the big city. The other three children came into the world there – Glenda, then Gordon, then me.

Since immigrating, Fred had enthusiastically embraced Canada, possibly because he hadn't liked his life in England. (Mum told me that he didn't like to talk about "the old country".) He especially liked Canadian football, and was one of the first BC Lions fans when the team joined the CFL in 1954. His enthusiasm carried through the family: Gail became one of the first Lions cheerleaders, and all the Truscott children have remained loyal supporters.

My father died at the beginning of BC's centennial year. A pulmonary thrombosis killed him, the doctors said, a blood clot that had likely formed in his injured legs. I was with him when he died, but I don't remember it. I was just two years old.

Dad's life-insurance covered little more than the funeral. Mum had to take care of a mortgage and home-improvement loan. Gail got married and moved out later that year. Mum raised the rest of us on her own. She never remarried. She took in single-parent boarders and looked after their children while they worked, and also

minded some of the neighbourhood kids; I always had plenty of playmates.

My mother was quiet and unassuming, yet always there when her children needed her, including the ones she looked after. In 1964, we moved into a smaller house (purchased for $13,000), so she gave up the daycare and started working as a waitress at the dining counter in the basement of Woodward's Department Store in downtown Vancouver. Later, for a while, she took a second job as a chambermaid in a hotel on Howe Street.

Mum worked hard to give her children opportunities that she never had, and she supported us in all our endeavours. Family life improved as time went on – being the youngest, I probably had the easiest childhood of all my siblings. I never thought of myself as unfortunate because I had only one parent.

Gradually, as us children became adults, we all moved out of the home in the order we had come into it, and in time built happy families of our own. Mum, being the self-reliant soul that she was, lived the rest of her life on her own. She worked at Woodward's until her 70th year, retiring not because the work tired her but because she hated the long commute by bus.

Later, in her old age, she rejected any of our offers for her to come live with us. She died in 1999, beautifully, peacefully, as was fitting, while still living independently in her own way.

Laura Truscott, 1930s.
Family collection

Suggested Reading

General:

Akrigg, G.P.V., and Helen Akrigg. *British Columbia Place Names*, third edition. Vancouver: UBC Press, 1997.

Barman, Jean. *The West Beyond the West: A History of British Columbia*, third edition. Toronto: University of Toronto Press, 2007.

Cannings, Richard, and Sydney Cannings. *British Columbia: A Natural History*. Vancouver: Greystone (Douglas & McIntyre), 1996.

Duff, Wilson. *The Indian History of BC: The Impact of the White Man*, third edition. Victoria: Royal BC Museum, 1997.

Forsythe, Mark, and Greg Dickson. *The BC Almanac Book of Greatest British Columbians*. Madiera Park: Harbour Publishing, 2005.

Francis, Daniel. *Far West: The Story of British Columbia*. Madiera Park: Harbour Publishing, 2006.

Francis, Daniel, editor. *Encyclopedia of British Columbia*. Madiera Park: Harbour Publishing, 2000.

Francis, Daniel, editor. *Imagining British Columbia: Land, Memory and Place*. Vancouver: Anvil Press, 2008.

Newsome, Eric. *Wild, Wacky, Wonderful British Columbia*. Victoria: Orca Book Publishers, 1997.

PTC Phototype Composing. *British Columbia Recreational Atlas*, fourth edition. Victoria: PTC Phototype Composing, 1997.

Reksten, Terry. *The Illustrated History of British Columbia*. Vancouver: Douglas & McIntyre, 2001.

Regarding certain stories:

Augaitis, Diana, Nika Collison, Robert Davidson, Marianne Jones, Peter Macnair and Bill Reid. *Raven Travelling: Two Centuries of Haida Art*. Vancouver: Vancouver Art Gallery, Douglas & McIntyre, 2006.

Baird, Ann, and Gord Baird. *Eco Sense*. Website: http://www.eco-sense.ca.

Black, Martha. *Bella Bella: A Season of Heiltsuk Art*. Toronto: Royal Ontario Museum; Vancouver: Douglas & McIntyre, 1997.

Black, Martha. *Out of the Mist: Treasures of the Nuu-chah-nulth Chiefs*. Victoria: Royal BC Museum, 1999.

Bridge, Kathryn Anne. *By Snowshoe, Buckboard and Steamer: Women of the Frontier*. Victoria: Sono Nis Press, 1998.

Bridge, Kathryn Anne. *Henry & Self: The Private Life of Sarah Lindley Crease 1826–1922*. Victoria: Sono Nis Press, 1996.

Bridge, Kathryn Anne. *A Passion for Mountains: The Lives of Don and Phyllis Munday*. Calgary: Rocky Mountain Books, 2004.

Bridge, Kathryn Anne. *Phyllis Munday: Mountaineer*. Montreal: XYZ Publishing, 2001.

Corley-Smith, Peter. *White Bears and Other Curiosities: The First 100 Years of the Royal British Columbia Museum*. Victoria: Royal BC Museum, 1989.

Ford, Corey. *Where the Sea Breaks its Back: The Epic Story of Early Naturalist Georg Steller and the Russian Exploration of Alaska*. Anchorage: Alaska North West Books, 1996.

Gasper, Eva, and Marcus Gasper. *Zensible Living*. Website: http://www.zensibleliving.com.

Grauer, Peter. *Interred With Their Bones: Bill Miner in Canada 1903–07*. Kamloops: Partners in Publishing, 2006.

Harris, Cole. *Making Native Space: Colonialism, Resistance, and Reserves in British Columbia*. Vancouver: UBC Press, 2002.

Hawker, Ronald W. *Tales of Ghosts: First Nations Art in British Columbia 1922–61*. Vancouver: UBC Press, 2003.

Keddie, Grant. *Songhees Pictorial: A History of the Songhees People as Seen by Outsiders (1790–1912)*. Victoria: Royal BC Museum, 2003.

Macnair, Peter L., and Alan L. Hoover. *The Magic Leaves: A History of Haida Argillite Carving*. Victoria: Royal BC Museum, 2002.

Macnair, Peter L., Alan L. Hoover and Kevin Neary. *The Legacy: Tradition and Innovation in Northwest Coast Indian Art*. Victoria: Royal BC Museum, 1984.

McLennan, Bill, and Karen Duffek. *The Transforming Image: Painted Arts of the Northwest Coast First Nations*. Vancouver: UBC Press, 2000.

Rajala, Richard A. *Up-Coast: Forests and Industry on British Columbia's North Coast, 1870–2005*. Victoria: Royal BC Museum, 2006.

Reksten, Terry. *Rattenbury*, second edition. Victoria: Sono Nis Press, 1998.

Roy, Patricia E. *White Man's Province: British Columbia Politicians and Chinese and Japanese Immigrants, 1858–1914*. Vancouver: UBC Press, 1989.

Sherwood, Jay. *Surveying Northern British Columbia: A Photojournal of Frank Swannell*. Prince George: Caitlin Press, 2004.

Sherwood, Jay. *Surveying Central British Columbia: A Photojournal of Frank Swannell, 1920–28*. Victoria: Royal BC Museum, 2007.

Thom, Ian. *E.J. Hughes*. Vancouver: Douglas & McIntyre, 2002.

Tippett, Maria. *Emily Carr: A Biography*. Toronto: Penguin Books, 1982.

Waddington, Alfred. *The Fraser Mines Vindicated*. Oakesdale, Washington: Ye Galleon Press, 2000.

Wright, Ronald. *A Short History of Progress*. Toronto: House of Anansi Press, 2004.

Acknowledgements

Free Spirit was a collaborative project involving almost every employee of the Royal BC Museum along with many volunteers, contractors and supporters. The creation of this book, as a part of the project, also involved a lot of people. Many things done for one component of the project (e.g., photography) were also used in this book. For that reason I thank everyone who worked on the Free Spirit project.

Special thanks to the people I worked closely with during the writing and production of the *Free Spirit* book: Grant Hughes, Janet MacDonald, Angela Williams and Tim Willis for giving me the opportunity, encouragement and support, and Theresa Mackay for continuing that support in the later stages; Dr Bob Griffin (history), Kelly Sendall (natural history), Dr Martha Black (ethnology), Kathryn Bridge (archives) and Dr Lorne Hammond (history) for information, attention to detail, advice and patience; Chris Tyrrell for another beautiful design; Andrea Scott, because every writer needs a good editor; and Ellen Rooney for finding and arranging the bits and pieces, and for proofreading.

I also thank my wife, Christina, and my three daughters, Julia, Lauren and Allyson, for giving me the space and time to complete the work.

All text, photographs and art © Royal BC Museum, except for the following, which have been reprinted with permission (page numbers in parentheses).

Steller's Jay (25) and Sea Otter (121) © Jared Hobbs.
Western Redcedar (27) © Syd Cannings.
Kermode Bear (28) © Ian McAllister.
British Columbia flag (38) © BC Ministry of Finance, Public Affairs Bureau.
White Raven Stealing the Sun (46) © Art Thompson.
Raven (47) © Beau Dick.
Untitled (48), *Origin of the Nimpkish* (49) and *Untitled* (49) © Doug Cranmer.
Mungo Martin (52) © Jim Ryan.
Ceremonial curtain and bee mask (53) © Mungo Martin.
Hamat'sa bee mask (53) © Tony Hunt.
Saseenos 1935 (57) © Max Maynard.
"Our Eyes to the Past and Vision for the Future" (59) © Lenny Sellars.
Xat'sull Heritage Village teepees and summer home (59) © Rhonda Shackelly.
Mr Coyote Conducting his Weekly Prayer Meeting (60) © Reynold Smith.
Mr and Mrs Coyote and Their Magic Ladder (61) © Reynold Smith.
"Growing Up in Whonnock" (70) © Joan South.
Gibraltar Bluff, Paul Lake, from Echo Lodge (82) © Alfred W. Allen.
"The Day My Mother Met Bill Miner" (86) © Allan Shook.
"Magical Atlin", including three Atlin photographs, (89) © Wayne Merry.
"Alkali Lake Ranch, the Oldest Cattle Ranch in British Columbia", including two photographs of Bronc Twan and one of the Mervyns, (92–93) © Liz Twan.

Bill Twan photographs (92) © Twan family.
Bluebunch Wheatgrass (93) © Dick Cannings.
The Black Tusk, Garibaldi Park (98) © James W.G. Macdonald.
"Chilcotin Time", including Emily Lulua photograph, (99) © Sage Birchwater.
BC legislative buildings (108) © Mark Reber, Infocus Photography.
"Paul George", including *Claude Paul George* portrait, (110) © Keith F. Broad.
Workers Leaving a Factory (111) © Ina D.D. Uhthoff.
"A Blacksmith Forges Olympic Pride" (70) © Bonnie Kent.
Dryad Point (116) © Chris Mills.
Sea Otter feast bowl (120) © Henry Hunt.
Trumpeter Swan (121) © Ralph Hocken.
Survivor (123) © Susan Point.
"When Fish Owned the Capilano", including sketch, (124) © Gail Mackay.
Above Okanagan Lake (135) © Edward J. Hughes.
"Ogopogo of Okanagan Lake", including City Park photograph, (136) © Don Haaheim.
Excerpt from Chuck Poulsen article (136) © Kelowna *Daily Courier*.
Pinball machine (142) © Daniel Hurst.
"Before the Ice Age" (143) © Buster Wilson.
Radio and hockey sticks (143) © Gerald Truscott.
Nanaimo Fair (150) © Cecil Cunningham.
"Princess Patricia and the Ghosts" (151) © Ann Nelson.
Brian and Ann Nelson in front of Patricia Theatre (151) © Powell River *Peak*.
Patricia Theatre box office, front and interior (151) © Lilia C. Gould.
Delta Drive-In (152) © Vancouver Public Library.

About the Author

Gerald Truscott has lived all his life in British Columbia, growing up in Vancouver, then raising a family in Victoria. After earning a Creative Writing degree from the University of Victoria in 1982, he has spent his professional life editing and publishing fiction and non-fiction books.

Since 1989, Truscott has managed the Royal BC Museum's publishing program, having edited and produced dozens of books as well as its magazine, *Discovery*. He edits or writes most of the text that appears in the exhibition galleries. He also writes fiction and has had several short stories published in magazines and anthologies.

About the Royal BC Museum Corporation

British Columbia has a unique history, from the way climate has changed it over millions of years to how people have settled here, worked the land and learned to live together. The Royal BC Museum Corporation – British Columbia's museum and archives – captures this story and shares it with the world. It does so by collecting, preserving and interpreting millions of artifacts, specimens and documents of provincial significance. Flowing from these activities, the RBCM uses exhibitions, publications and public programs to bring the past to life in an exciting, innovative – and personal – way. It helps explain what it means to be British Columbian and further defines the role this province will play in the world tomorrow.

With roots dating to 1886, the Royal BC Museum Corporation today administers a unique cultural precinct in the heart of British Columbia's capital city. This site incorporates the Royal BC Museum (established in 1886), the BC Archives (established in 1894), Netherlands Carillon, Helmcken House, St Ann's Schoolhouse and Thunderbird Park, which is home to Wawadiƛa (Mungo Martin House).

Although its buildings are located in Victoria, the Royal BC Museum Corporation has a mandate to serve all citizens of the province, wherever they live. It meets this mandate by conducting and supporting field research, producing travelling exhibitions, lending artifacts, specimens and documents to other institutions, delivering a variety of services by phone, fax, mail and e-mail, and providing a vast array of information on its website about all of its collections and holdings.

John Fannin, the museum's first curator, prepares specimen mounts in about 1887. In the far corner sits Albert Maynard, who was probably the museum's first volunteer.
RBCM Photograph

From its inception more than 120 years ago, the Royal BC Museum Corporation has been led by people who care passionately about this province and work to fulfil its mission to preserve and share the story of British Columbia.

Index